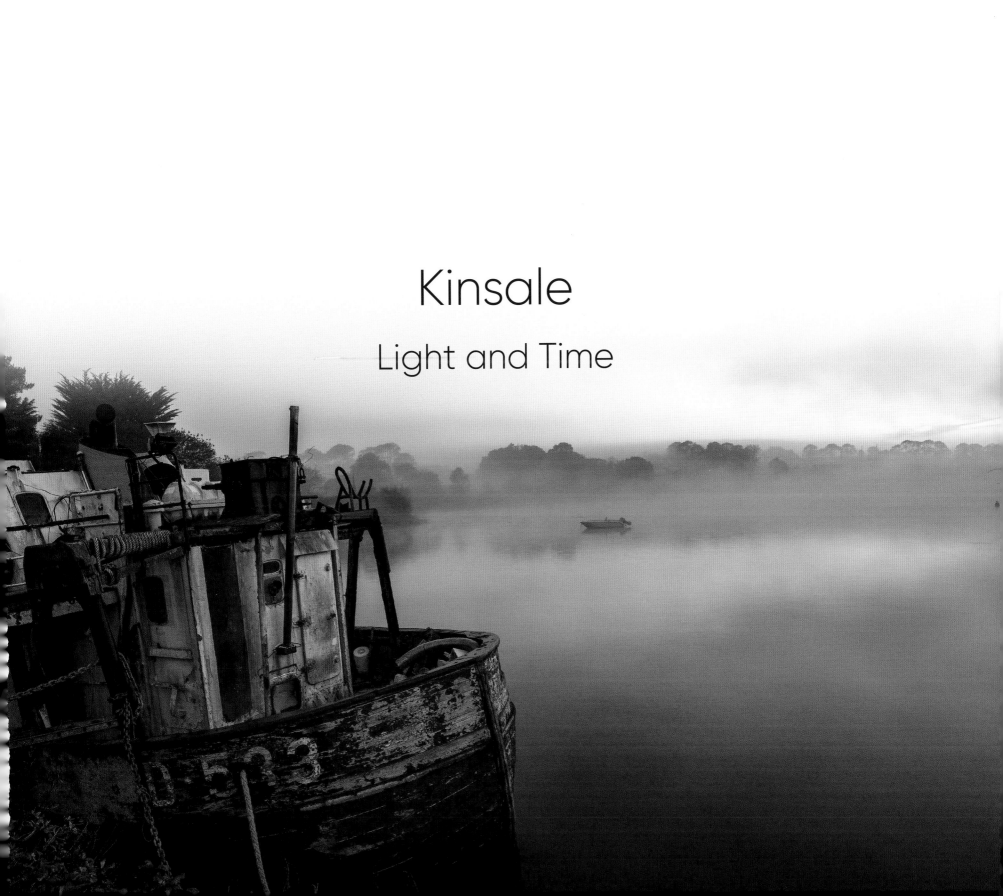

# Kinsale

## Light and Time

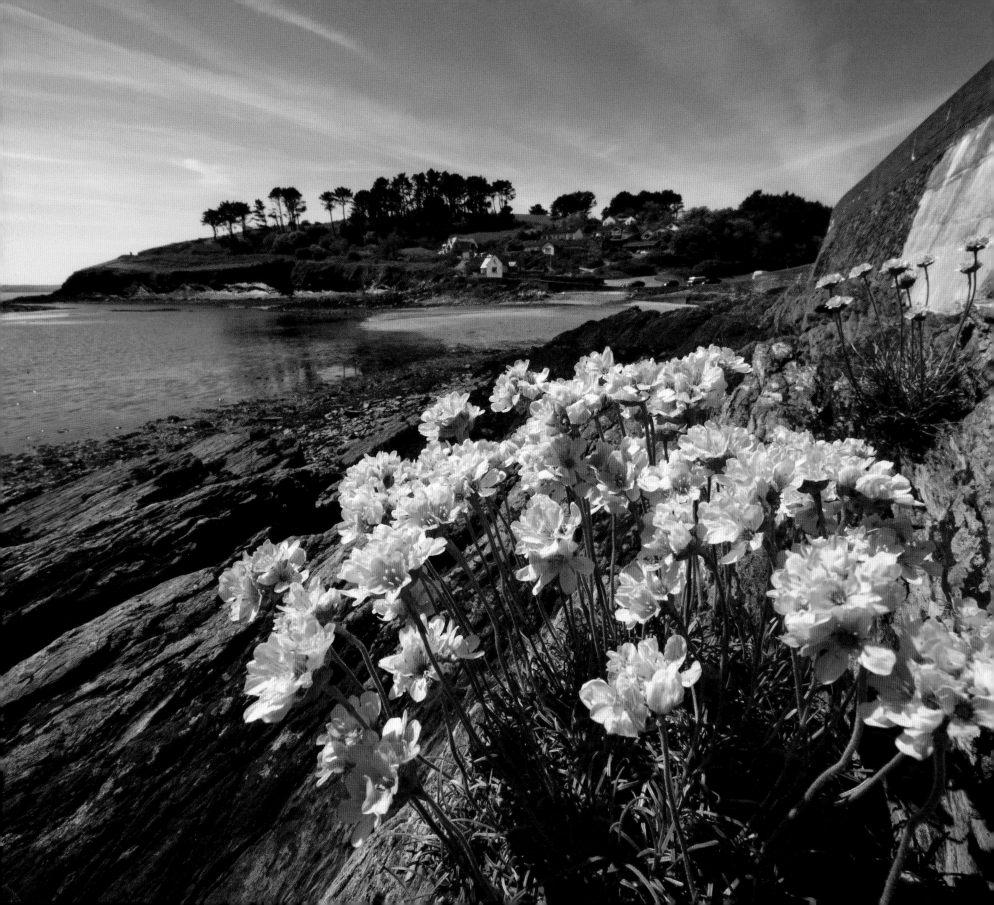

# Cionn tSáile

## Solas agus Am

First published in 2023 by
Atrium
(an imprint of Cork University Press)
Boole Library
University College Cork
T12 ND89
Ireland

Library of Congress Control Number: 2023932119
Distribution in the USA: Longleaf Services, Chapel Hill, NC, USA

ISBN: 978–1–78205–340–8

Book Design and typesetting: Anú Design, Tara

Printed in Poland by BZ Graf

**Jacket photographs:**
Sunrise, Lobster Quay (front); Dusk, Old Head lighthouse and Courtmacsherry Bay (back).

# Kinsale

## Light and Time

John Collins

ATRIUM

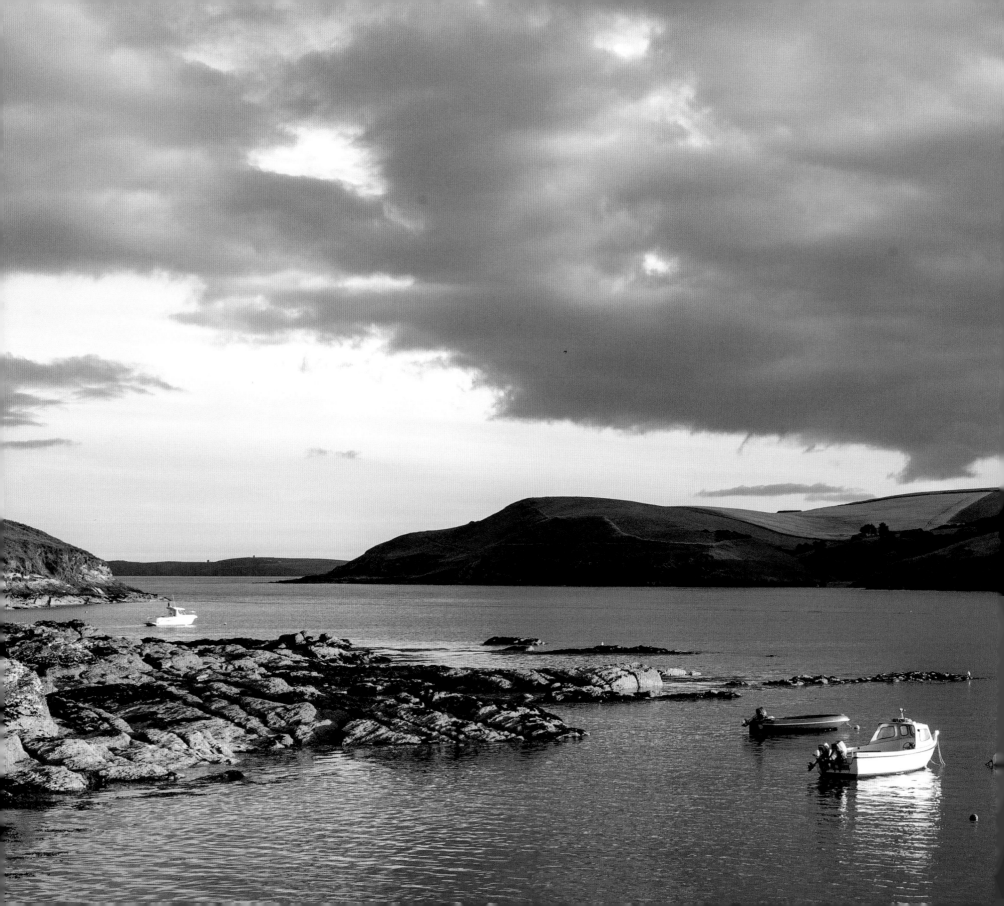

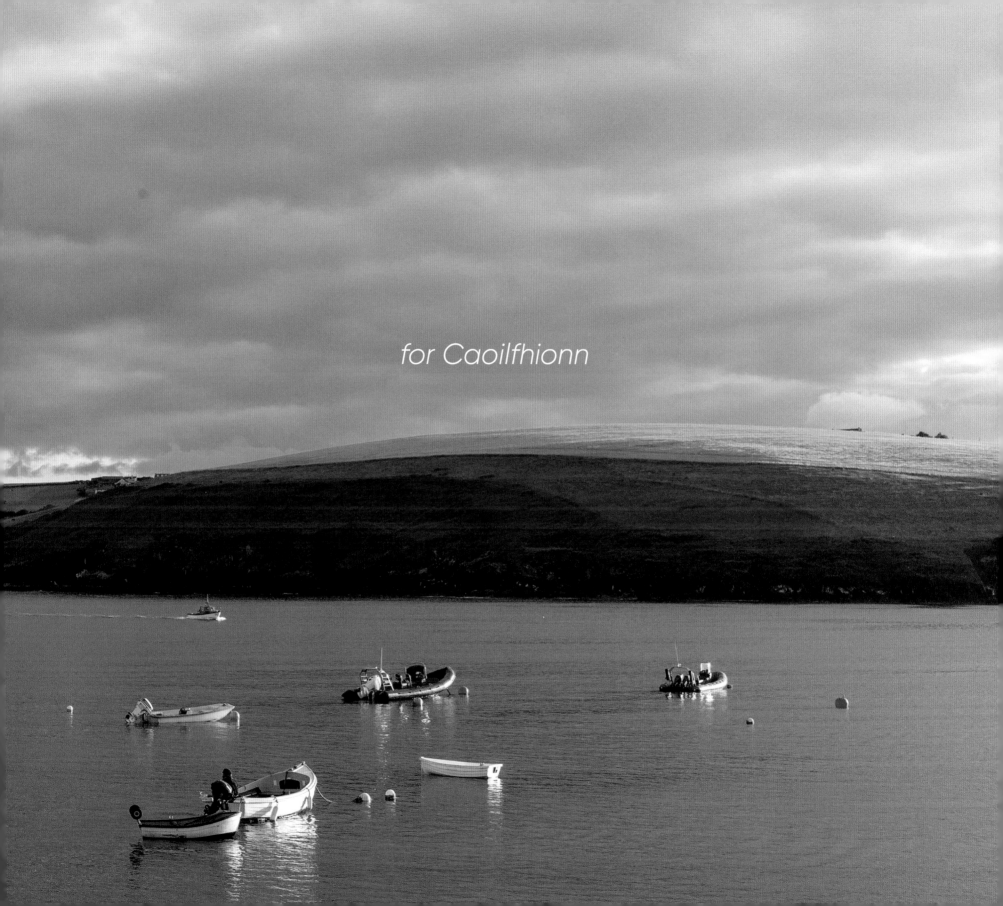

for Caoilfhionn

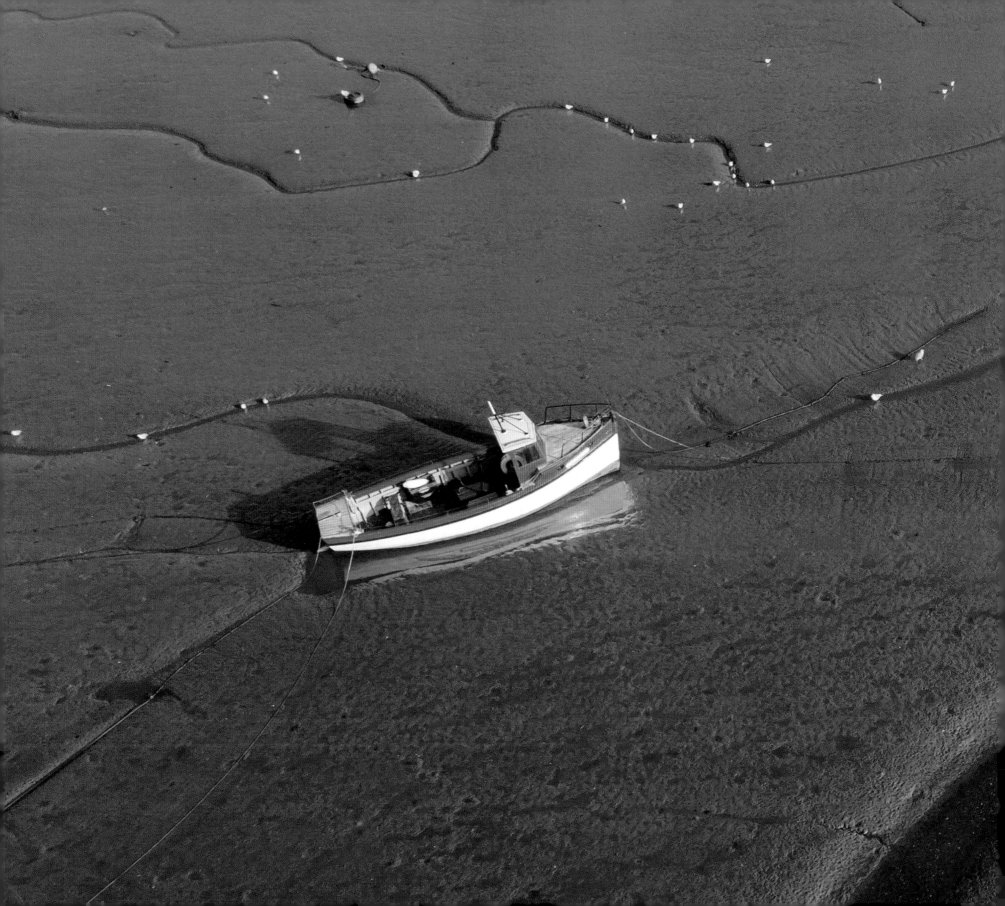

# Contents

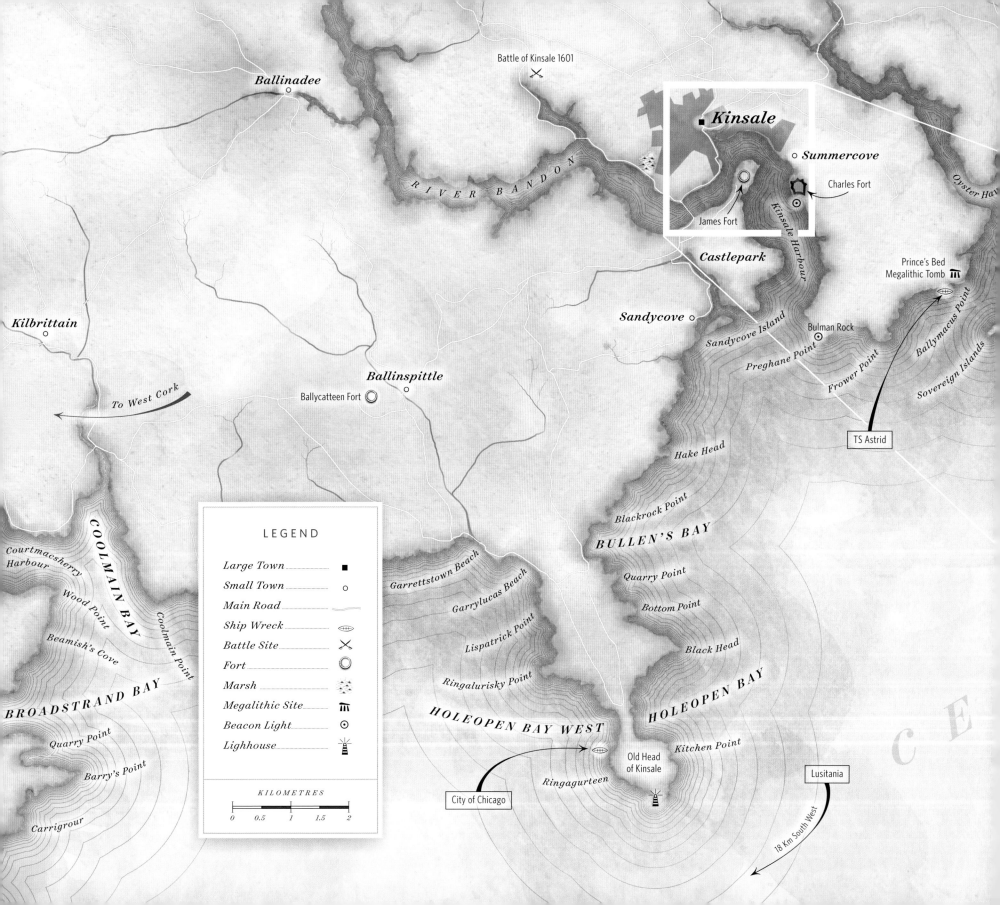

Battle of Kinsale 1601

**Kinsale**

○ **Summercove**

Charles Fort

James Fort

*RIVER BANDON*

*Ballinadee* ○

**Castlepark**

Prince's Bed
Megalithic Tomb 𝖆

*Sandycove* ○

*Sandycove Island*

Bulman Rock ⊙

*Preghane Point*

*Frower Point*

*Ballymacus Point*

*Kinsale Harbour*

*Sovereign Islands*

TS Astrid

*Kilbrittain*

*Ballinspittle* ○

Ballycatteen Fort ◎

*To West Cork*

*Hake Head*

*Blackrock Point*

**BULLEN'S BAY**

*Quarry Point*

*Bottom Point*

*Black Head*

*Courtmacsherry
Harbour*

**COOLMAIN
BAY**

*Wood Point*

*Coolmain Point*

*Beamish's Cove*

**BROADSTRAND BAY**

*Garrettstown Beach*

*Garrylucas Beach*

*Lispatrick Point*

*Ringalurisky Point*

**HOLEOPEN BAY WEST**

**HOLEOPEN BAY**

*Kitchen Point*

*Quarry Point*

*Barry's Point*

*Carrigrour*

*Ringagurteen*

*Old Head
of Kinsale*

City of Chicago

Lusitania

*18 Km South West*

## LEGEND

| | |
|---|---|
| *Large Town* | ■ |
| *Small Town* | ○ |
| *Main Road* | 〜 |
| *Ship Wreck* | ⬭ |
| *Battle Site* | ✕ |
| *Fort* | ◎ |
| *Marsh* | ⁂ |
| *Megalithic Site* | 𝖆 |
| *Beacon Light* | ⊙ |
| *Lighhouse* | 🗼 |

*KILOMETRES*

0    0.5    1    1.5    2

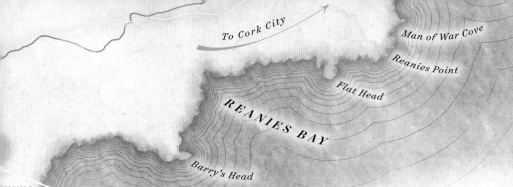

# KINSALE

To Cork City

Man of War Cove

Reanies Point

Flat Head

REANIES BAY

Barry's Head

nure

Big Doon

Little Doon

Kinure Point

Sovereign Island

ATLANTIC SEA

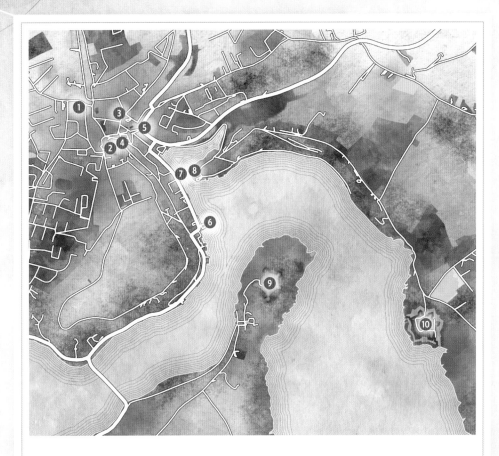

1 Fán na Tobraide – Abbey Well

2 St. Multose Church

3 Desmond Castle

4 Market House (Courthouse), now Kinsale Museum

5 Old Fish Market

6 Lobster Quay

7 Pier Head

8 Fish Pallace, Scilly

9 James Fort

10 Charles Fort

N

The phenomenon appears to me to partake of the character of the marvellous ... the most transitory of things, a shadow, maybe fettered by the spells of our Natural Magic, and maybe fixed forever in the position which it seemed only destined for a single instant to occupy.

William Henry Fox Talbot
*On Photogenic Drawing* (1843)

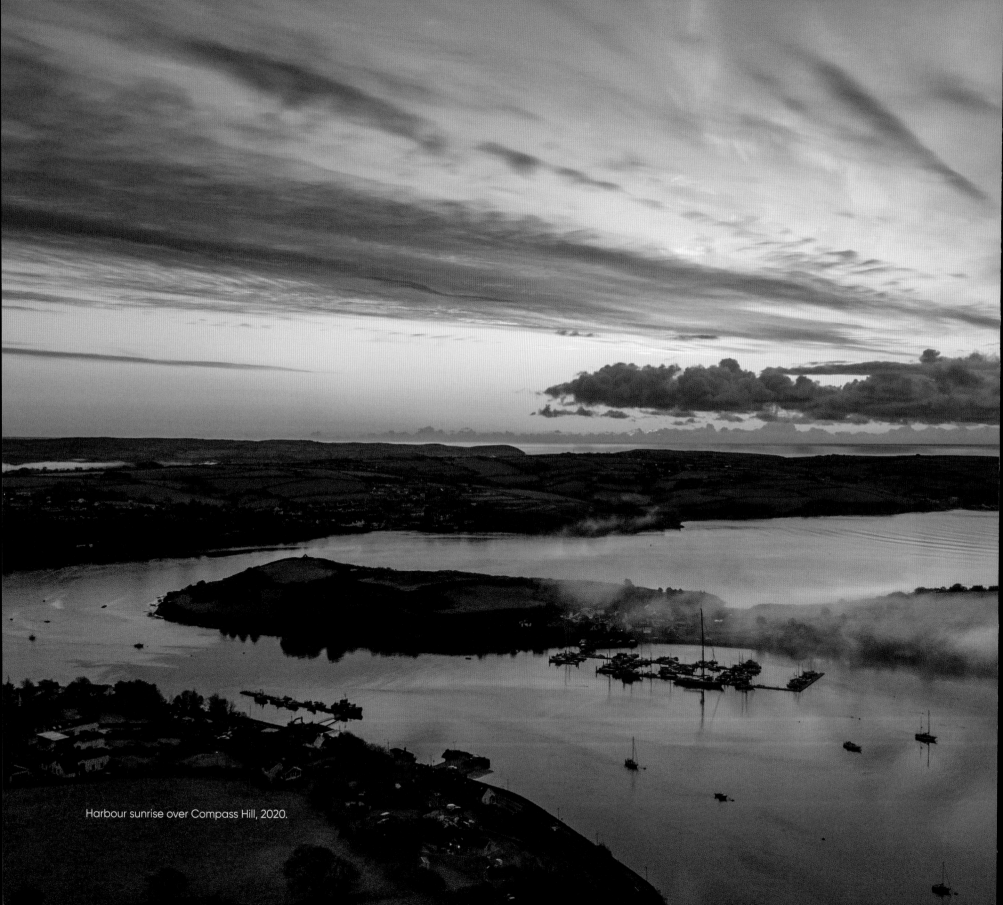

Harbour sunrise over Compass Hill, 2020.

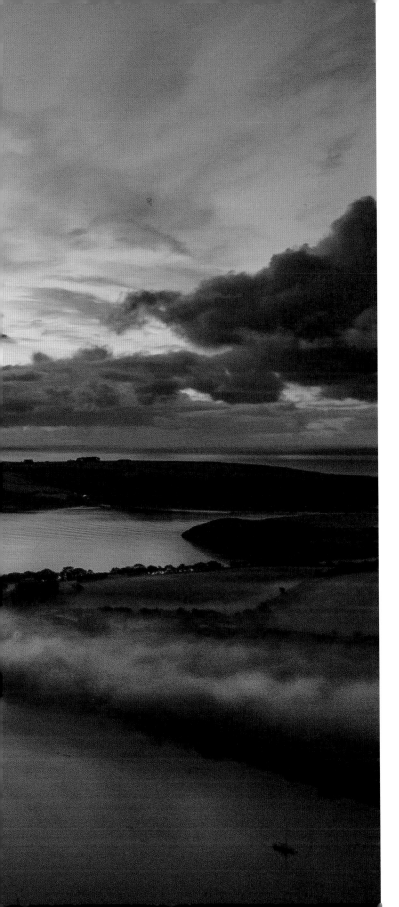

# 01

## Light and Time

The winter light was fading fast. We were busy fixing and tying down our small dive boat, recovering it onto its trailer after a day on the water. The slipway and pier were quiet, the chill keeping those with any sense indoors. A few swans glided towards the slipway in our wake, seemingly keen to come out and stretch their legs. I glanced skyward to gauge if there was a possibility of a photograph. I had a roll of Kodachrome 64 slide film loaded in my Nikon camera – not ideal for the late hour and low light. A fishing boat manoeuvred towards the slip as I made my way gingerly back down the slipway towards the swans, while a van arrived and began to reverse to meet the fishermen and land the day's catch.

Light and time are the essential ingredients for photography – a comparatively modern process that allows us to translate fleeting instants into lasting images. In compiling this collection of colour work, starting with that roll of Kodachrome in the late 1980s, I am struck by the timeless beauty of land and sea, the wonder of everyday life and my personal journey mapping time. Quiet moments of standing on silent stone, watching shimmering reflections, or documenting people and events connect me with life's journey. I remain aware of the rise and fall of light each day, the ebb and flow of the tide on the coast, and time through the seasons.

Making photographs is a core act of enquiry and attentive looking, curating the retention of light and moment. The challenge in seeing the familiar each day is to remain present with these ethereal instants. A 'third eye' becomes aware of the passage of time, reminding us that these moments will not be repeated. A mantra has evolved for me through these wanderings with a camera –

Photographs abound but are within;
the light of your open presence reveals them.

The resulting images also hold a stillness – each moment held like a breath, alive and contained.

The visual timeline of this collection of images, spanning four decades, forms a backdrop to explore Kinsale over the millennia of natural evolution and human settlement. Along the way, we will imagine deep time – the ages of ice and primaeval forests – explore our vibrant seas and abundant marine life, and imagine the lives of the early explorers – those mysterious megalith and ringfort builders. We will also look at the emergence of a vibrant harbour and walled town in Gaelic times, and the following centuries of invasion, battle and conflict – events that shaped history on near shores and far.

Kinsale's position in the Celtic Sea as it opens to the wild Atlantic defines its location, but it is people that give this geography its colour. Documenting life through photographs made in a single lifetime creates a real sense of place while revealing the everyday wonder of living and working among the vibrant community of Kinsale.

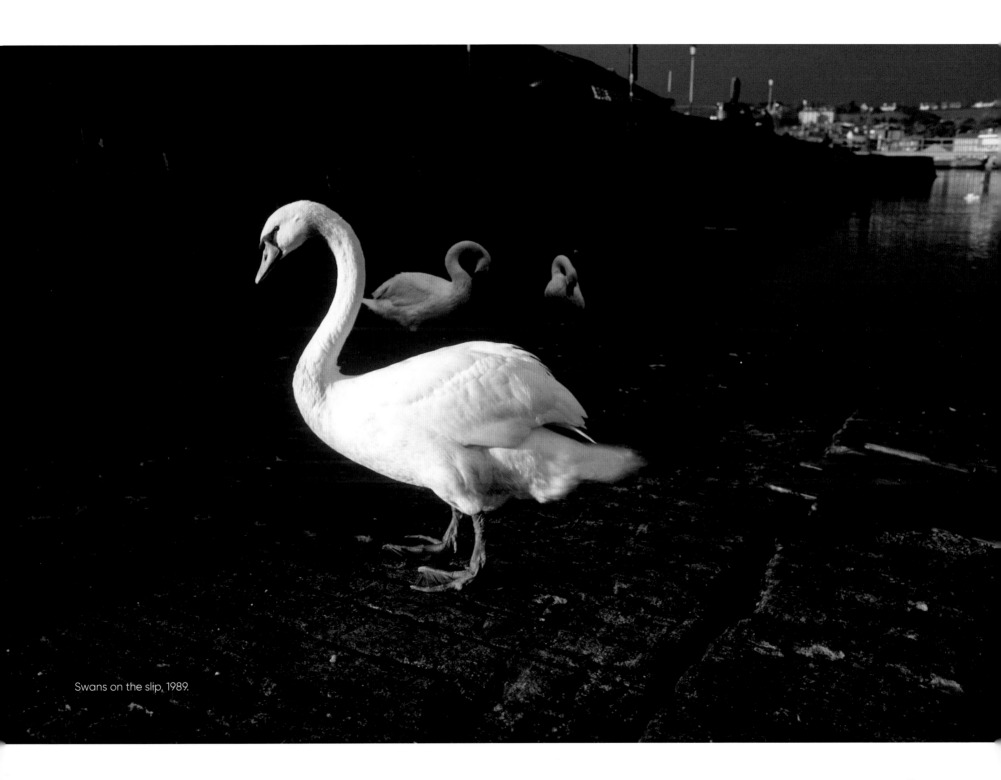

Swans on the slip, 1989.

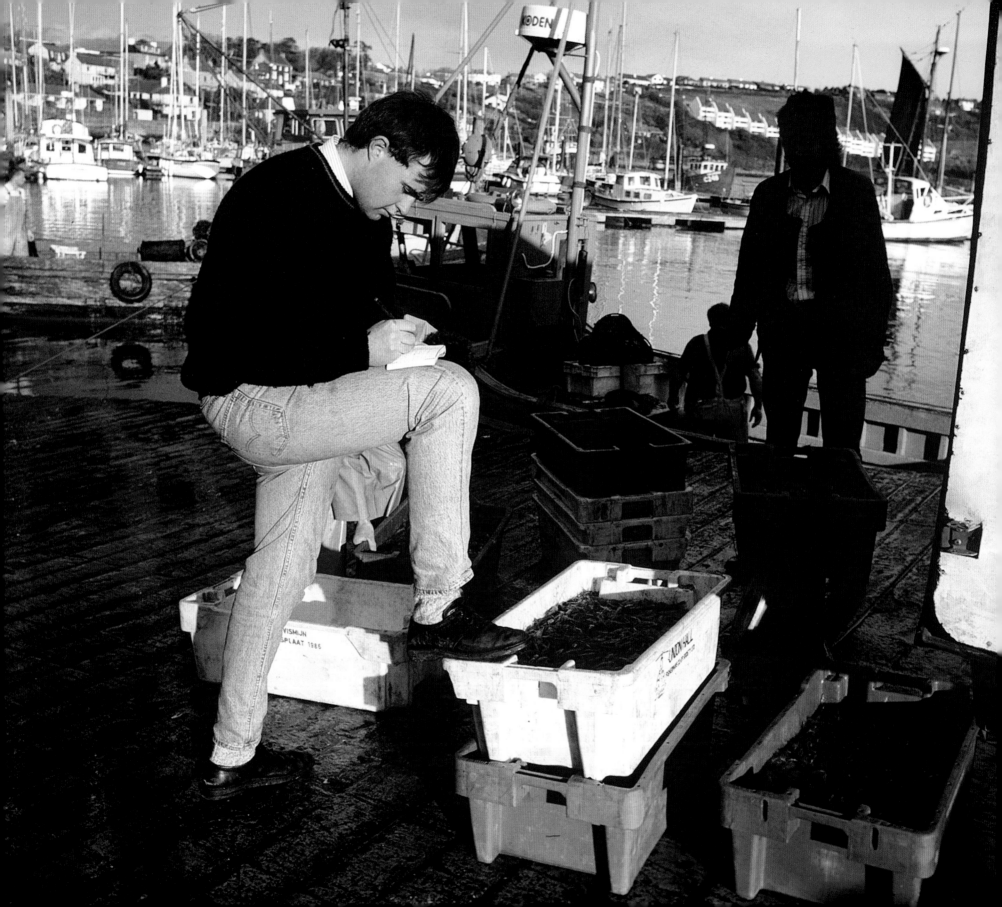

As I turned and made my way back up the slipway on that winter afternoon, the business of landing the catch of winter shrimp was in full swing. Boxes were hauled up and the contents transferred to the van – each tracked in a pocket notebook. A single film frame captures the moment, tells the story and pauses time, ever so briefly.

Landing shrimp, Pier Head, 1989.

Nets on quay wall, Scilly, 2006.

6

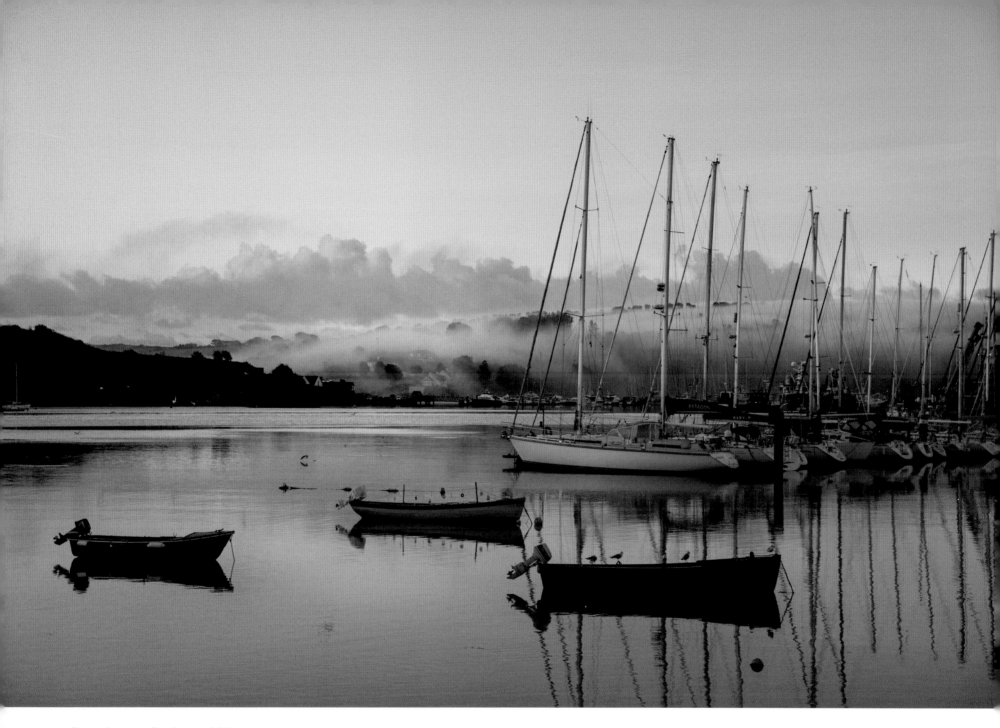

Dawn fog over Castlepark, 2016.

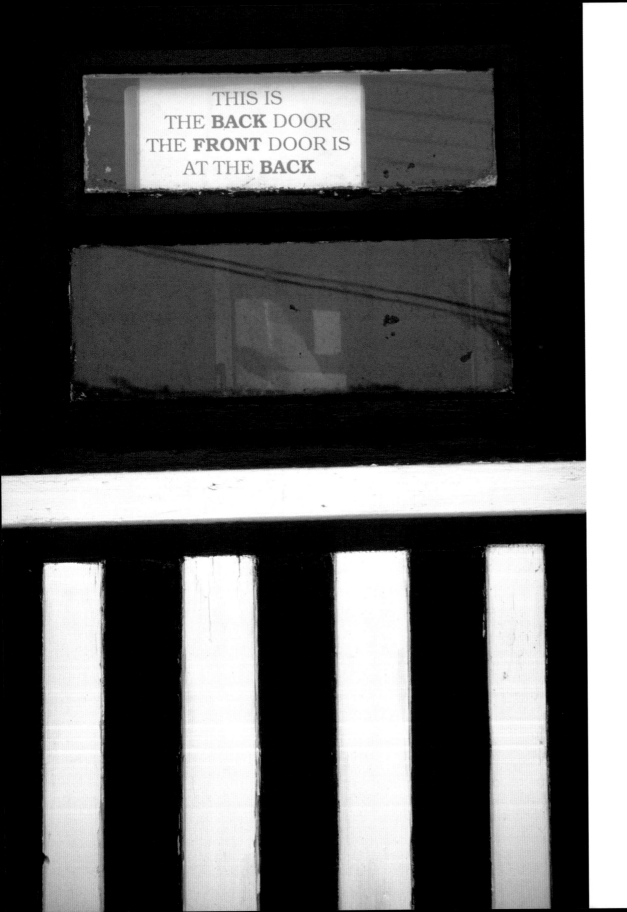

THIS IS
THE **BACK** DOOR
THE **FRONT** DOOR IS
AT THE **BACK**

**Left:** Peter Barry's back door, c. 1994.

**Opposite:** Lobster quay, 1989.

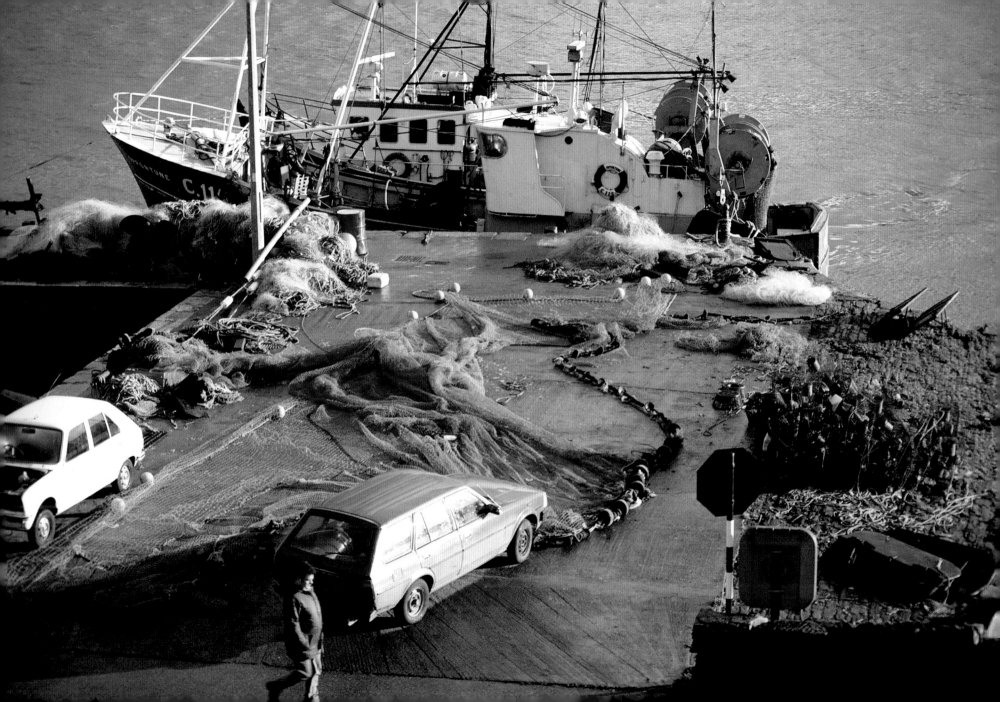

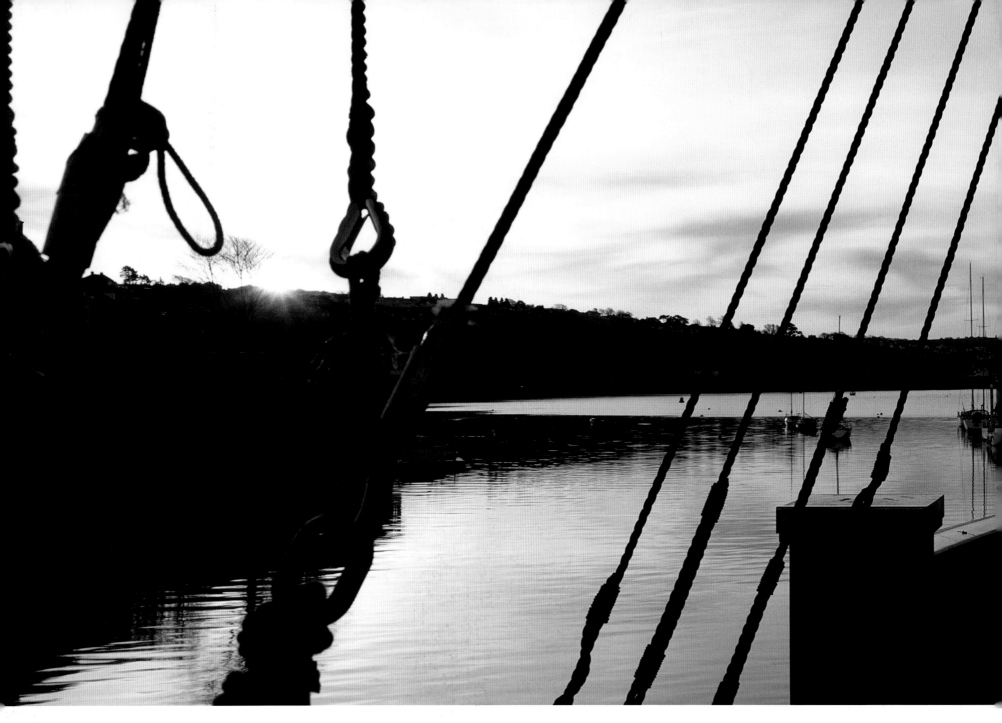

Sunrise at the mast, Pier Road, 2020.

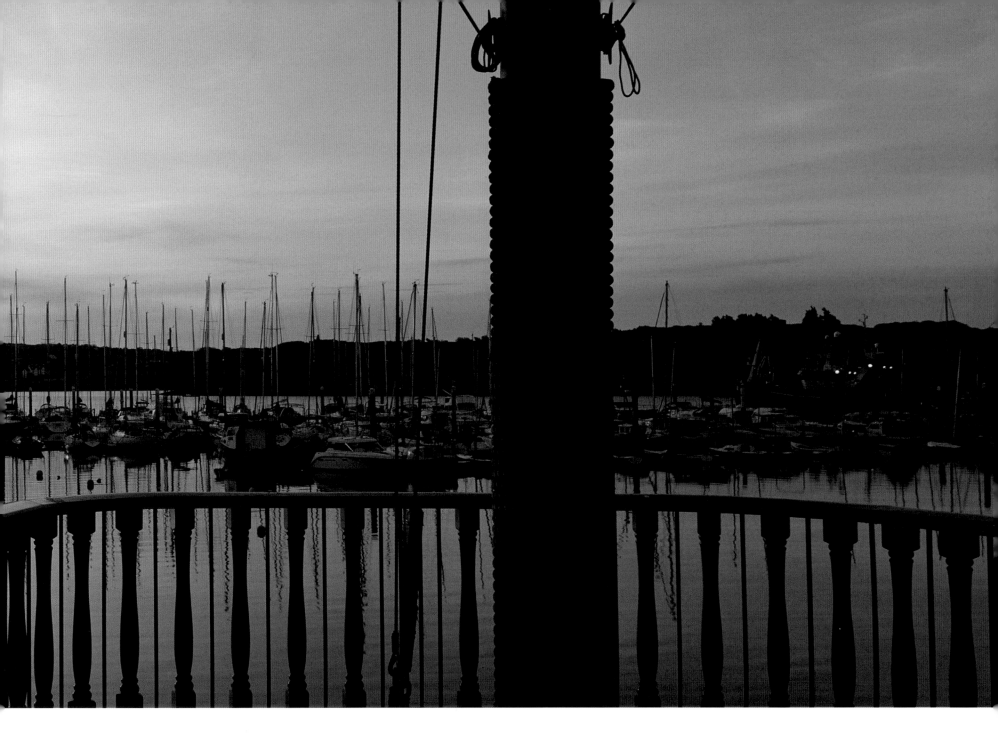

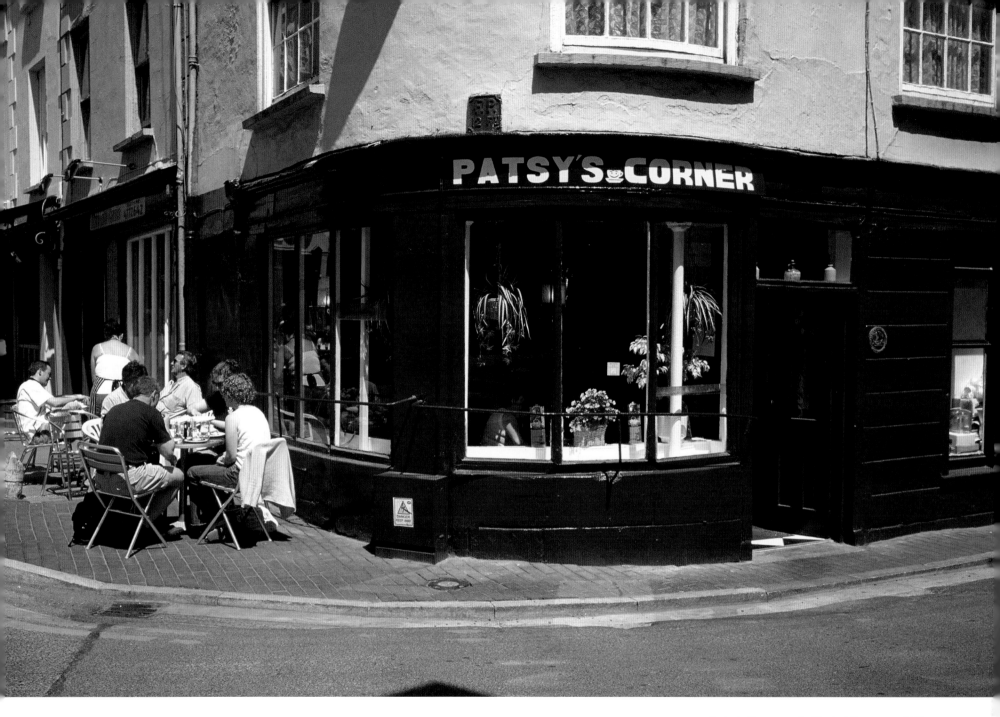

Patsy's Corner cafe, Market Square, c. 1997.

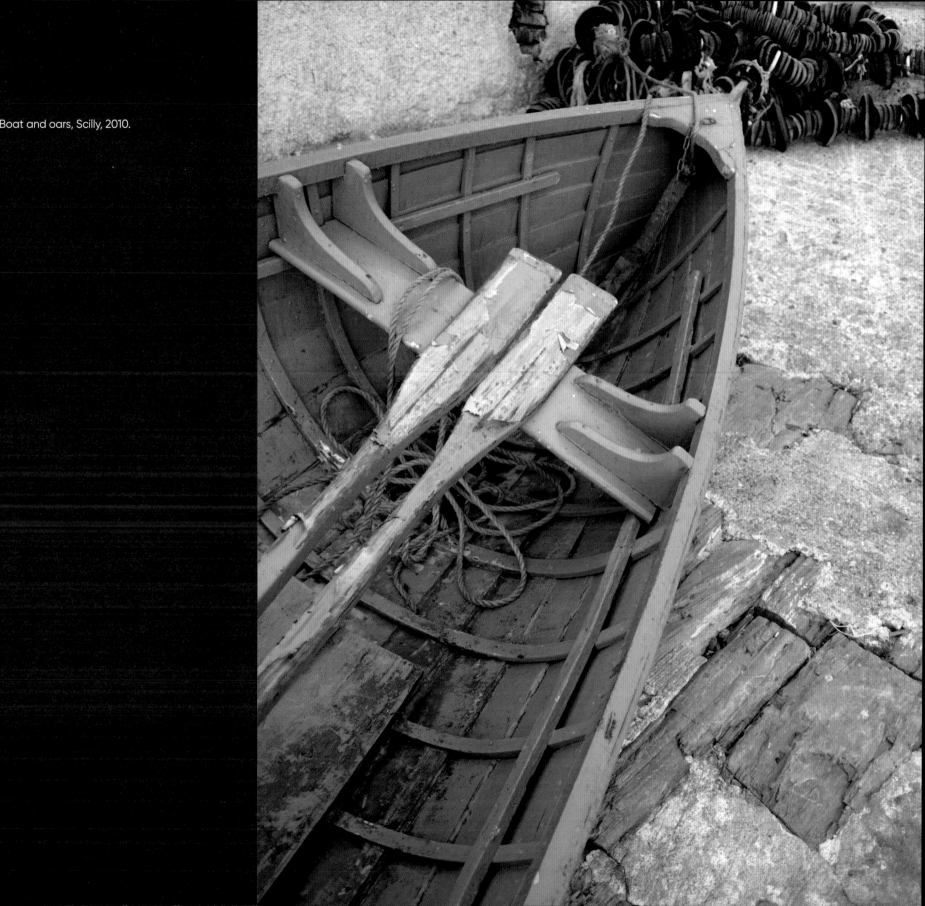

Boat and oars, Scilly, 2010.

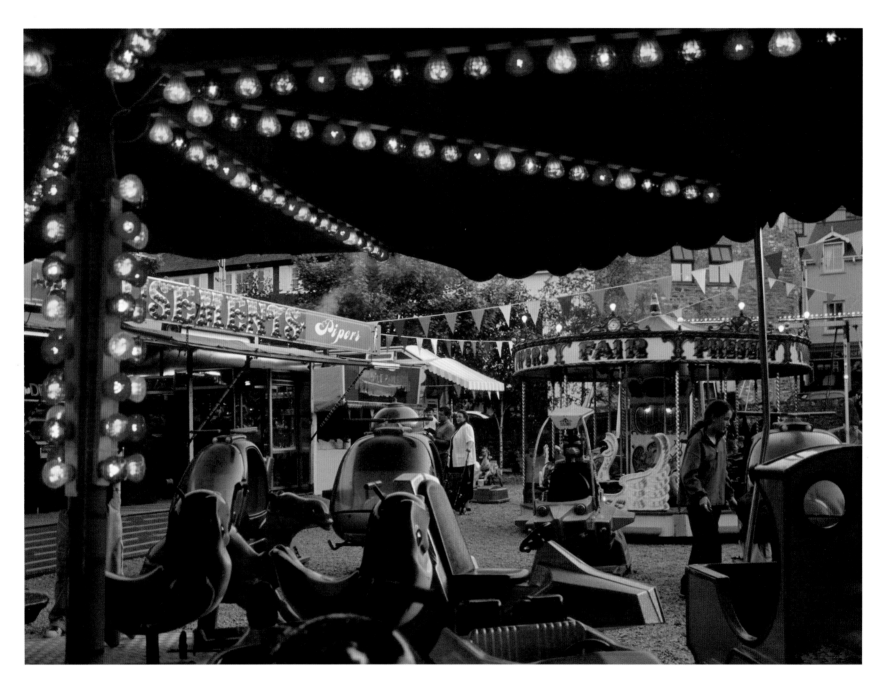

'The Merries', Piper's funfair, 1998 and 2012.

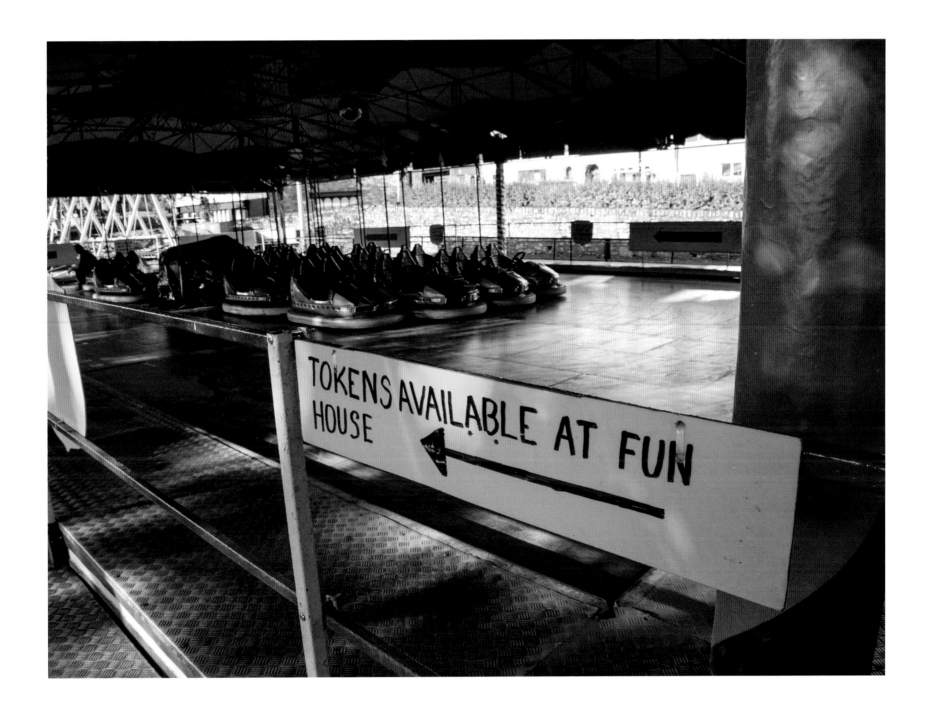

Icicles, Market Bar, 2018.

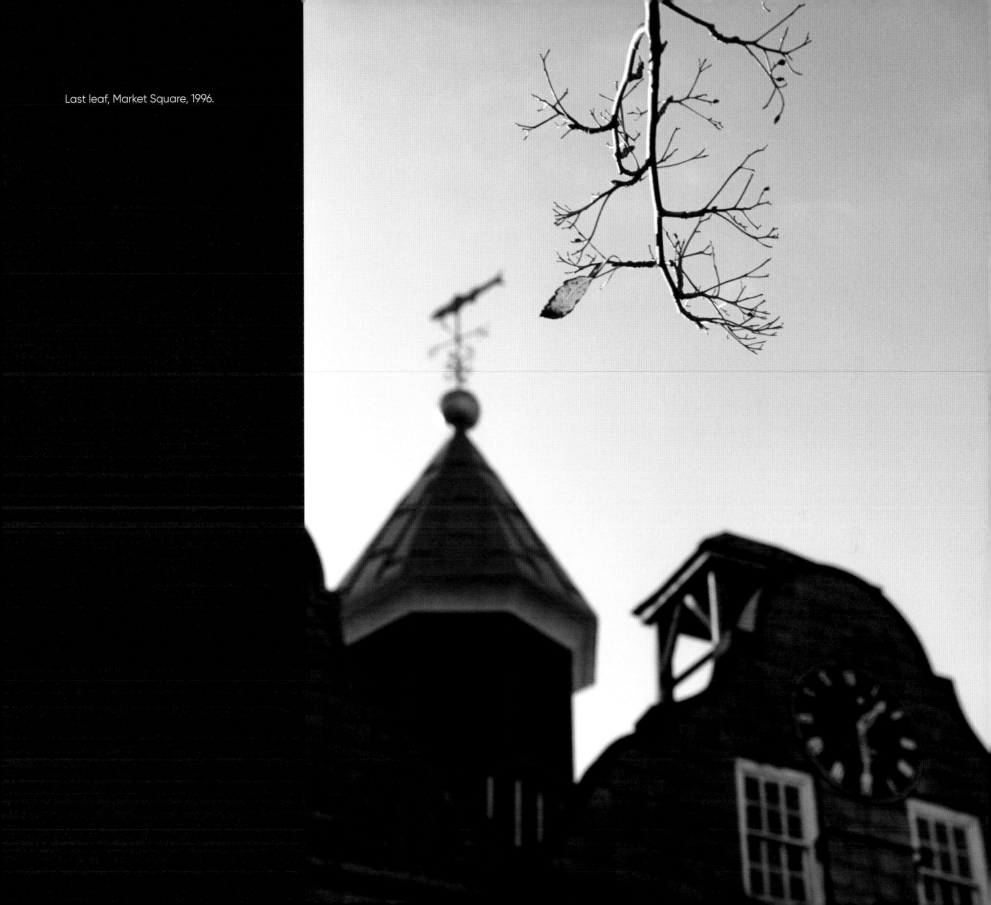

Last leaf, Market Square, 1996.

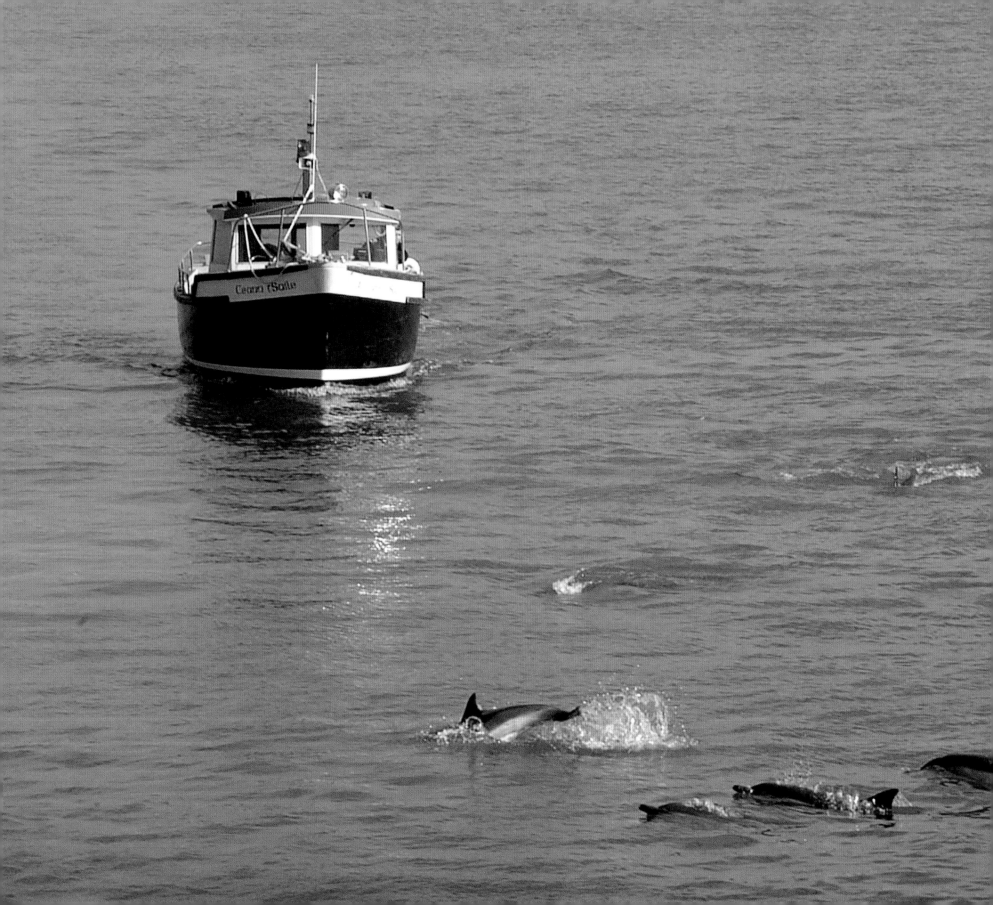

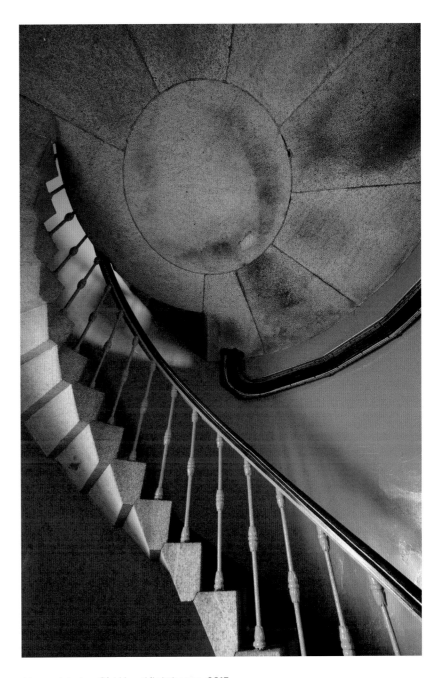

**Above:** Interior, Old Head lighthouse, 2015.

**Opposite:** Dolphins, Kinsale harbour, 2002.

Lantern, Old Head
lighthouse, 2015.

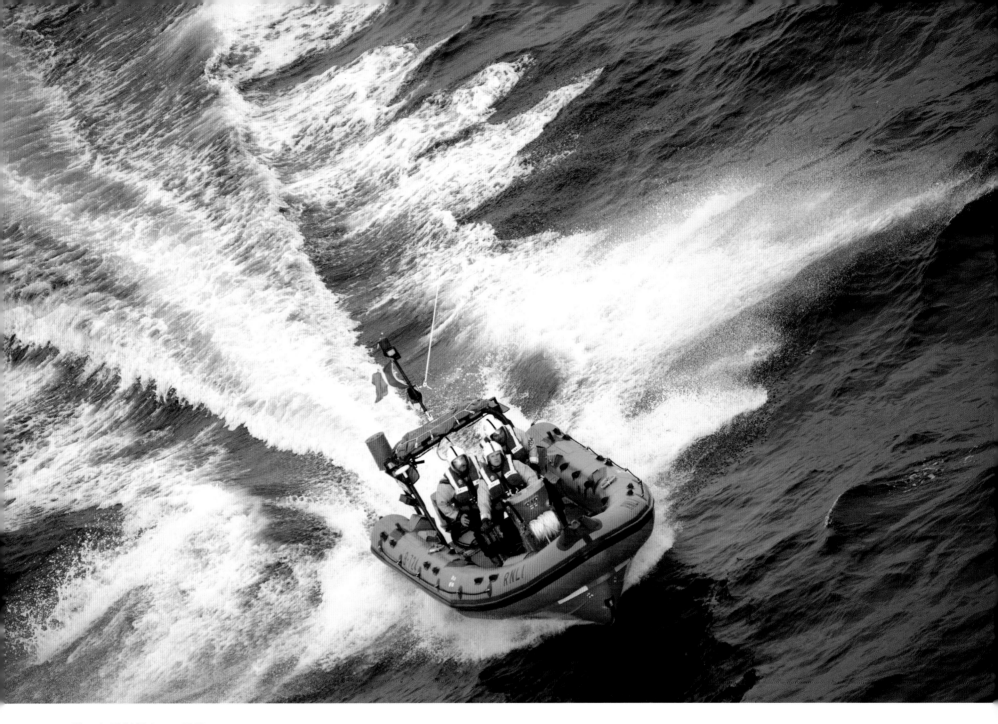

Kinsale RNLI lifeboat, 2010.

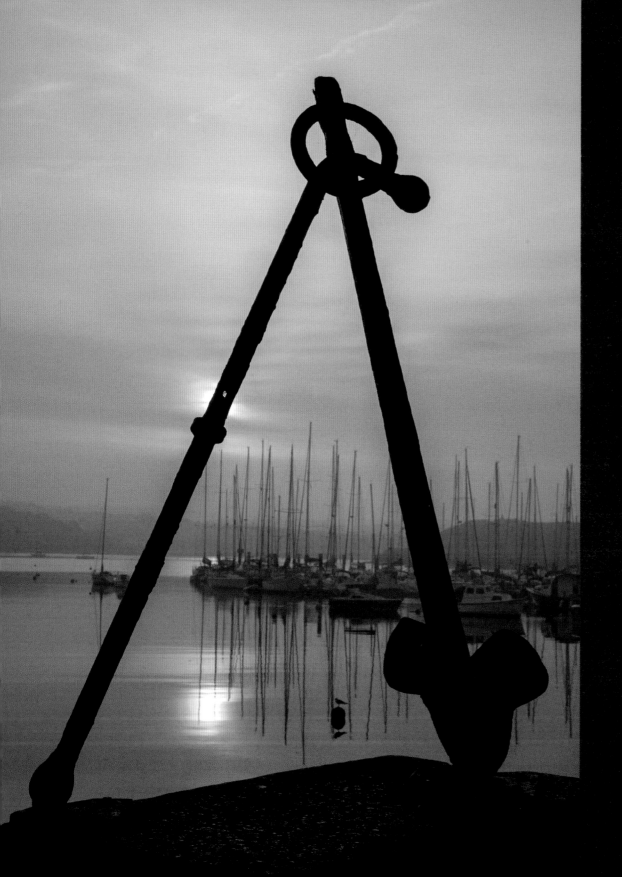

Hazy harbour sunrise, 2016.

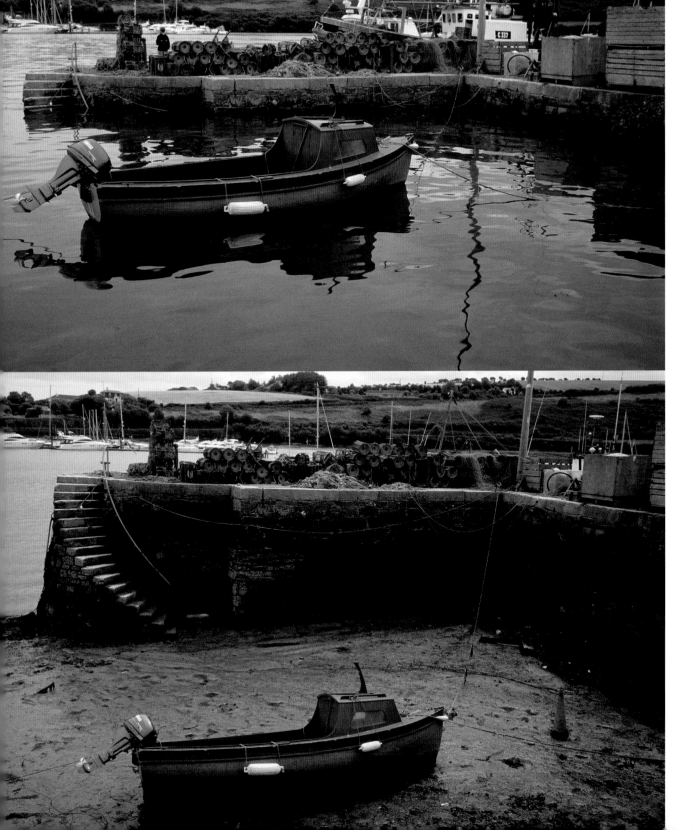

*They give us those nice bright colours*
*They give us the greens of summers*
*It makes you think all the world's a sunny day*
*So mama, don't take my Kodachrome away.*

Paul Simon

lyrics to 'Kodachrome' (1973)

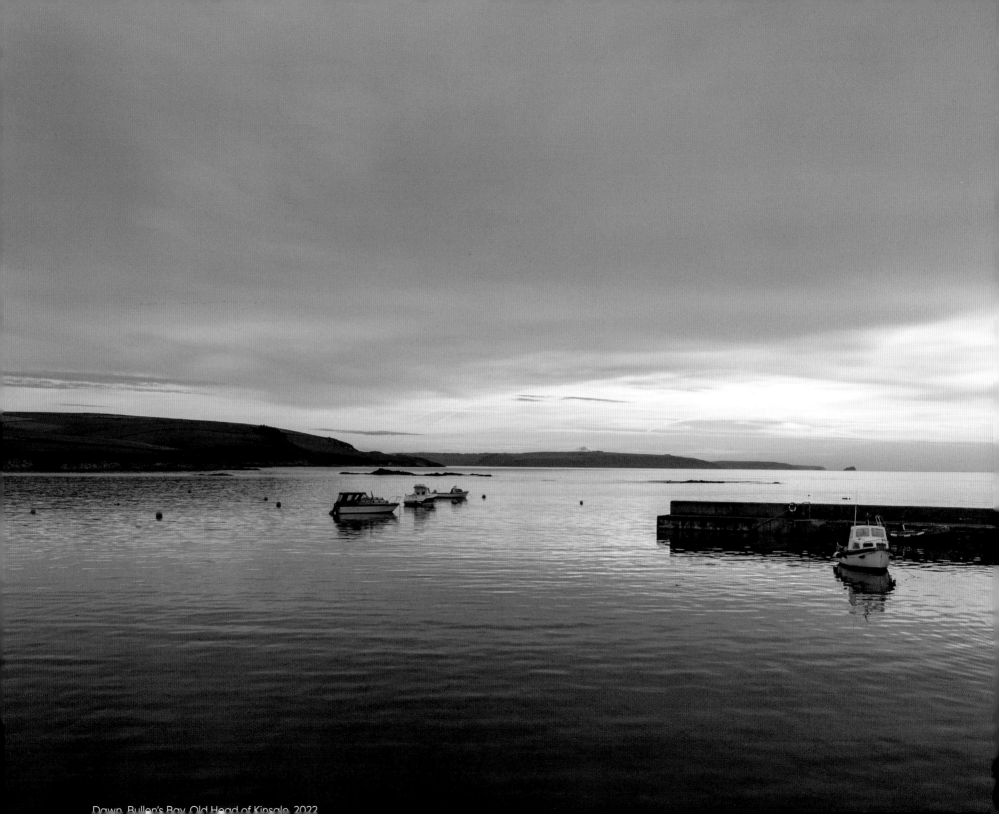

Dawn, Bullen's Bay, Old Head of Kinsale, 2022

# Elusive Colour

Today, we take colour photography for granted, but it proved technically elusive for decades after the invention of Fox-Talbot's photogenic drawing. The amazement of being able to record reality in such exquisite detail was tinged with disappointment at the lack of colour. It was a long and tedious challenge for scientists, and an impatient public pushed entrepreneurs to find solutions. Photographers literally took things into their own hands by adding colour to their monochrome images. This hand-tinting first made its way to the novelty of the day – postcards.

Kinsale's visual charm attracted these early postcard creators, with names like Valentine's and Cardall printed on

the dividing line between the address and message. The hand-colouring looks crude by today's standards, but it remained popular throughout the early twentieth century. The first practical and commercially viable colour process came from France, the *Autochrome Lumière*. These transparent glass plates were initially successful, as they worked in existing cameras and made beautiful, dreamlike photographs; but their high cost and difficulty in exhibiting limited their use.

Across the Atlantic, in 1935 the Eastman Kodak company made the technical breakthrough that would popularise colour photography. Developing the film after the photographs were taken was complex, and Kodak decided that its laboratories alone were up to the task. So, every roll of film had a mailing envelope included, and it made the round trip from the photographer to the lab and back by post. The layers of colour chemistry that made the finished photograph gave Kodachrome a unique palette. Favoured by cinematographers and photographers alike, National Geographic photographers in particular championed it in the first decades of printing the magazine in colour. Competing films from Agfa in Germany and Fuji in Japan further drove demand for ever-more realistic and saturated colours.

Colour photography then was a slow art, in stark contrast to the instantaneous and rapid digital photographs we make today. The nature of chemical media induced a considered approach to making photographs. A film type was selected for the light and subject matter at hand; each exposure was made with some awareness of the cost of materials, and care was taken to make each shot count. Colour slide film, especially Kodachrome, required good light and sharp camera skills to get the best results.

These innovations gave photographers the materials to make vibrant colour photographs and postcards, popularised in Ireland by John Hinde and a small team of German and British photographers in the 1960s. Hinde had the vision to create picture-perfect, uplifting scenes across Ireland that would 'convey a positive, good feeling, something which makes people happy, which makes them smile'. They were wildly successful and became a template for colour photography, seeking blue skies and idyllic sunny days. They remained a mainstay in seaside locations like Kinsale until the digital era, with a rolling stand outside every newsagent and gift shop – an essential part of the Irish holiday experience.

**Opposite:** Six swans, Kinsale harbour, 1996.

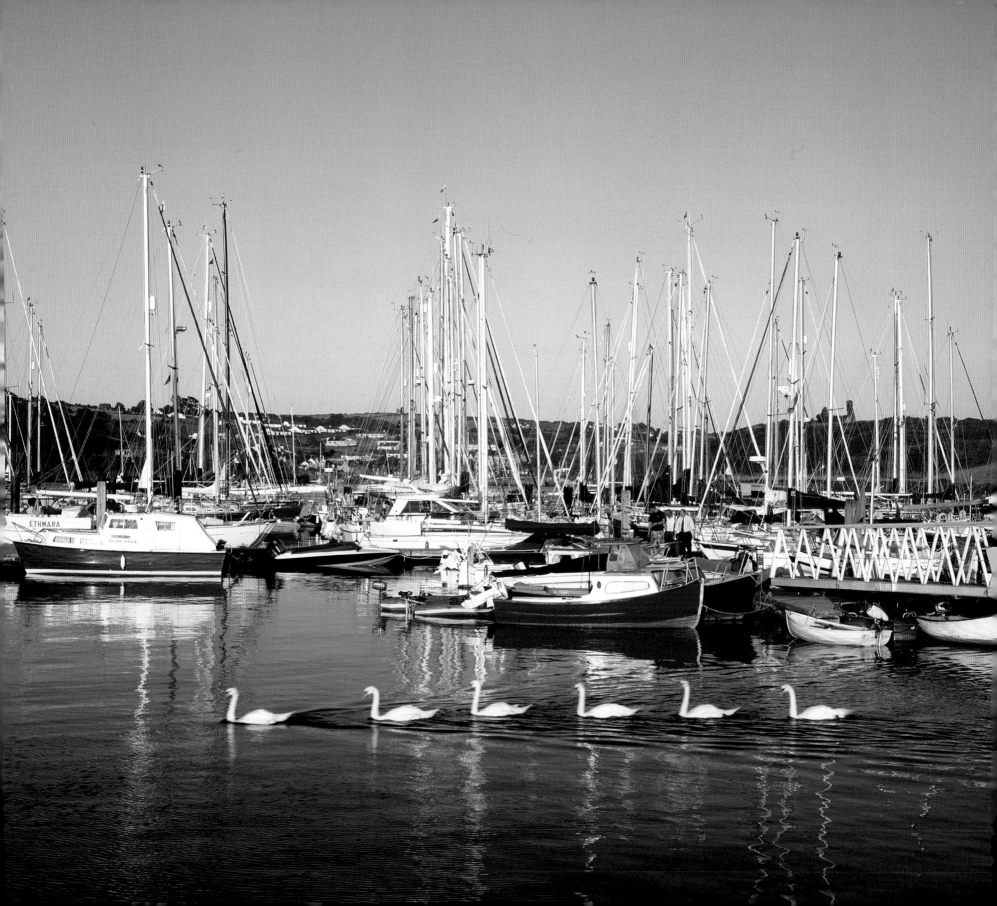

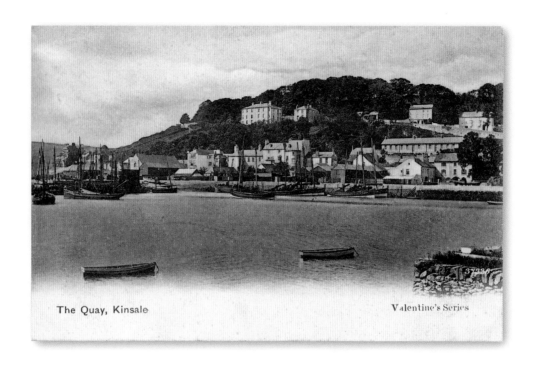

The Quay, Kinsale                    Valentine's Series

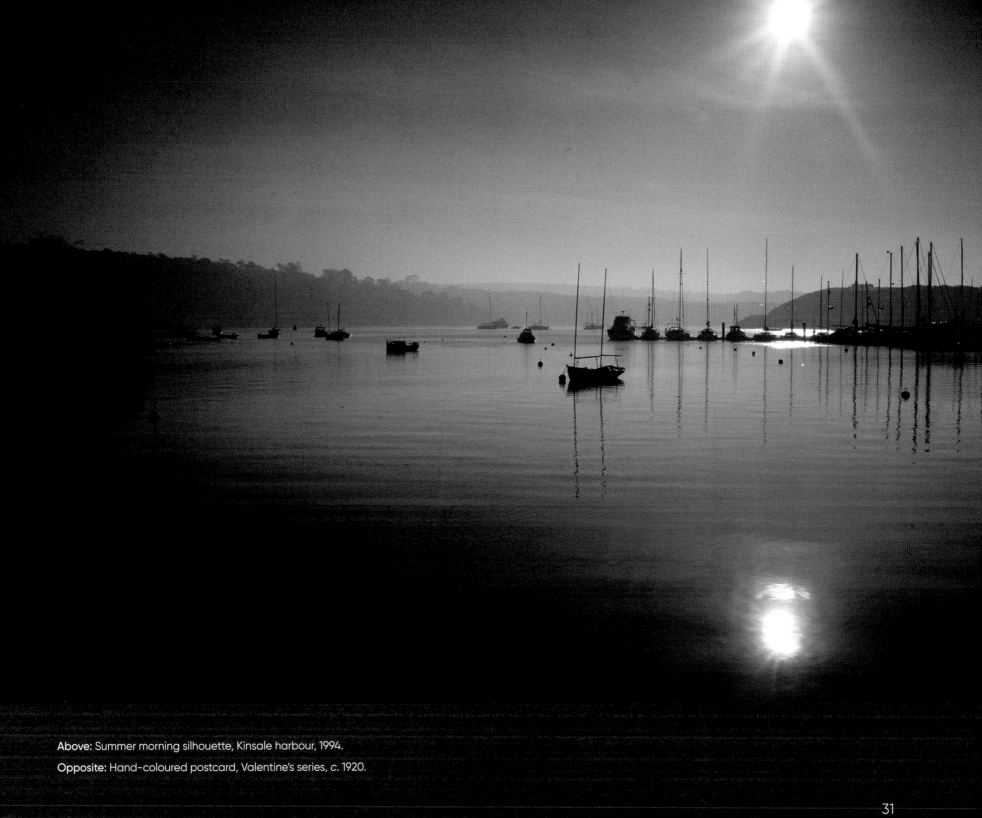

Above: Summer morning silhouette, Kinsale harbour, 1994.

Opposite: Hand-coloured postcard, Valentine's series, c. 1920.

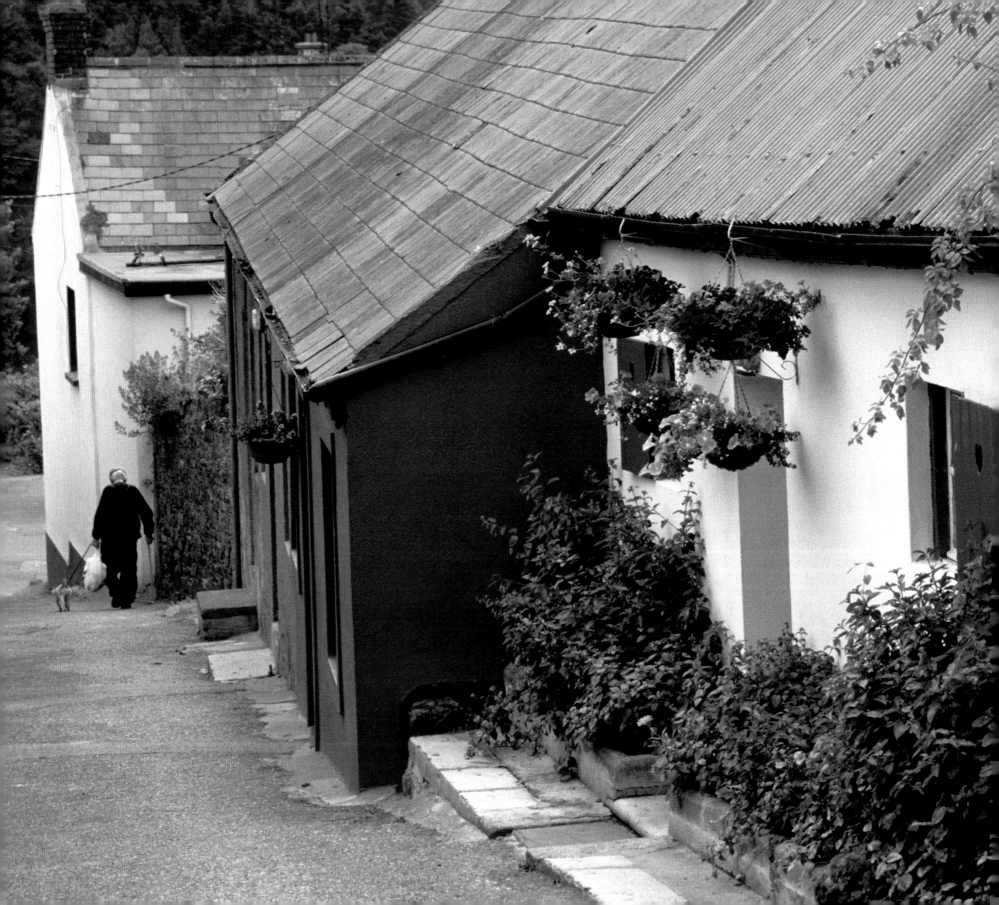

Above: Chairman's Lane, c. 1997.

Opposite: Friary Lane, c. 1997.

Yachet Club marina and Kinsale Candle factory, Pier Road, 1995.

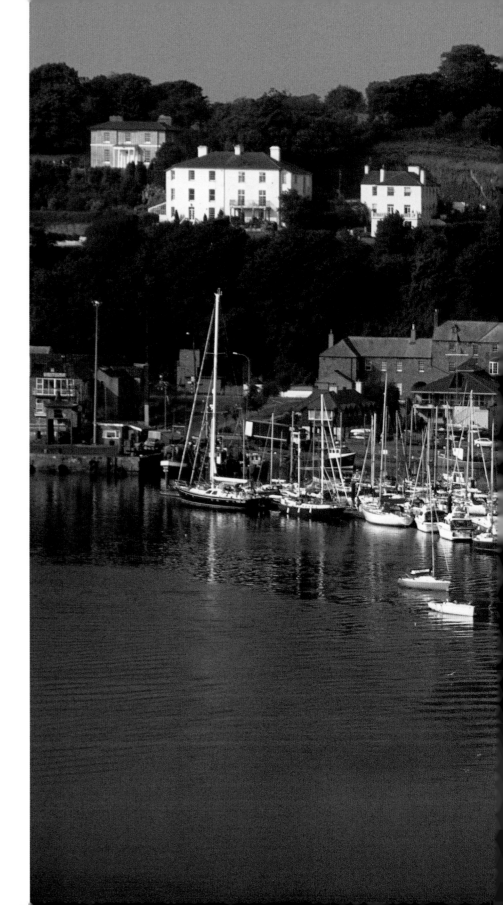

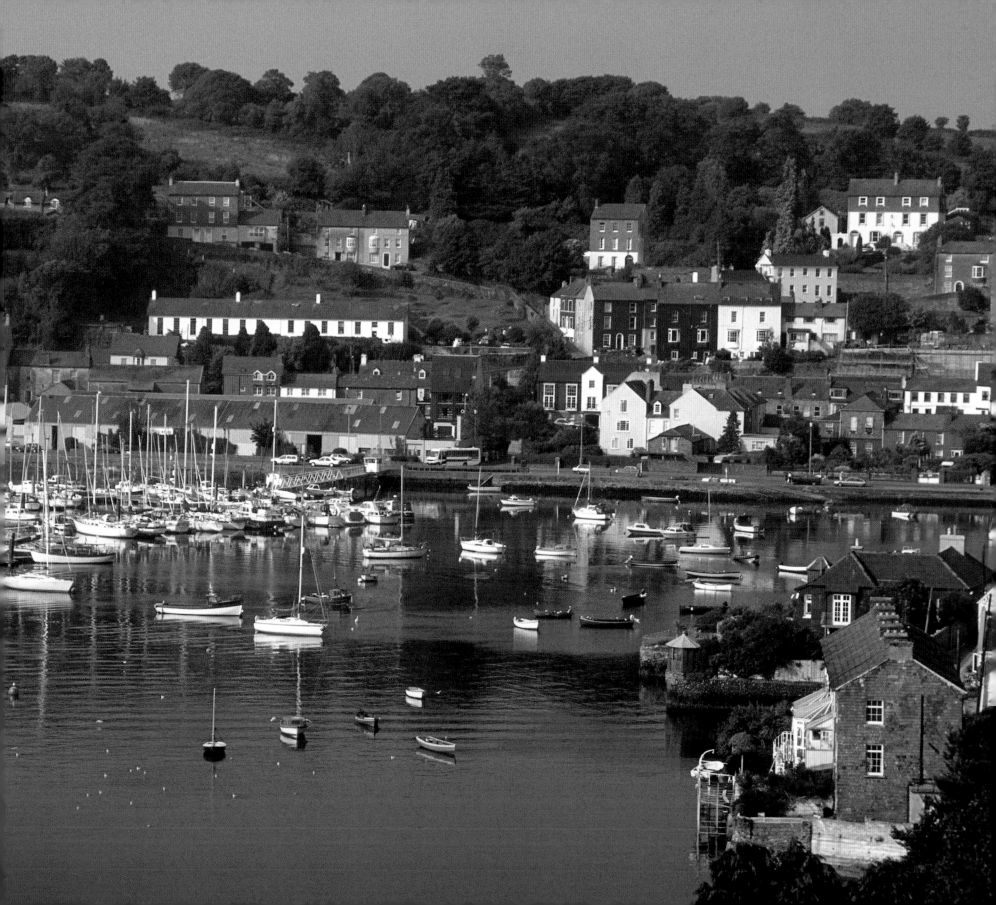

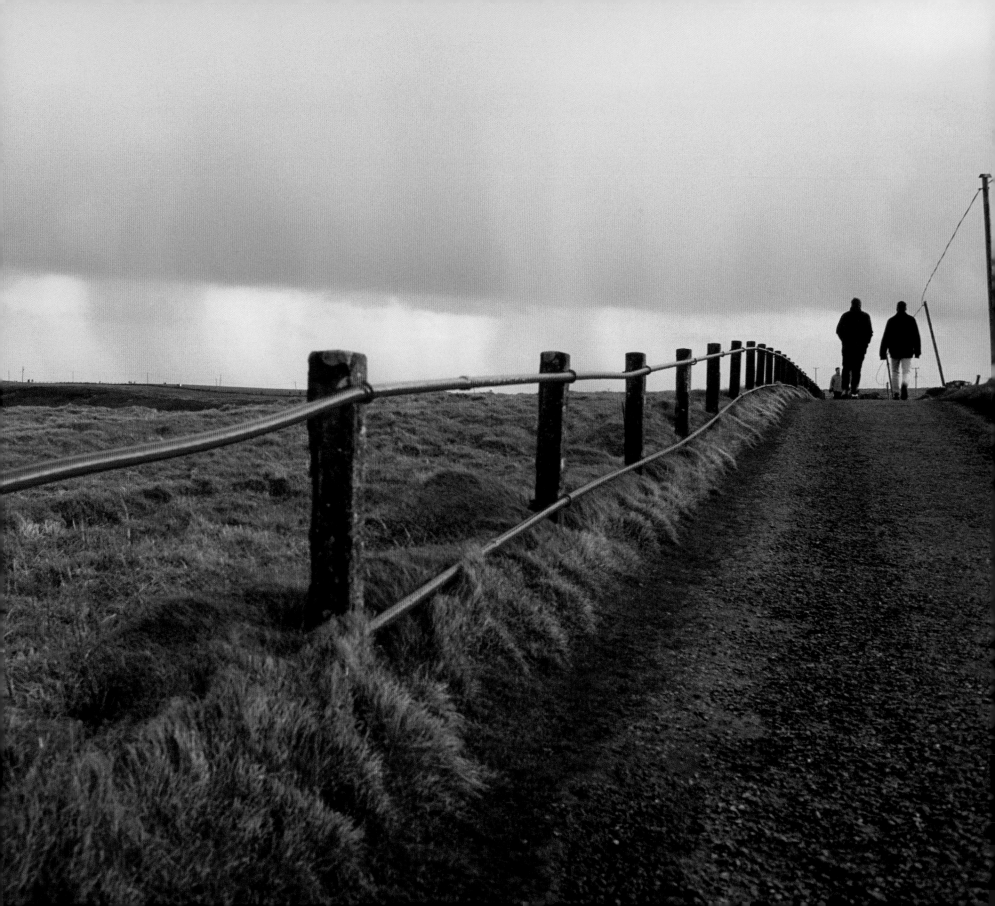

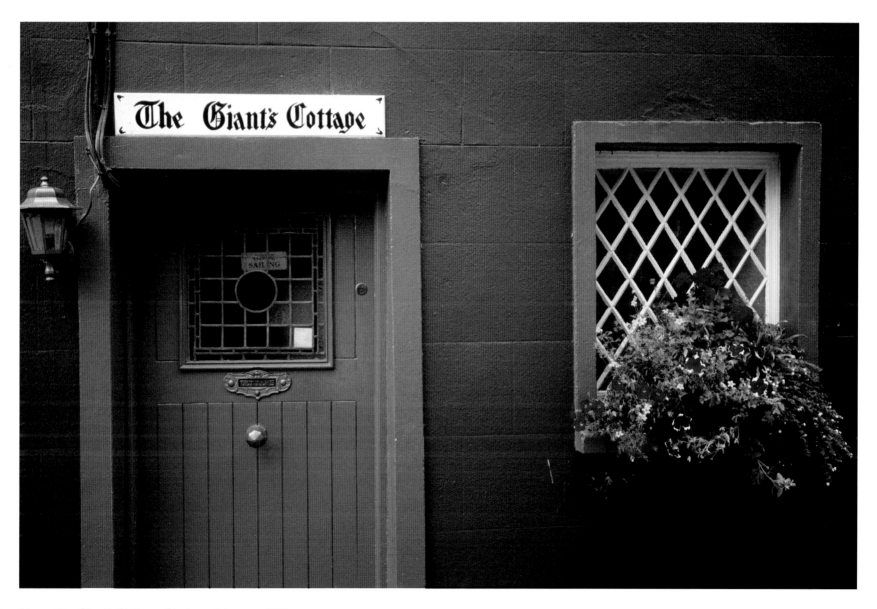

**Above:** The Giant's Cottage, Chairman's Lane, *c.* 1997.

**Opposite:** Lighthouse walk, Old Head, *c.* 1993.

Galway chapel, St Multose church 1998.

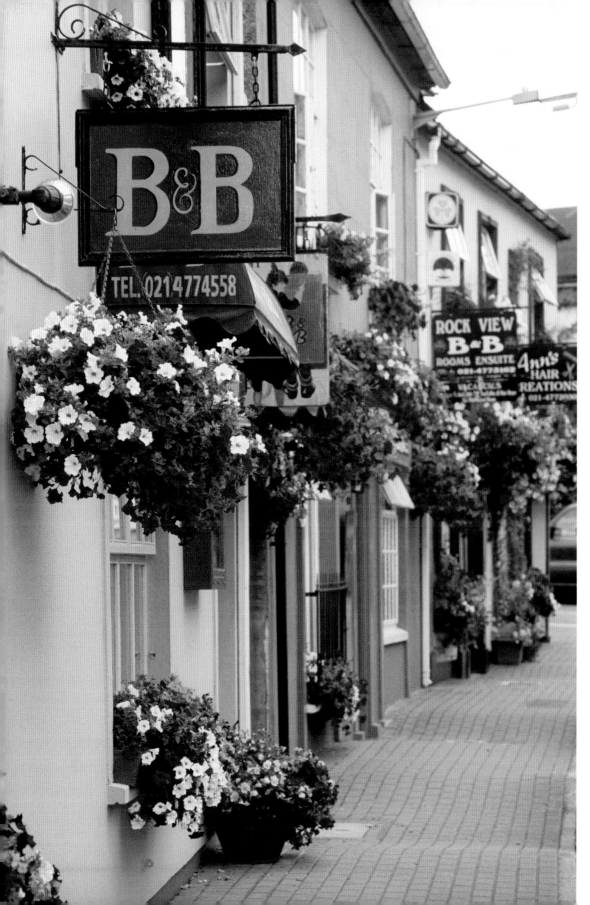

Flower baskets, The Glen, 1998.

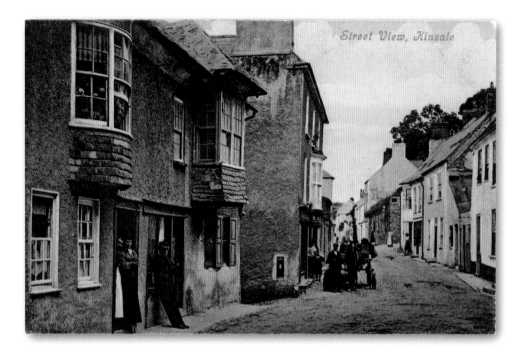

Hand-coloured postcards,
early twentieth century.

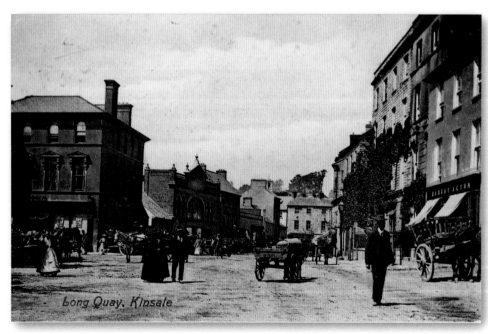

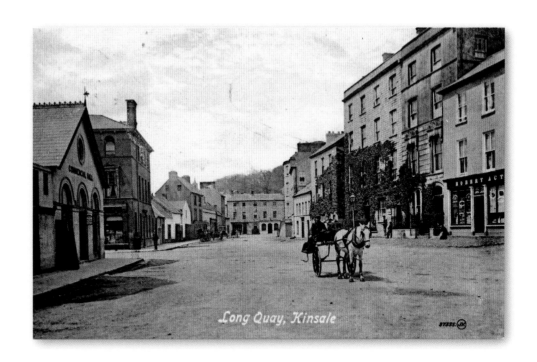

Long Quay, Kinsale

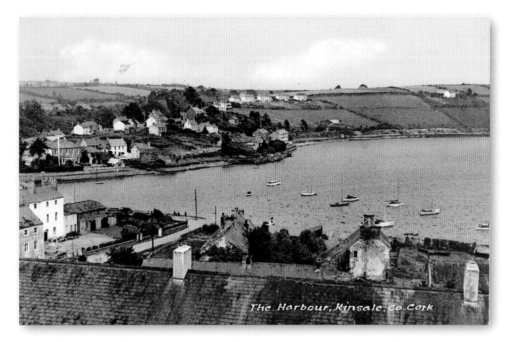

The Harbour, Kinsale, Co. Cork

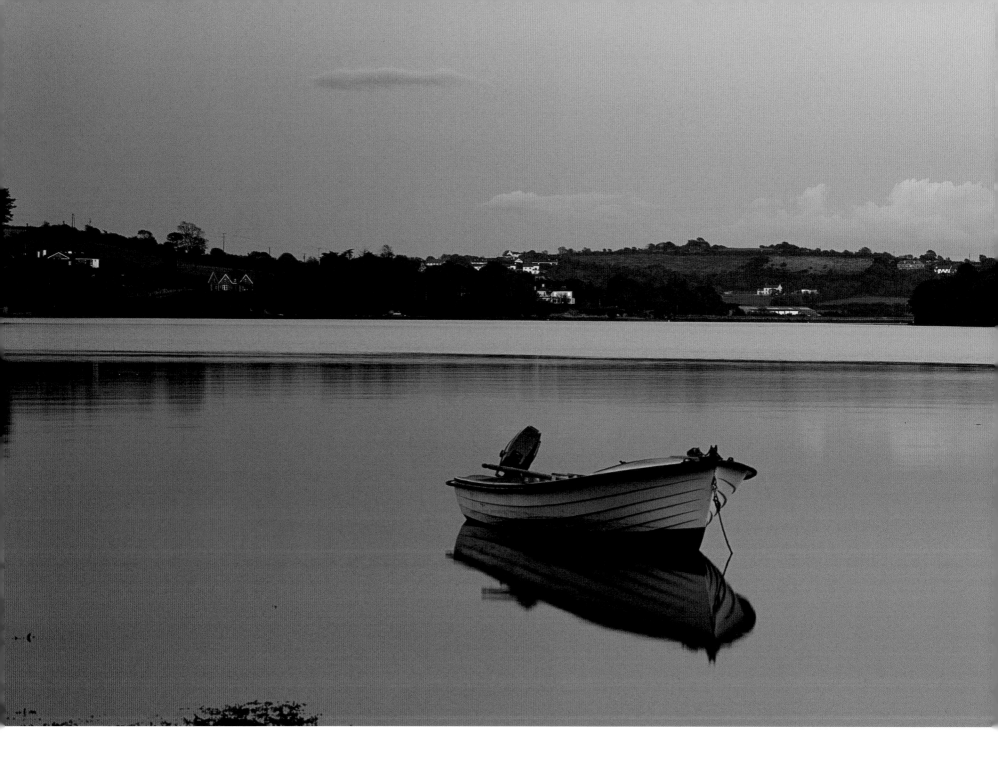

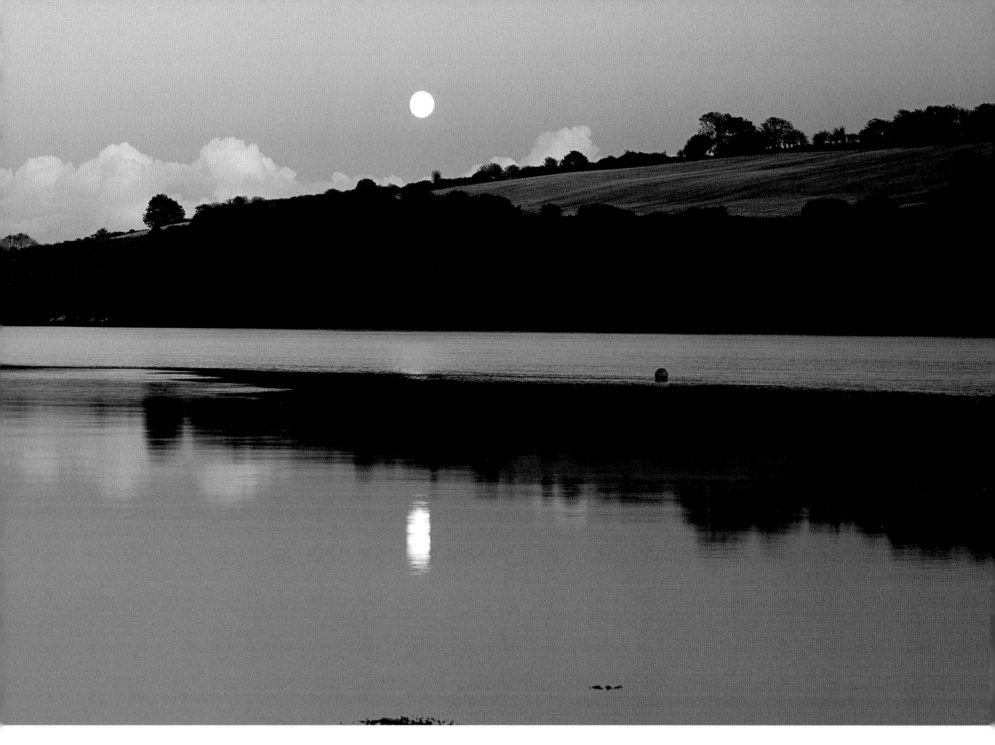

Moonrise over the Bandon River, Tisaxon, *c.* 2003.

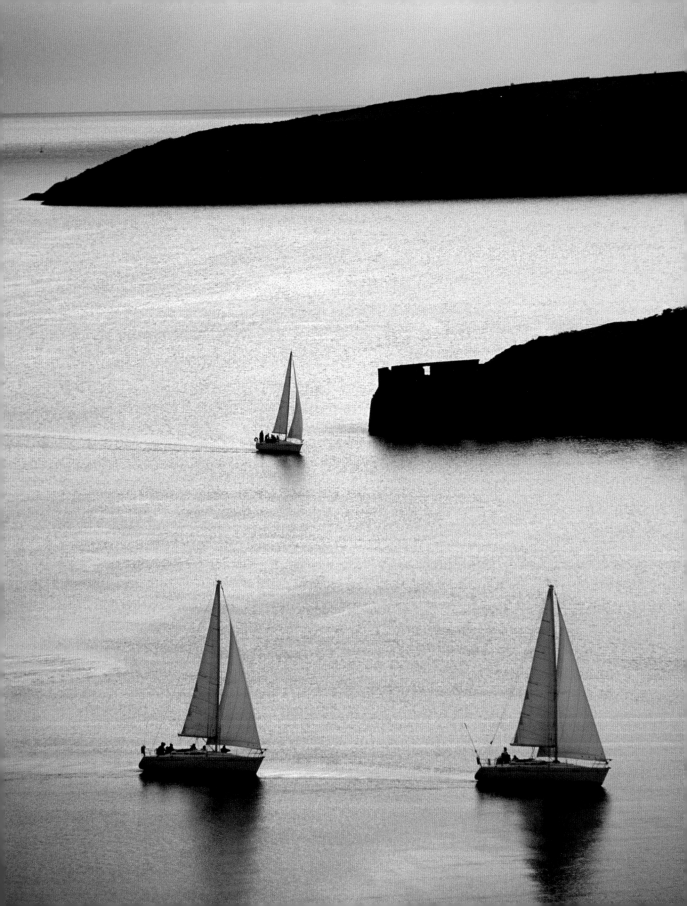

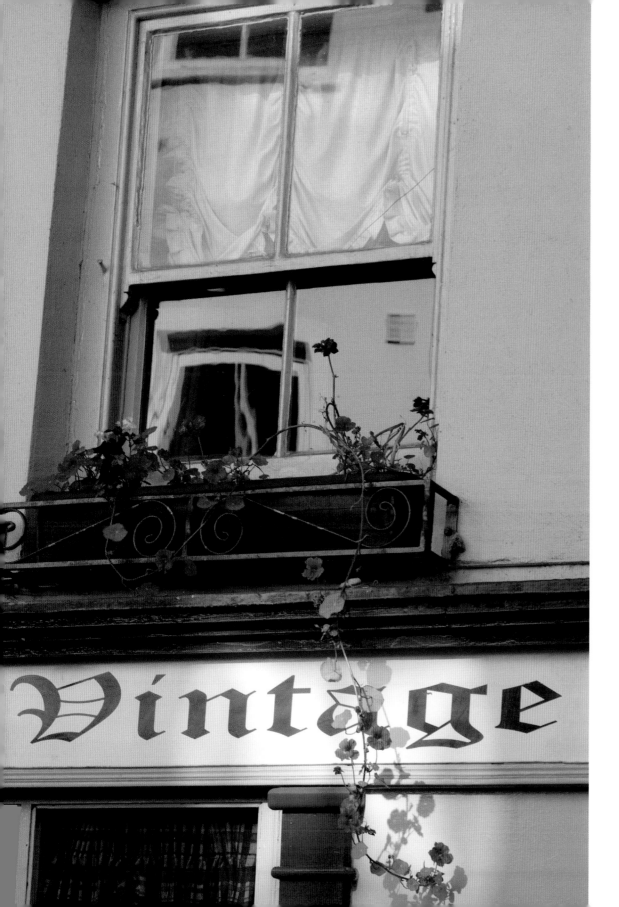

**Left:** Flowers, Vintage restaurant, *c.* 1997.

**Opposite:** Final approach, Kinsale harbour, *c.* 1998.

*Summer Cove near Kinsale, Co. Cork, Ireland.* *Colour Photo by John Hinde, F.R.P.S.*

*The Harbour, Kinsale, Co. Cork, Ireland.* *Photo: P. O'Toole, John Hinde Studios.*

Deep Sea Fishing Centre, Kinsale, Co. Cork, Ireland.

Colour Photo by John Hinde, F.R.P.S.

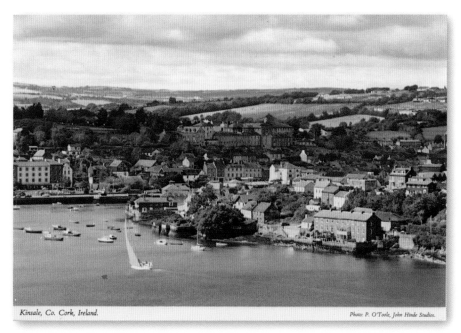

Kinsale, Co. Cork, Ireland.

Photo: P. O'Toole, John Hinde Studios.

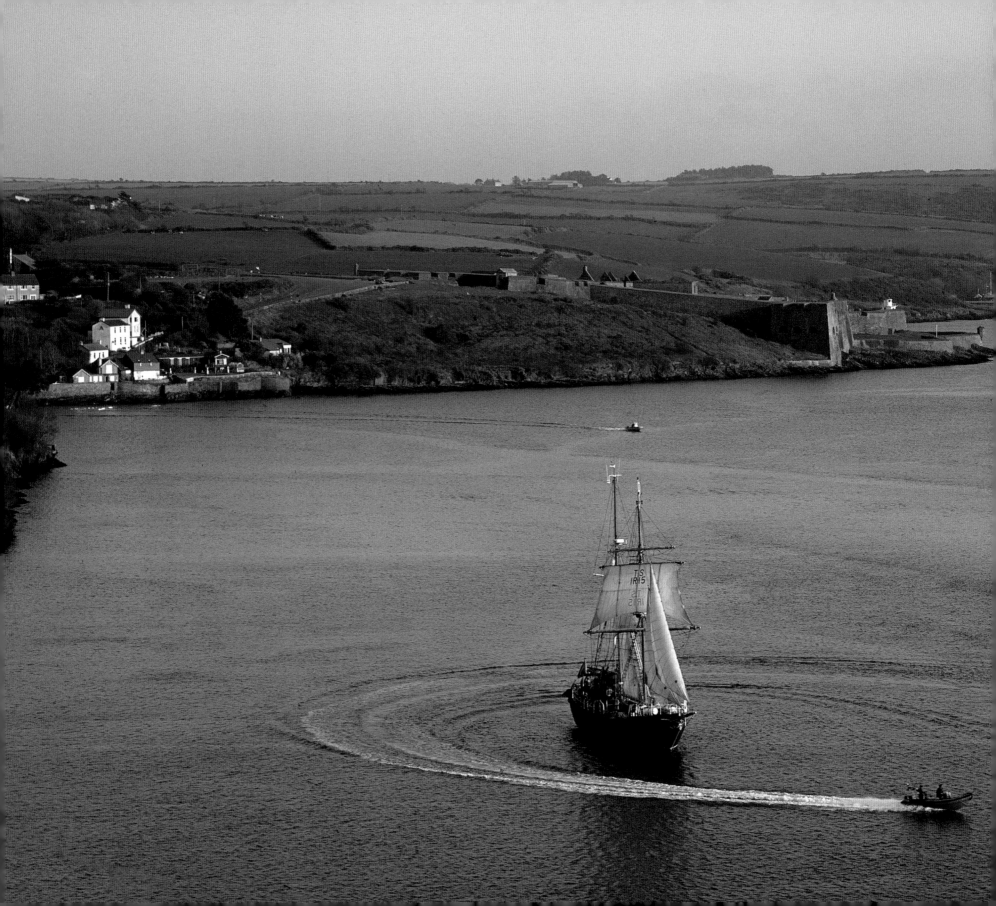

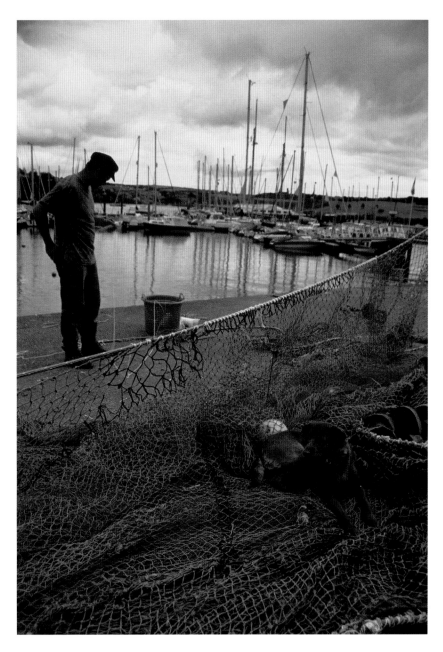

**Above:** Mending nets on the pier, *c.* 1994.

**Opposite:** *Asgard II* entering Kinsale, *c.* 1997.

Surfing at sunset, Garretstown beach, 2021.

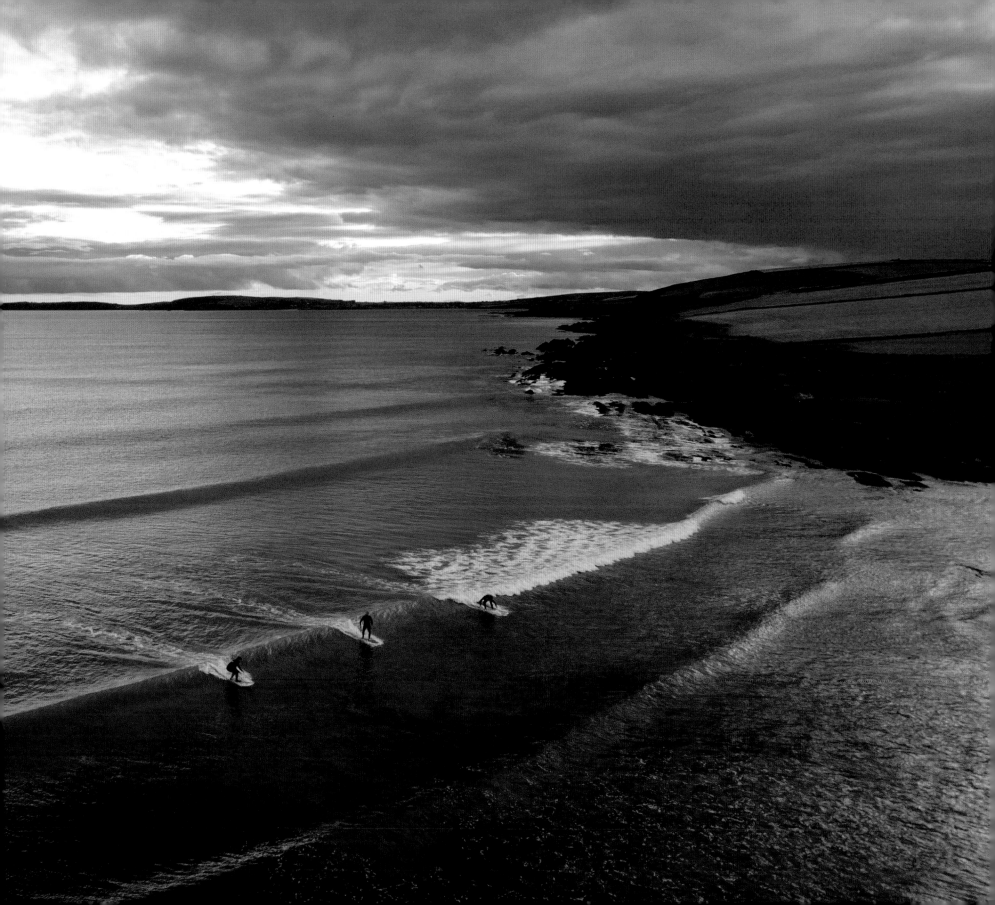

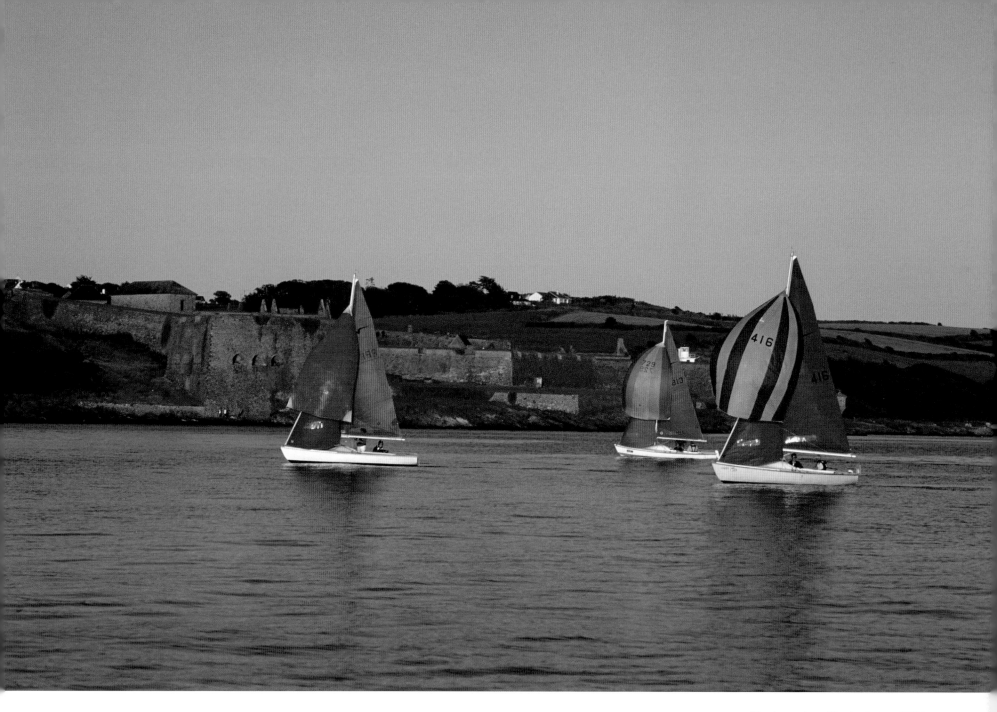

Dinghy racing, Charlesfort, c. 2003.

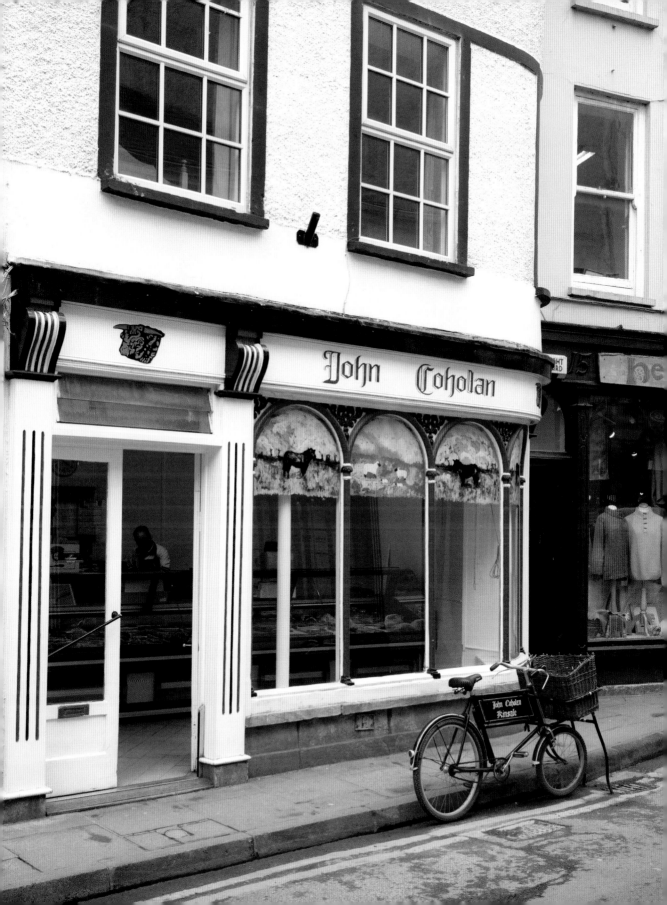

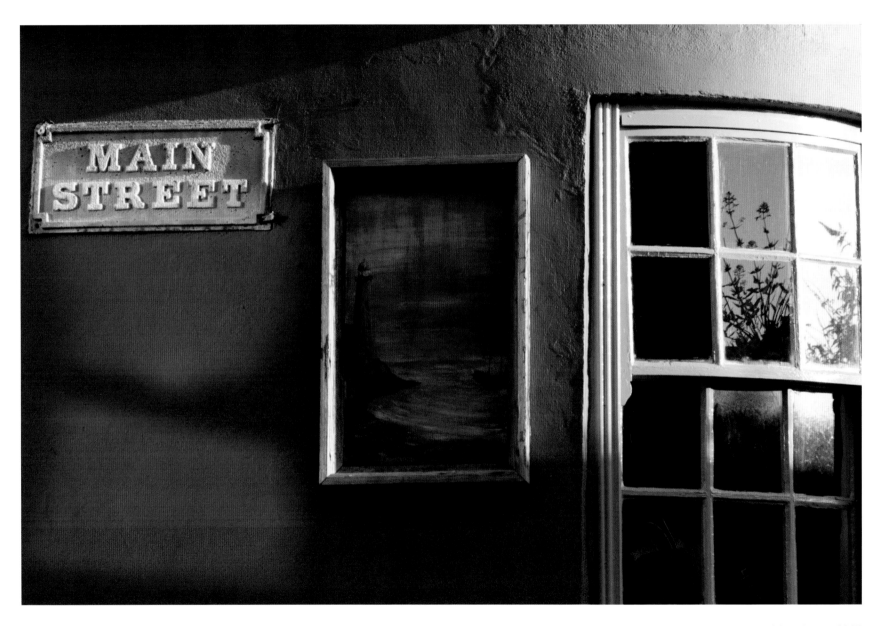

Morning shadows, Main Street, 2007.

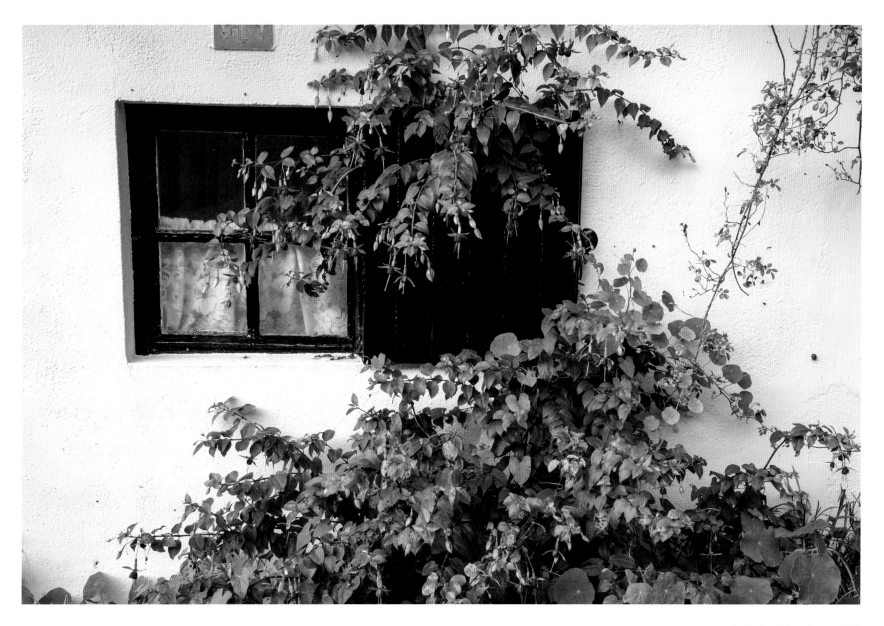

Fuchsias, Friary Lane, 1997.

*You don't make a photograph just with a camera. You bring to the act of photography all the pictures you have seen, the books you have read, the music you have heard, the people you have loved.*

Ansel Adams

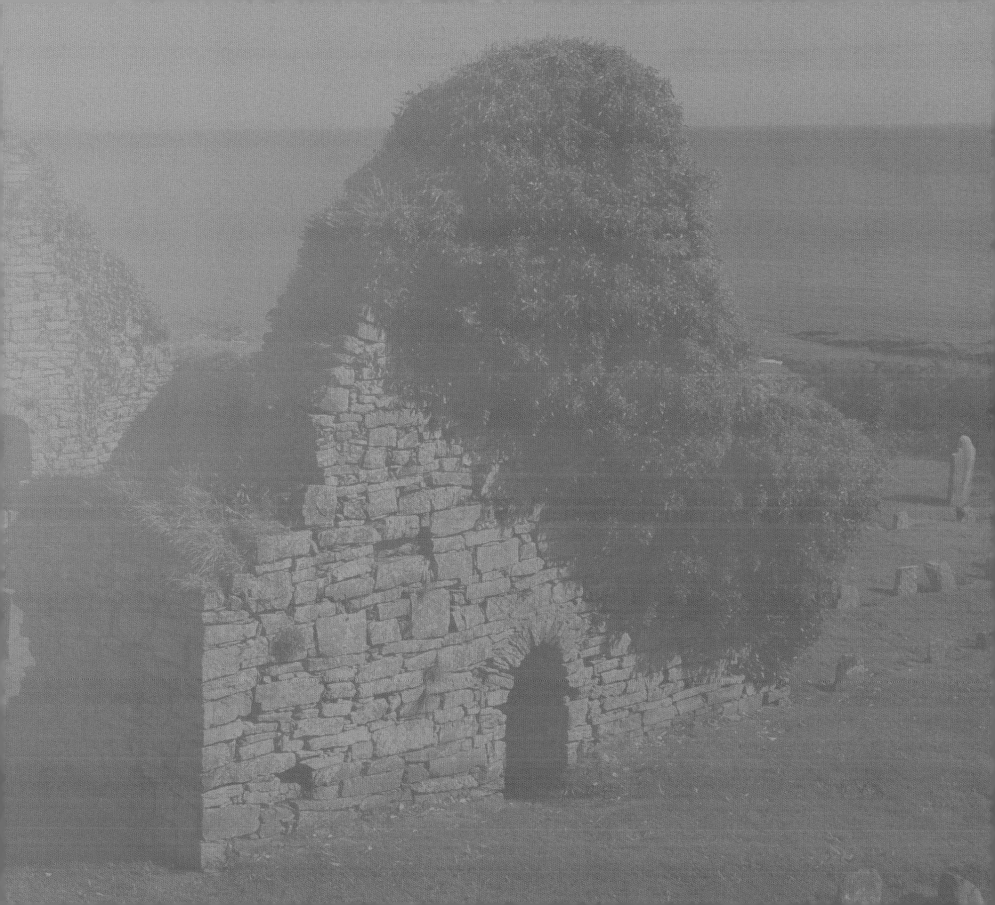

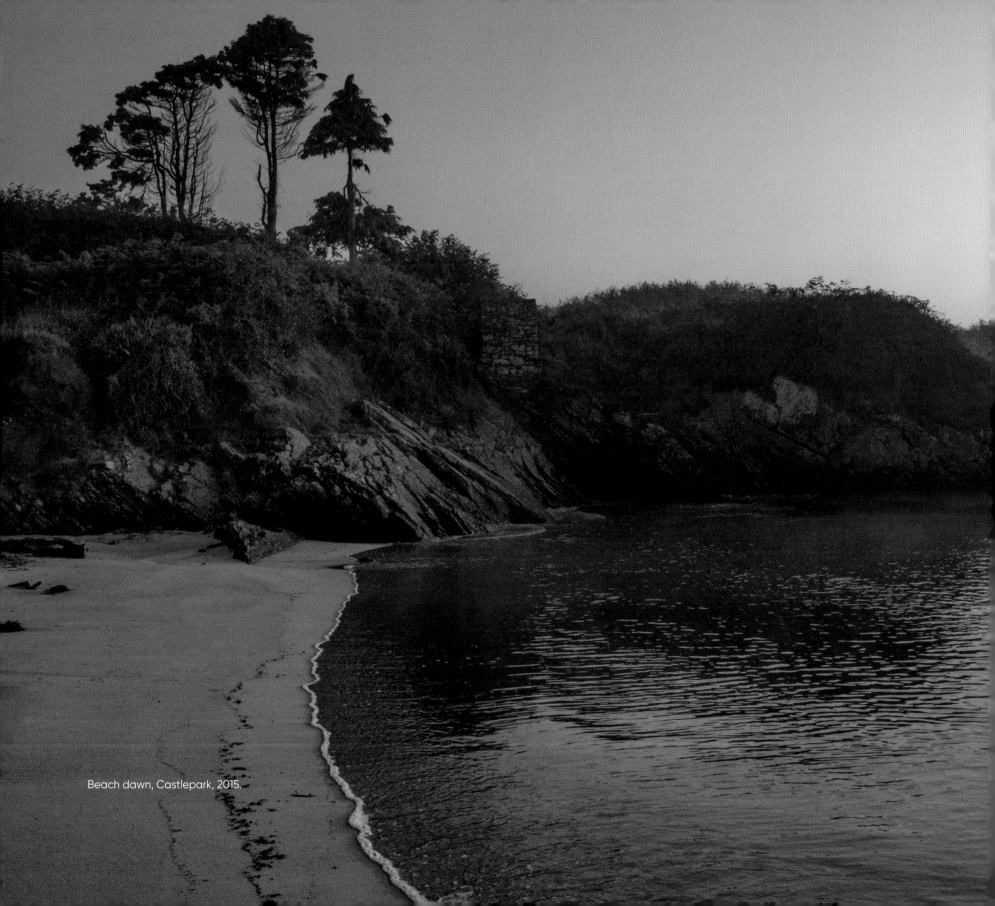

Beach dawn, Castlepark, 2015.

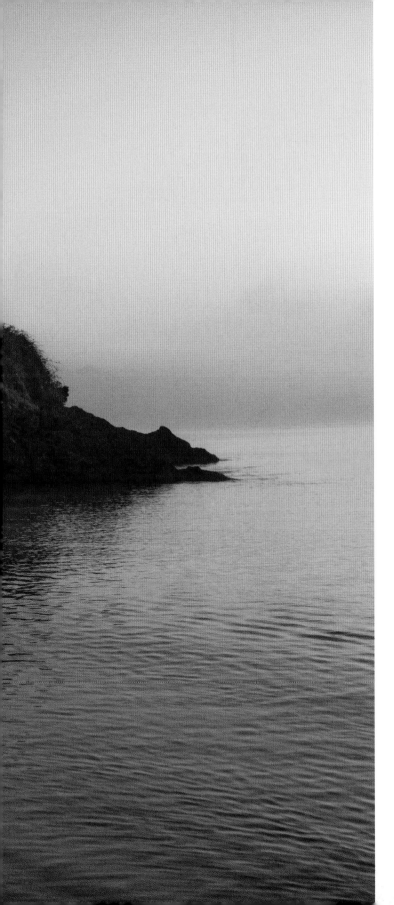

# 03

# Dawn of Man

It was harder to find the way in the dark. I knew the route because I had seen it during the day, but it felt different now in the predawn twilight. The first part was easy. A satisfying crunch of hiking boots on gravel, lit only by the beam of my head torch. As I started to make my way across the fields towards the cliff edge, there were moments when I wasn't quite sure if I was wandering off track or not. I checked the time – it was still forty minutes before sunrise, and I settled my giddy thoughts.

I found a rhythmic stride, my camera pack snug on my back while I carried my tripod, resting it on my shoulder. It was helpful to hold down brambles or give a steady hand getting

over a low ditch. Soon, I heard the distant sound of the waves at the base of the cliffs. I was near. Now, I was outside the arable land, and there was a bounce underfoot from the clifftop grasses, springing me forward. The final, narrow path through gorse and heather was easier to follow but also to trip over. Thorny gorse scratched at my jacket and pack, and I recovered from a couple of clumsy stumbles in my enthusiasm to get to the tomb.

Then I was upon it – *Leaba na Prionsa*, the prince's bed, also known locally as the chieftain's grave. I had visualised a sunrise photograph and planned it for an autumn morning with favourable conditions. It looked good as I found the location that I had scouted in daylight. I extended and locked the tripod legs and took my backpack off. Some high cloud was beginning to receive the rising light, sculpting a patterned sky. Once I had clamped the camera on the tripod head and attached a filter set to the lens, I began to relax.

Creating photographs at first light nurtures awe and wonder like no other time. The feeling of being at one with a new day is both meditative and nurturing – driving the creativity to capture the beauty and stillness of the morning. As my eyes adjusted to the rising light, I paused to look at the 5,000-year-old stone monoliths speckled white with age. I couldn't help but reach out and touch what felt like time itself.

Officially an 'unclassified megalithic tomb', this ancient burial site predates written history. I now stood alongside the oldest known connection to our forebears in the Kinsale area. While there are many ancient sites throughout Ireland, few have survived in areas of intense settlement. I wondered about the people who lived here a hundred generations ago. Who was laid to rest here? Why this place? The questions keep coming.

The great thing about prehistory is its rich mythology and folklore, which fuels the imagination. Perhaps in their symbolic and spiritual beliefs, we feel the most vital connections to our ancestors. In moments like this, straddling the natural and ancient worlds, I think about how we have become disconnected from Earth and nature through industrial and technological times. The lengthy timeline from early human settlement to written history encompasses so much that we cannot fully know – long

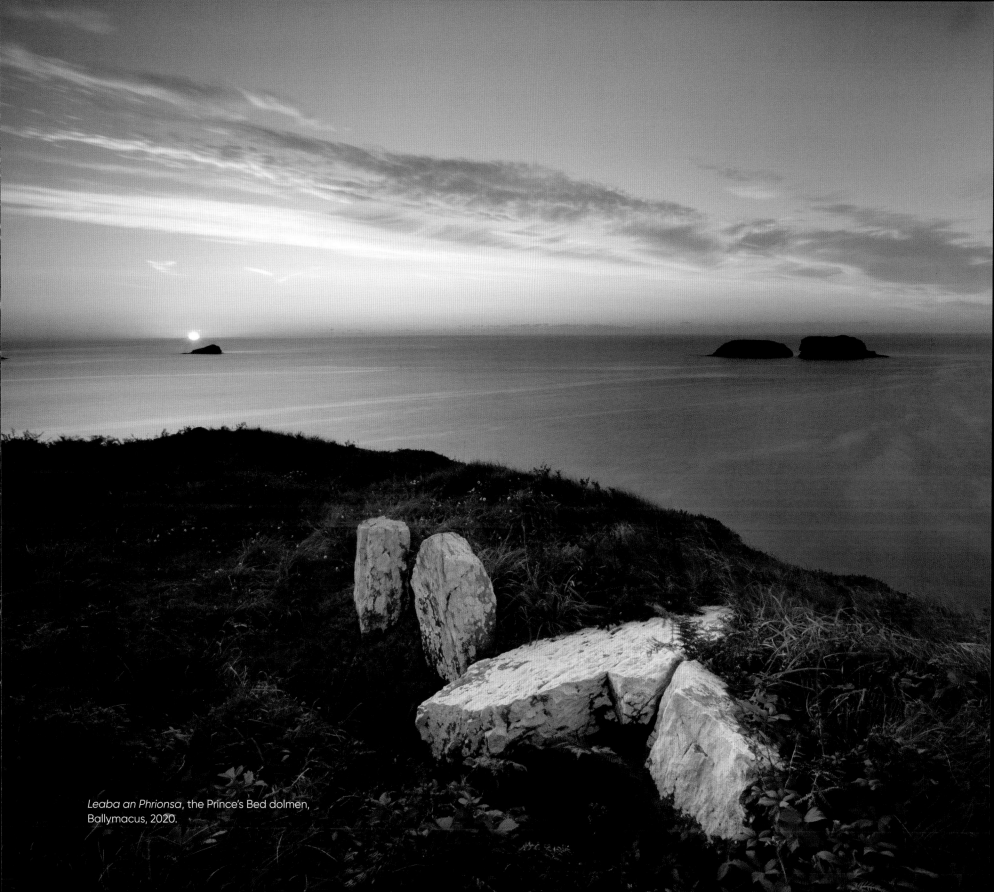

*Leaba an Phrionsa*, the Prince's Bed dolmen, Ballymacus, 2020.

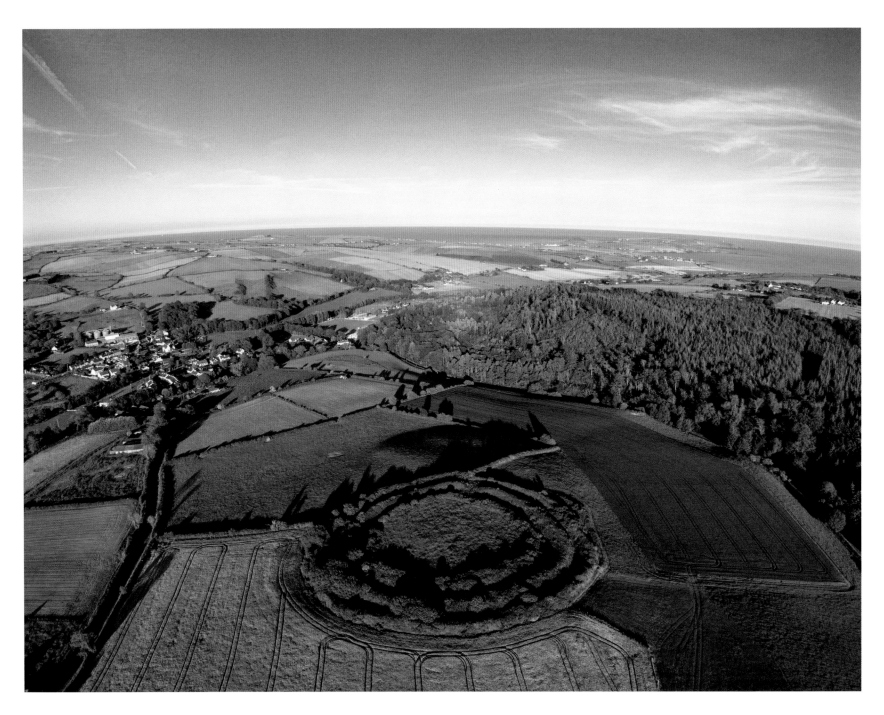

Ballycatteen ringfort, Ballinspittle, 2022.

before the arrival of Christianity. Yet, in these ancient stories passed on by oral tradition, it is clear that our ancestors' lives were deeply entwined with the natural world – the land, the seasons, the plants and the animals on which we depend.

But how was life then, before the written word, when we lived in small communities of hunter-gatherers and, eventually, farmers? We surmise that the symbolic and spiritual were an integral part of life, alongside the practical needs of food, shelter and social belonging. Life was an essential part of a universe alive with spirit – the seasons, stars, forests and seas formed a world in which oneness with nature was inherent in lives and beliefs.

The sun was beginning to lift over the eastern horizon by the small Sovereign island. The two larger Sovereigns directly out to sea to the south were now distinct shapes on the horizon. It was time. I made a final check on the focus and exposure settings on the camera and gently released the shutter. A moment of dawn light was captured, the tiniest fraction of time since fellow humans built this tomb to honour those passing to the next life. As the sun rose higher, it lifted the autumnal morning chill. I packed the equipment to get ready to go and took out a small flask of hot tea. Its settling warmth slowed my busy mind, creating space to savour the panorama unfolded from the night. Where my attention had been to the east and the rising sun, I could now see the narrow estuary of Oysterhaven, snaking its way inland. Dominating the view to the west was the proud promontory of the Old Head of Kinsale.

I had been aware of its presence earlier in the darkness. The lighthouse sequence of two bright flashes every ten seconds is visible for 20 miles or more in clear conditions. This long peninsula juts deceptively far out to sea, some 5 miles from the town of Kinsale. Enquiry into the geology of our land and seas yields unimaginable timelines – units of millions of years, then hundreds of millions and beyond. To read accounts of planetary change over four billion years becomes mind-bending. The Earth beneath my feet at this moment has moved around on tectonic plates for aeons, eventually forming land as 'Old Red' sandstone from the Devonian era, 400 million years ago. This, combined with Carboniferous limestone, deposited when Ireland was bathed in warm tropical seas tens of millions of years later, gives us the foundations on which we live today.

I donned my backpack to start the hike back towards Ballymacus point, the views and sounds spectacular in the morning sunshine. A short distance along the cliff path, I reached an overlook above Quay Rock, where the ghostly image of the shipwrecked tall ship *Astrid* came to mind. It was sailing from Oysterhaven into Kinsale on a July morning in 2013 when it lost engine power, and a strong onshore wind drove it up on the rocks. My memory of a similar dawn hike to make that photograph reminds me that time along the coast is compressed from millennia to moments.

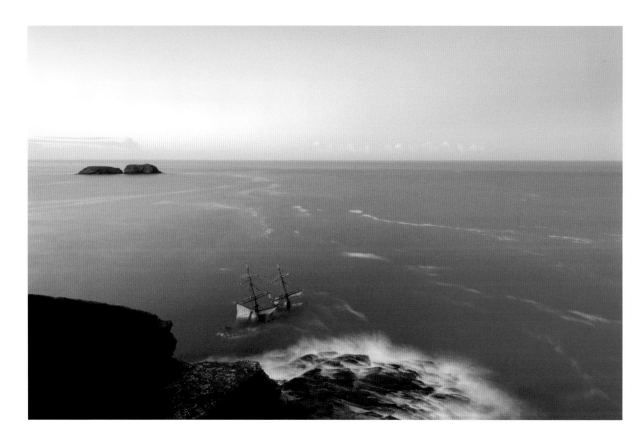

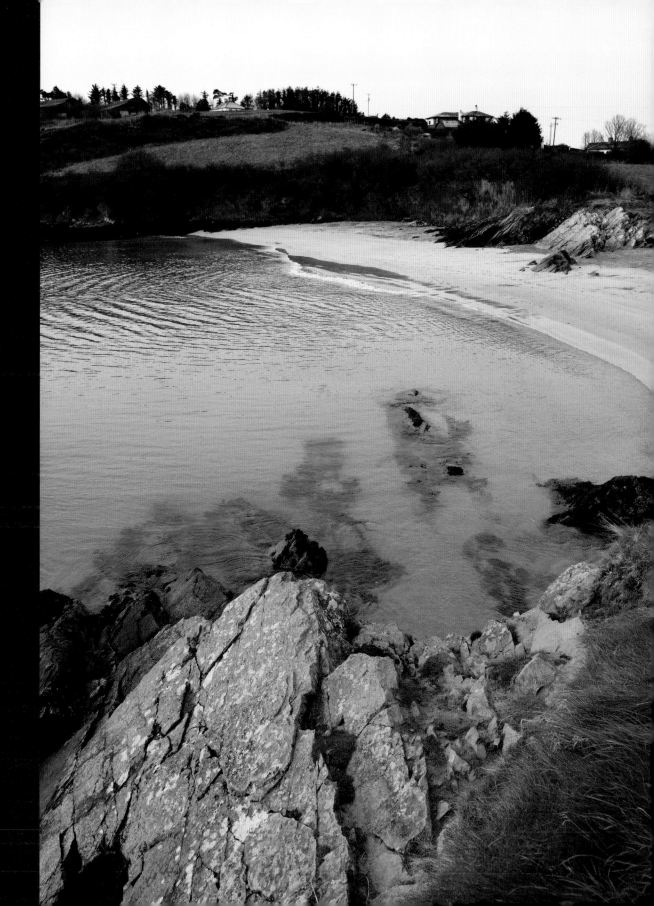

**Right:** The Dock beach,
Castlepark, 2006.

**Opposite:** Tallship *Astrid* sinking,
Ballymacus Point, 2013.

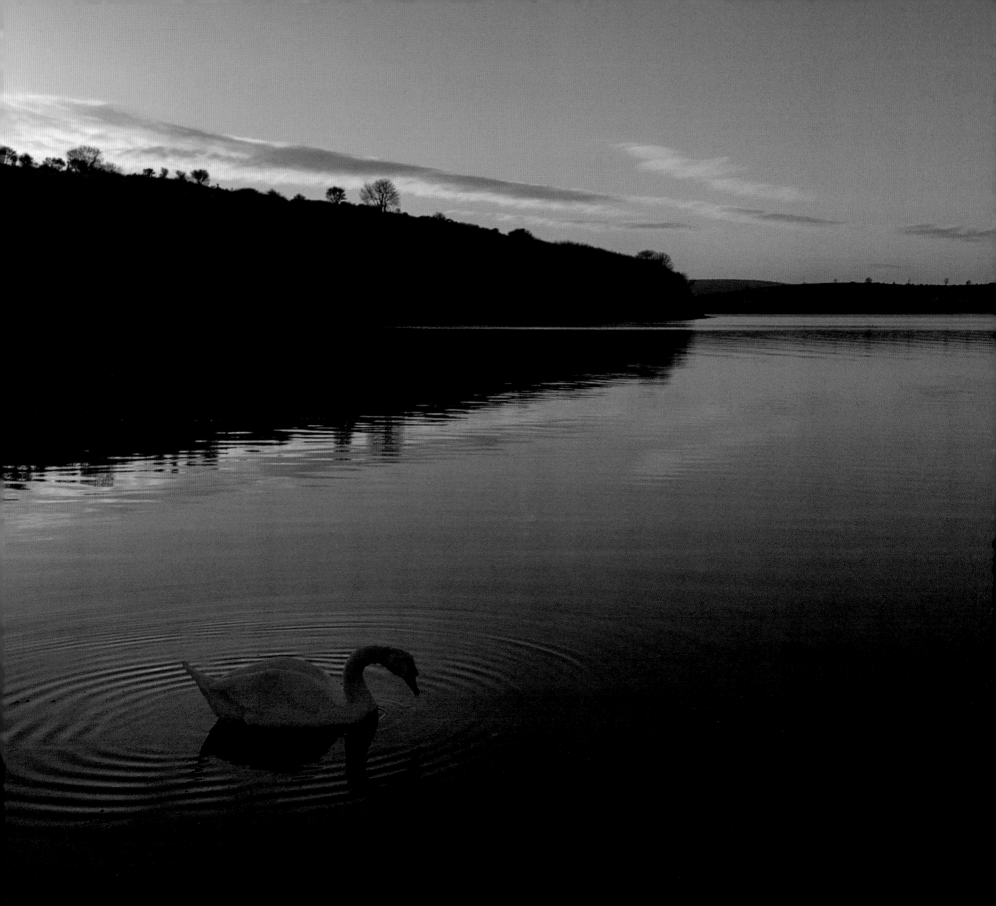

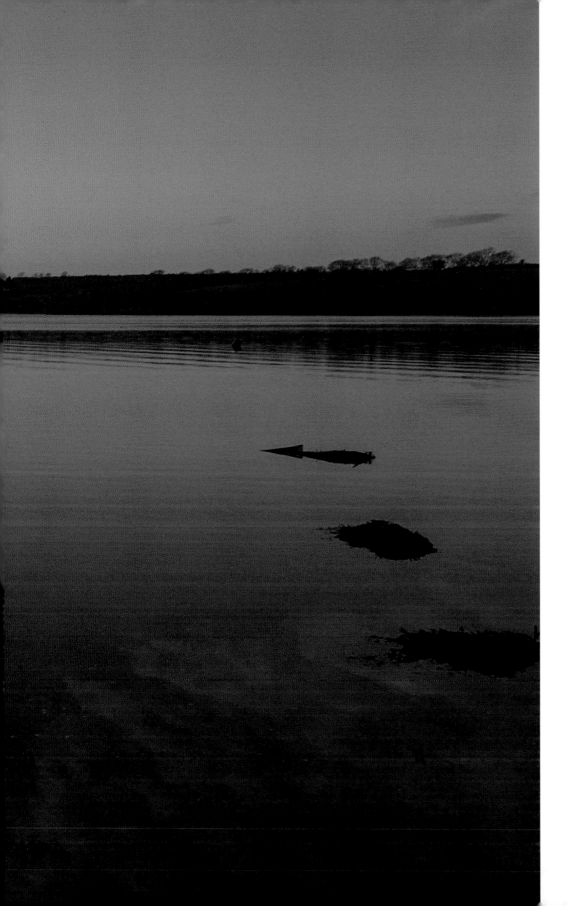

Swan sunset, Bandon River, 2003.

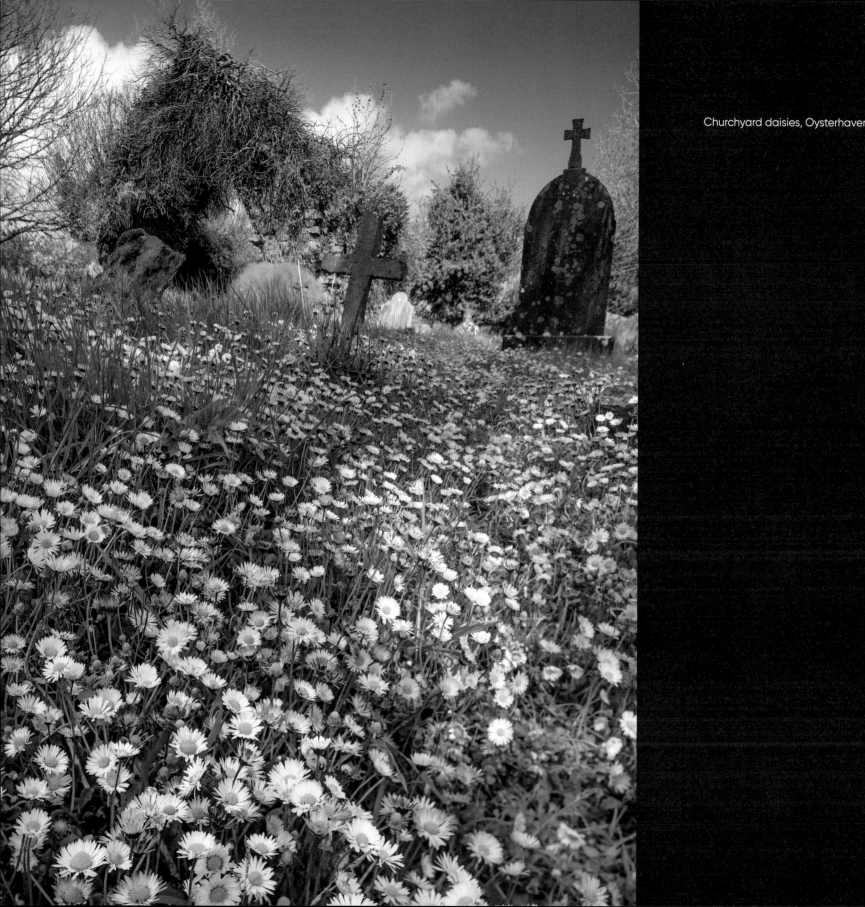

Churchyard daisies, Oysterhaven

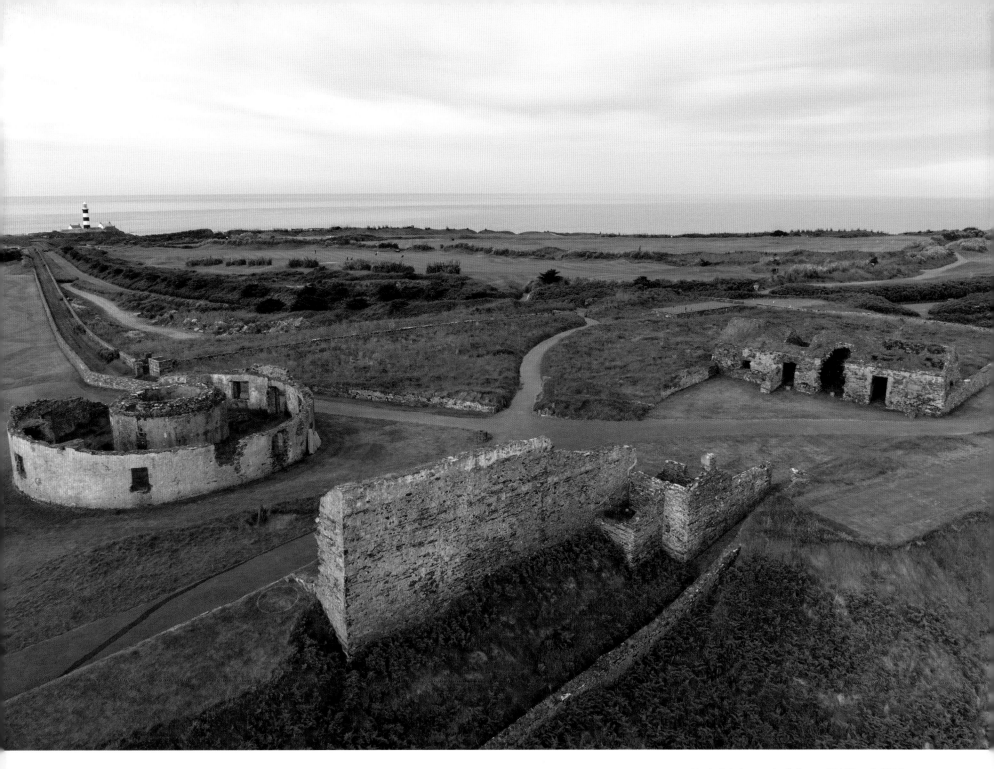

Early lighthouse buildings, Old Head, 2022.

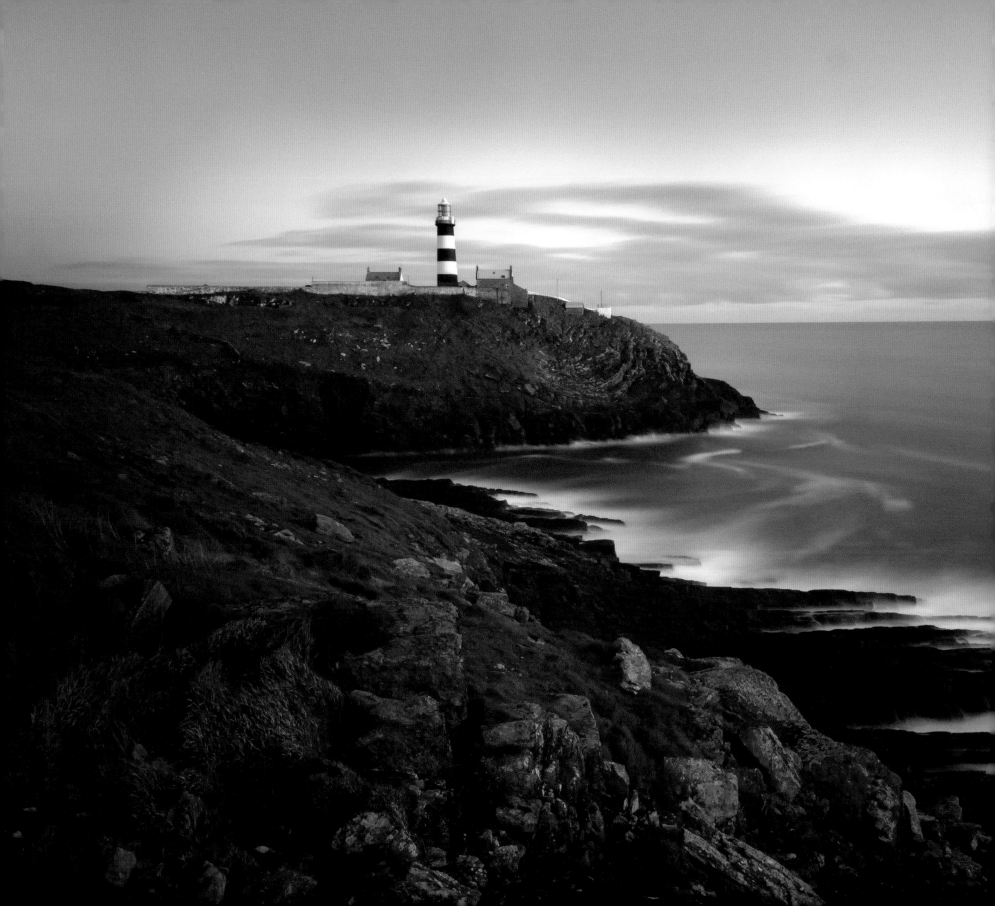

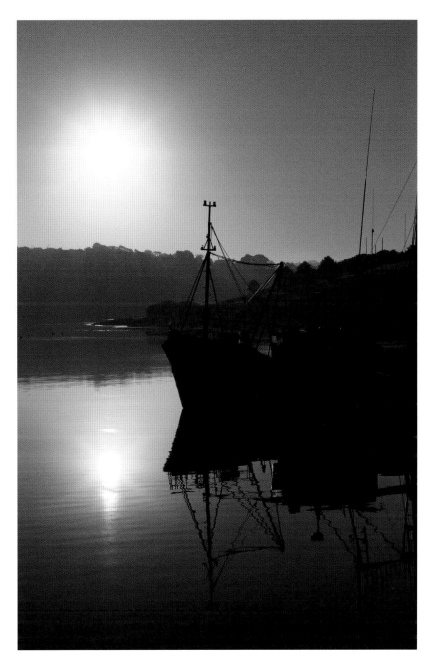

**Above:** Pier head silhouette, 2007.

**Opposite:** Old Head and Cuas Gorm, 2020.

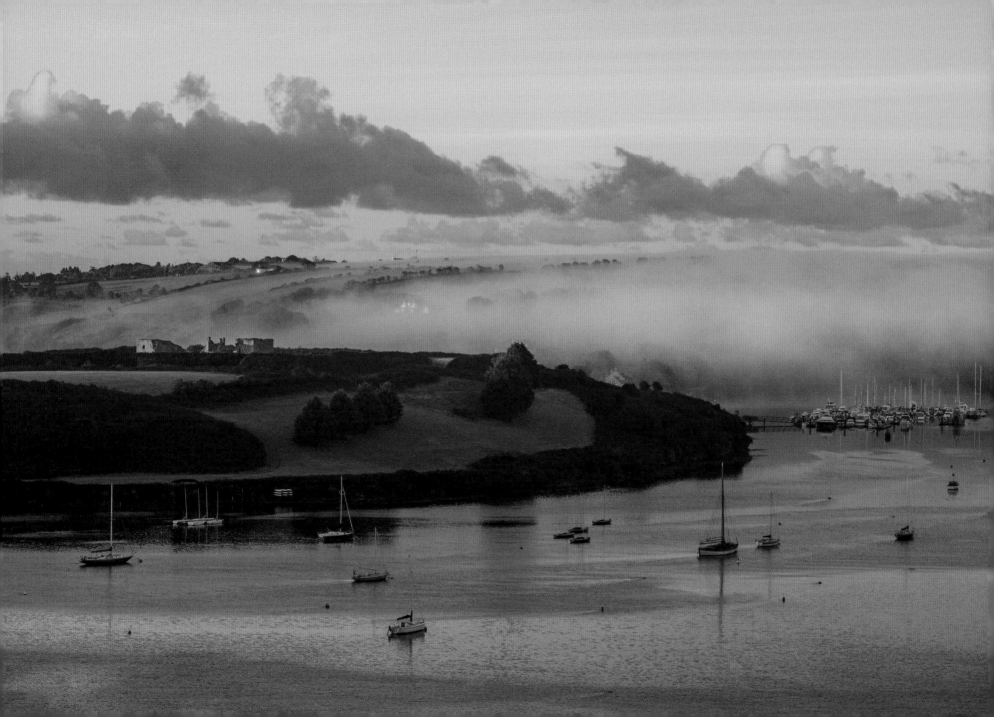

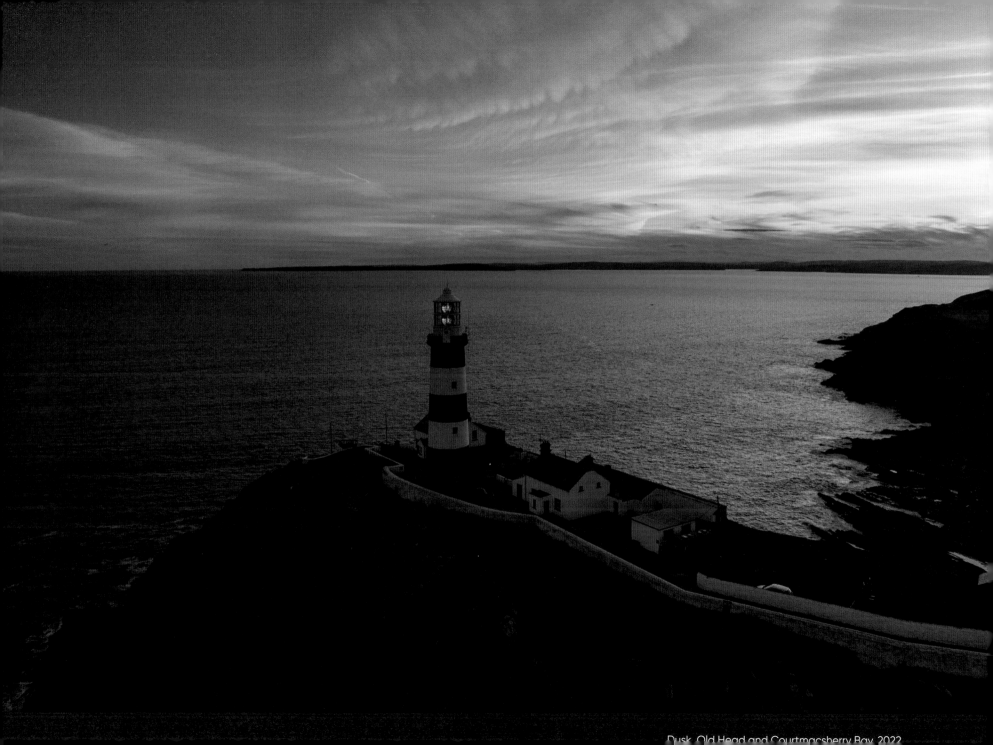

Dusk, Old Head and Courtmacsherry Bay, 2022

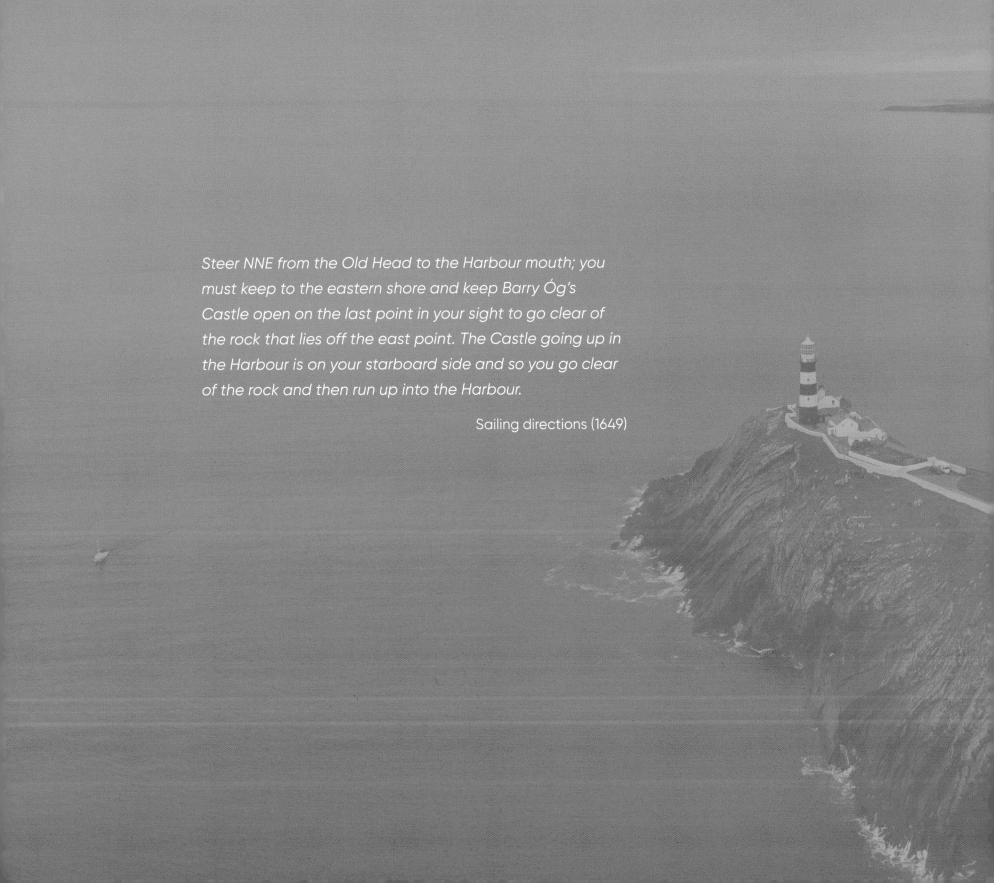

*Steer NNE from the Old Head to the Harbour mouth; you must keep to the eastern shore and keep Barry Óg's Castle open on the last point in your sight to go clear of the rock that lies off the east point. The Castle going up in the Harbour is on your starboard side and so you go clear of the rock and then run up into the Harbour.*

Sailing directions (1649)

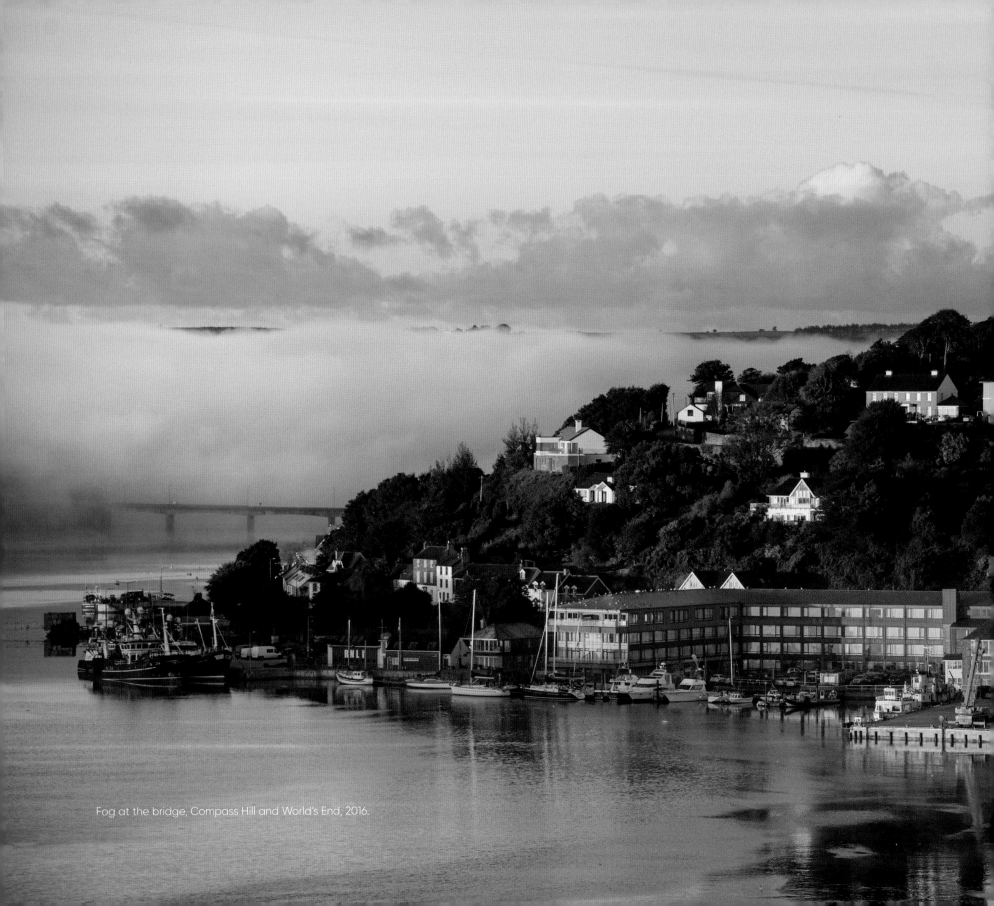

Fog at the bridge, Compass Hill and World's End, 2016.

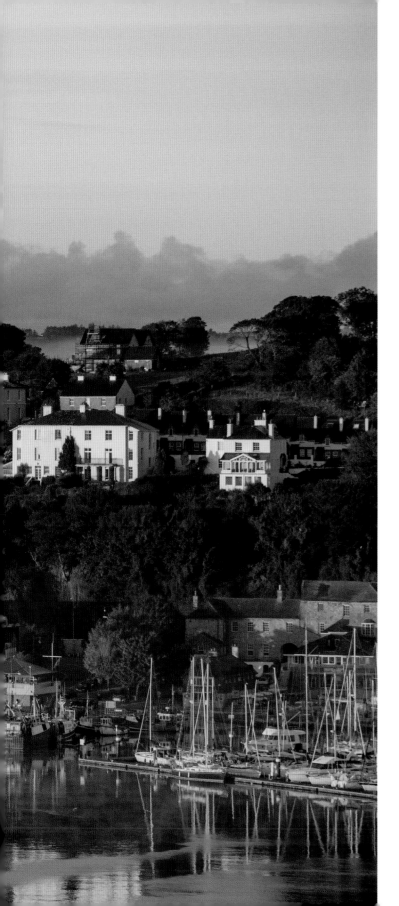

# 04

# Between Hill and Shore

The long, low swells coming from the east were deceptive. The boat rose slowly, then paused before pitching down perilously, grey water all around. It was strangely quiet with the wind behind, and I was glad that Kinsale was nearby. We were close to the harbour now, having passed the Sovereign islands and Oysterhaven. The black and yellow marker buoy of the Bulman Rock came into view, warning of the danger beneath. Soon, we would turn towards Preghane point – its rocky tuft marking the eastern flank of the harbour. Within minutes we were inside – the sea calmed, the wind disappeared, and we glided smoothly towards Charles Fort.

A key attraction of Kinsale is shelter. The Old Head creates a long breakwater from the prevailing south-westerly weather, while the Bandon River carves a series of bends as it meets the sea, creating a natural harbour. The contours of the coast may have been different when human eyes first encountered it, but the sheltered estuary would have been attractive to early settlers. Intrepid hunter-gatherers may have made their way from the Iberian peninsula, France or Britain following the Atlantic coast, starting around 8000 BC. For thousands of years before this, ice sheets covered Ireland and were up to a kilometre thick. As the glaciers released their icy grip, the landscape changed to tundra, then to grassland until trees began to take hold. The first of these was the hardy juniper – a shrubby conifer – soon followed by willow, birch and pine. Finally, the great forest trees of oak and elm began to dominate these wildwoods, reaching their peak just as the first humans started to arrive.

What might these first explorers have encountered as they entered the harbour? The coastline was undoubtedly different from what we saw as we slowed our boat speed approaching the port. Dense forests would have covered the land and teemed with animal and birdlife. As these early explorers made their way on the same waterway we were now on, the wooded hills and cliffs gave way in places along the estuary. Small sand beaches offered easy landing, freshwater flowed from springs, and abundant food sources were nearby.

We slowed our engine and paused at Middle Cove to prepare the boat to come alongside at the yacht club marina, arranging mooring lines and fenders to protect the hull. I could still see the Old Head and Bream Rock silhouetted in the distance. The earliest Celts are thought to have made a settlement here – *Dún Cearmna* – on the current Old Head Golf Links site. It is thought that a later wave of Celts displaced them when they arrived in Ireland, fleeing the Roman domination of Europe. Their culture and skills as ironsmiths were ideally suited to life in Ireland, and they prospered as they expanded across the island. Enclosed ringforts, or raths, are thought to have emerged with the Celts, and an extensive one is located in Ballycatteen, near the village of Ballinspittle.

The Celts are also thought to have given us the name *Cionn tSáile* – the head of the salt – where the sea met freshwater flowing from the Bandon River. This became a natural landing place as the

buoyancy provided by saltwater gave way to fresh, and it was the place around which early Christian settlements expanded. The freshwater spring of *Fan na Tubride* – the abbey well – is where the town of Kinsale began, pre-dating Eltin, who built a Christian settlement and church in the sixth century. This would later become St Multose church, after Viking and Norman waves of colonisation began to dominate.

The delight of approaching Kinsale by boat never wanes. Passing the imposing Charles Fort and the calm bay of Jarley's Cove, we follow the red marker buoys leading to the inner harbour. Familiar sights look different from the water, and the slow ticking-over of the engine gives us time to savour it. After waving to some people sitting on the quay wall in Summercove, we hugged the shoreline along Ardbrack, keeping to the deep water of the channel. The tide was high as we made our final approach to the marina and passing cars on the pier road appeared to be driving on water. The sky cleared to blue and the sun spotlighted the town – we were home.

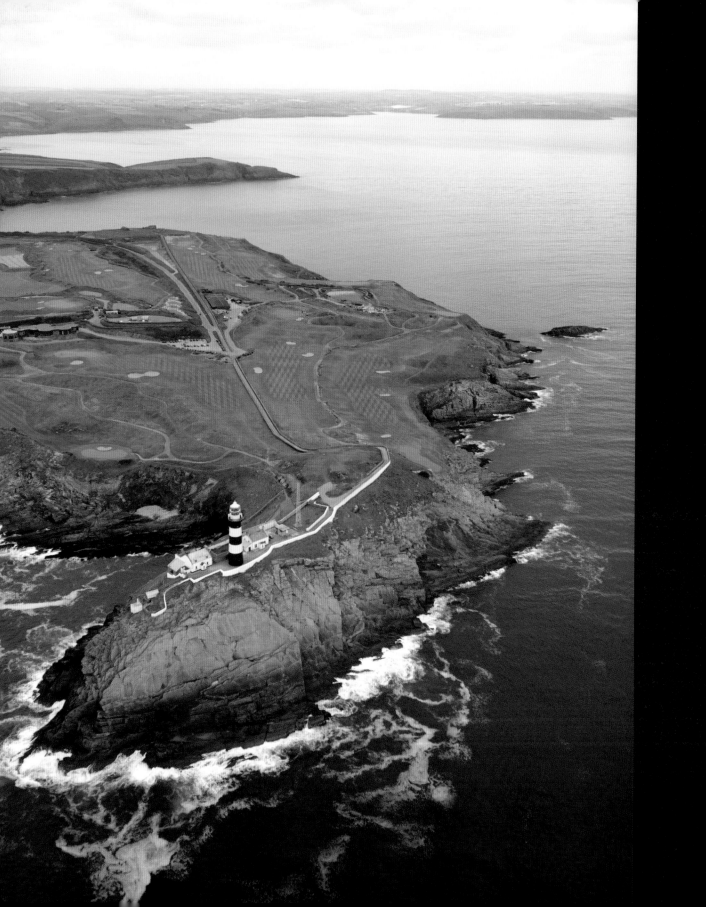

Old Head of Kinsale,
helicopter aerial, 2006.

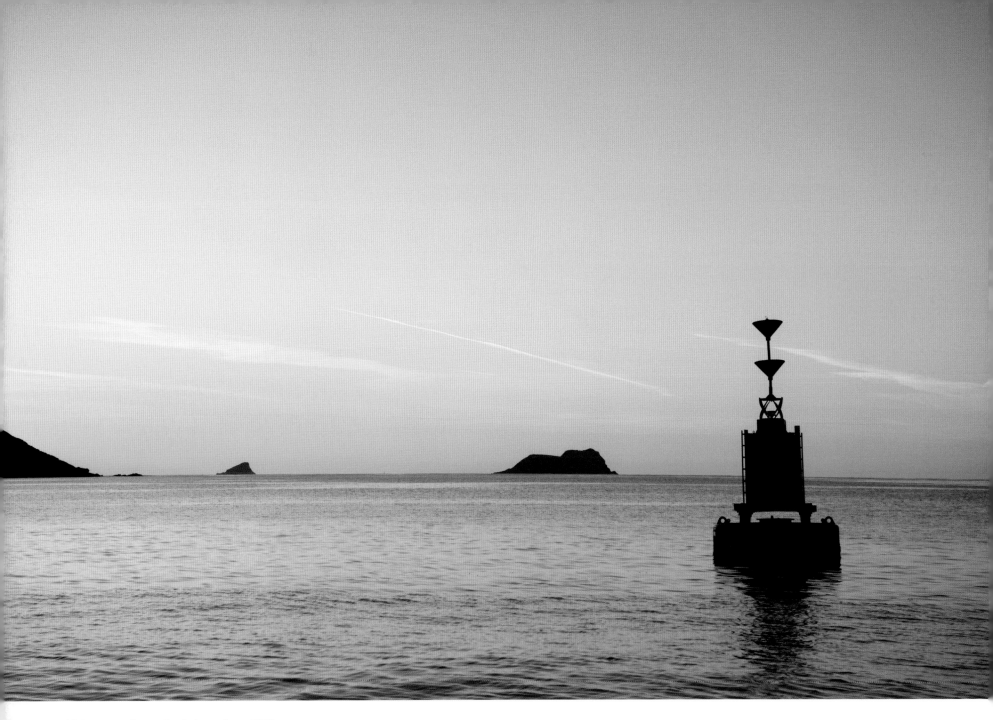

Midsummer dawn, the Bulman Buoy, 2010.

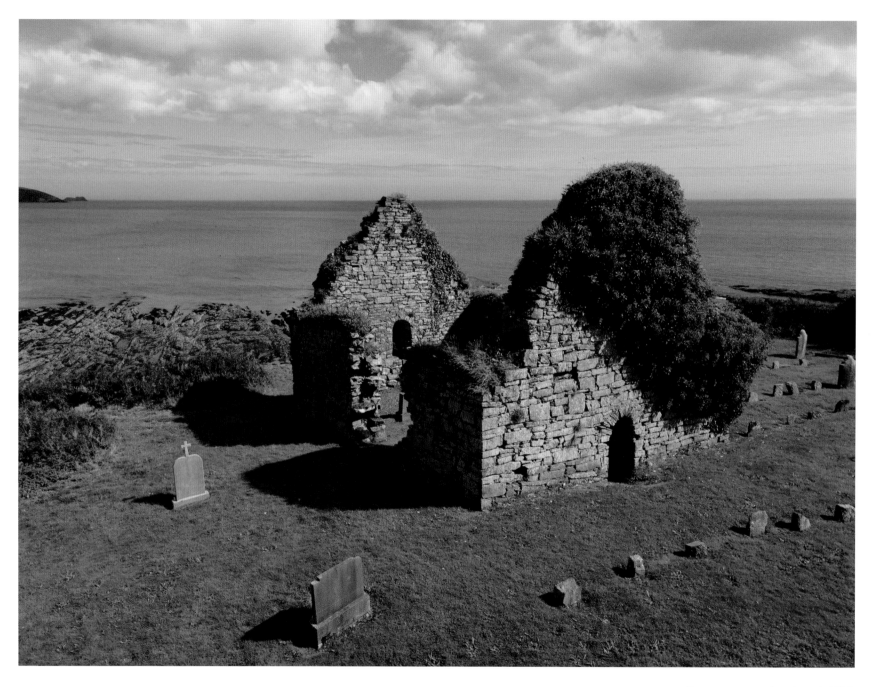

Courtaparteen churchyard, 2020.

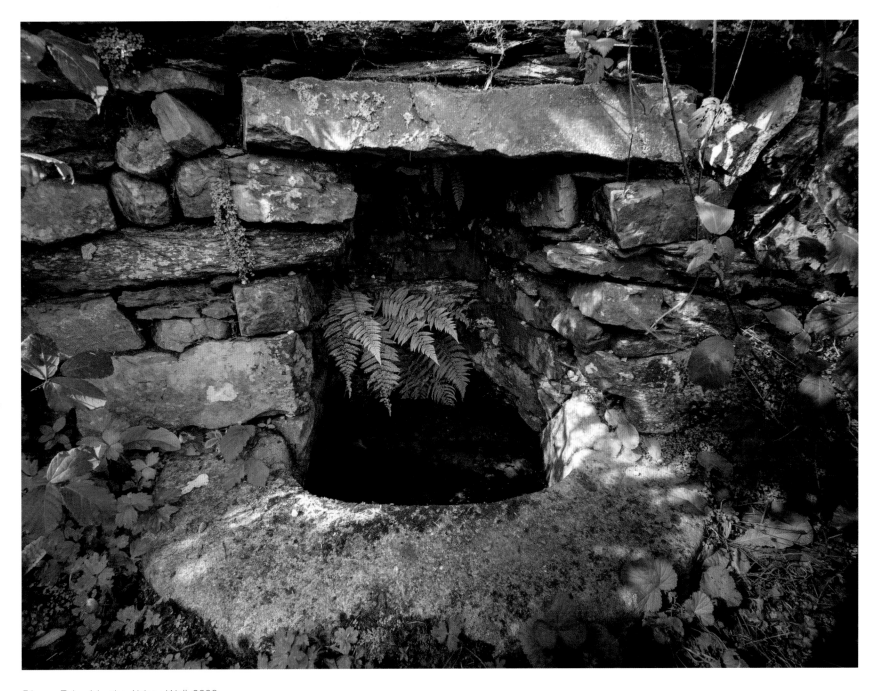

*Fán na Tobraide*, the Abbey Well, 2020.

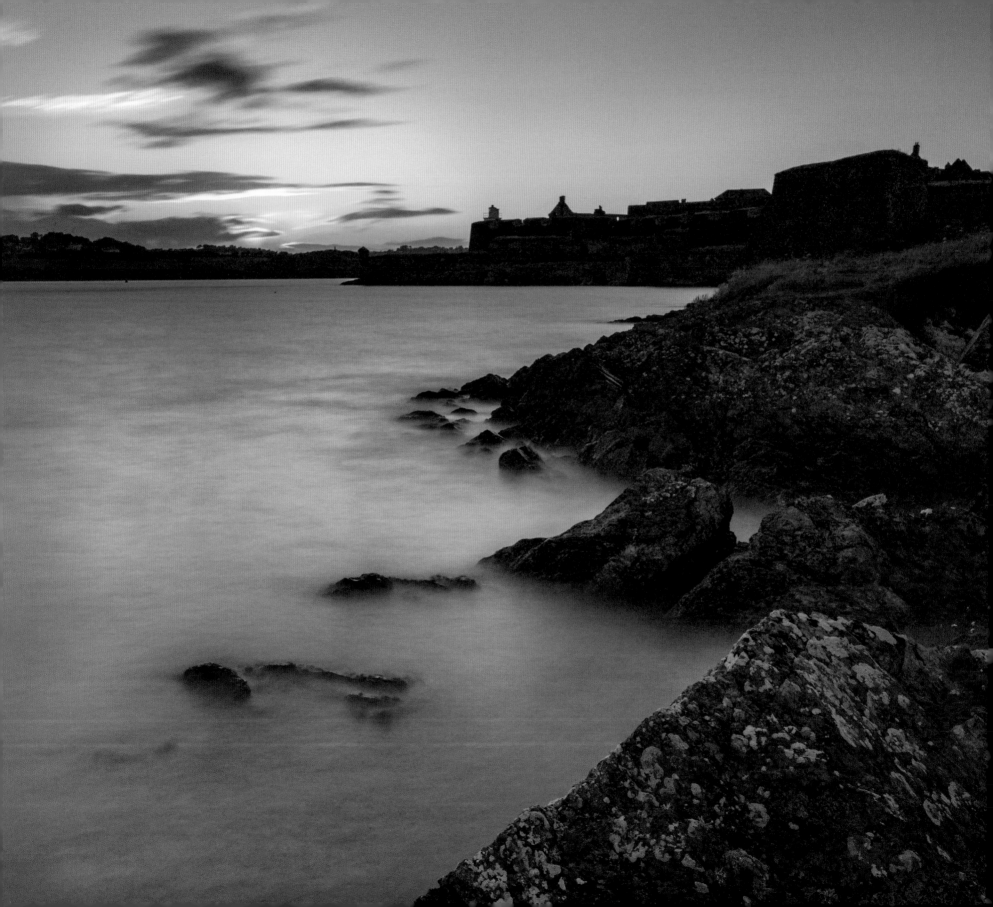

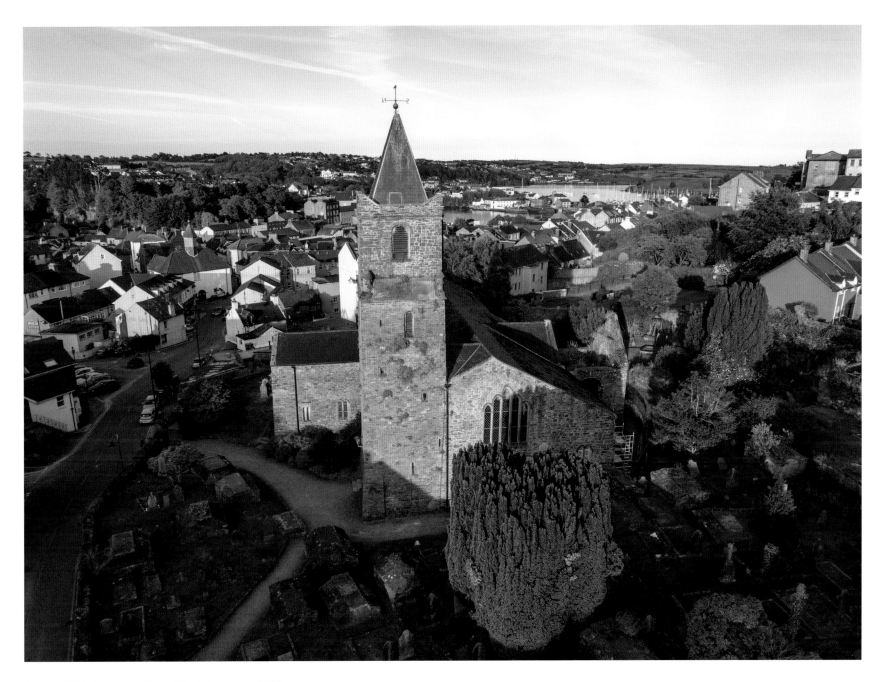

**Above:** St Multose church and Market Square, 2022.

**Opposite:** Sunset, outer harbour, 2017.

Flowering rapeseed,
near Milewater, 2016.

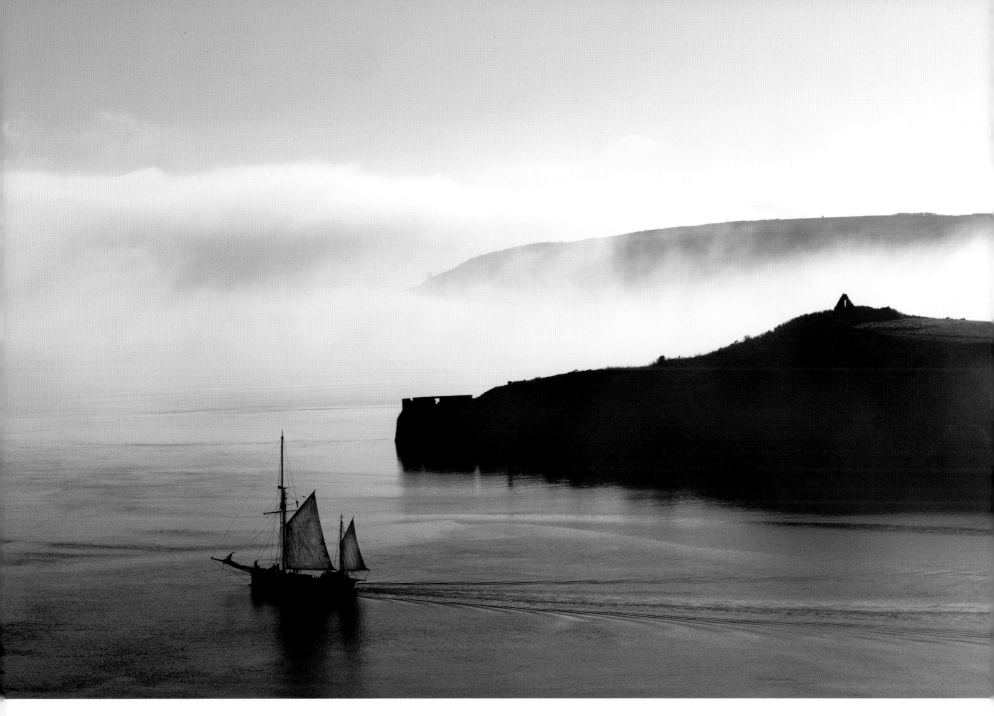

The ketch *Ilen* in morning fog, 2020.

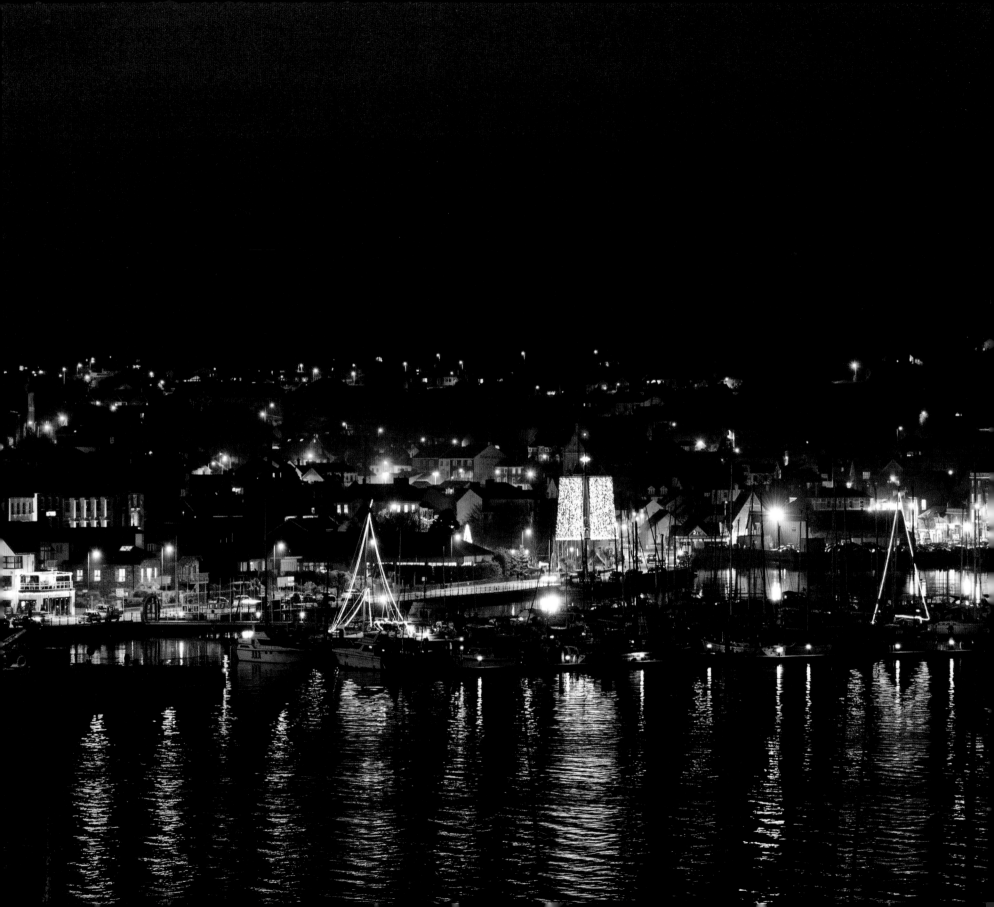

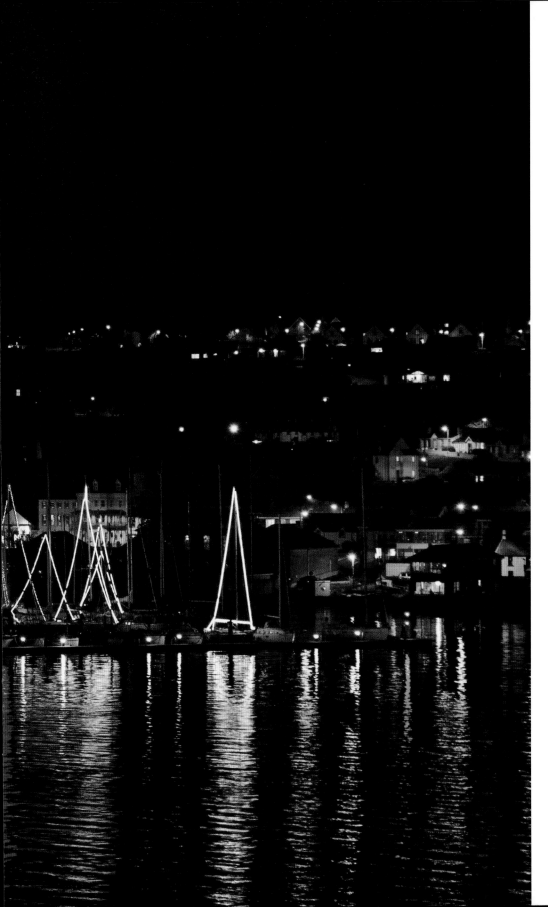

Christmas lights, 2014.

Twilight, the Gully bridge, 2011.

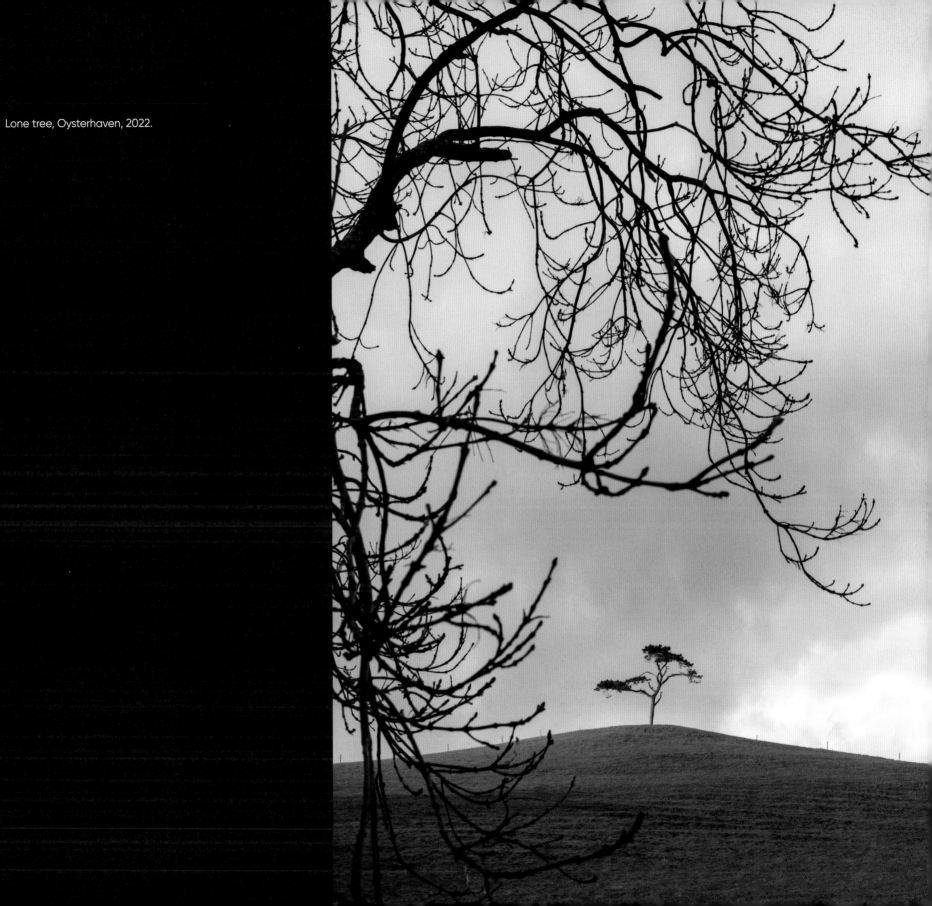

Lone tree, Oysterhaven, 2022.

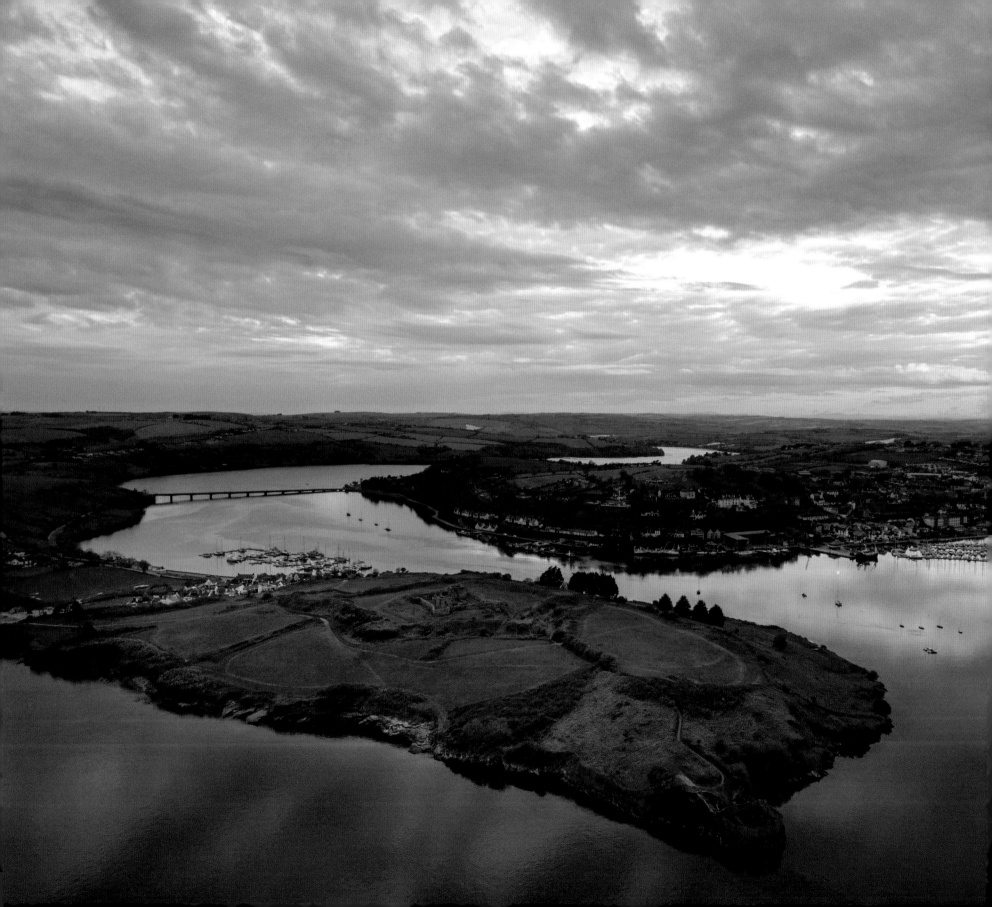

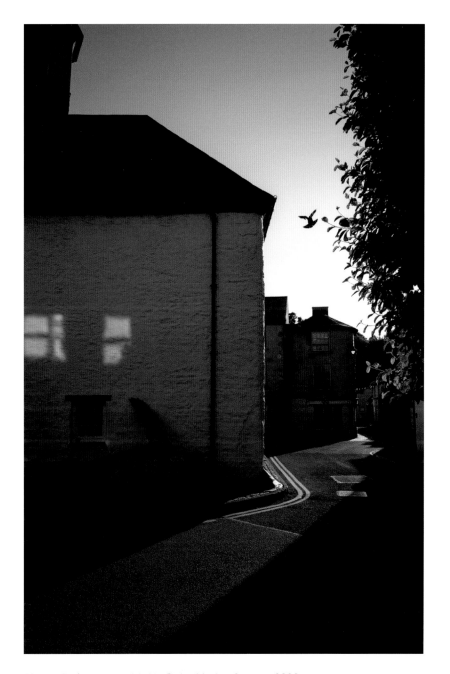

**Above:** Early morning bird in flight, Market Square, 2020.

**Opposite:** Still dawn, Kinsale harbour, 2021.

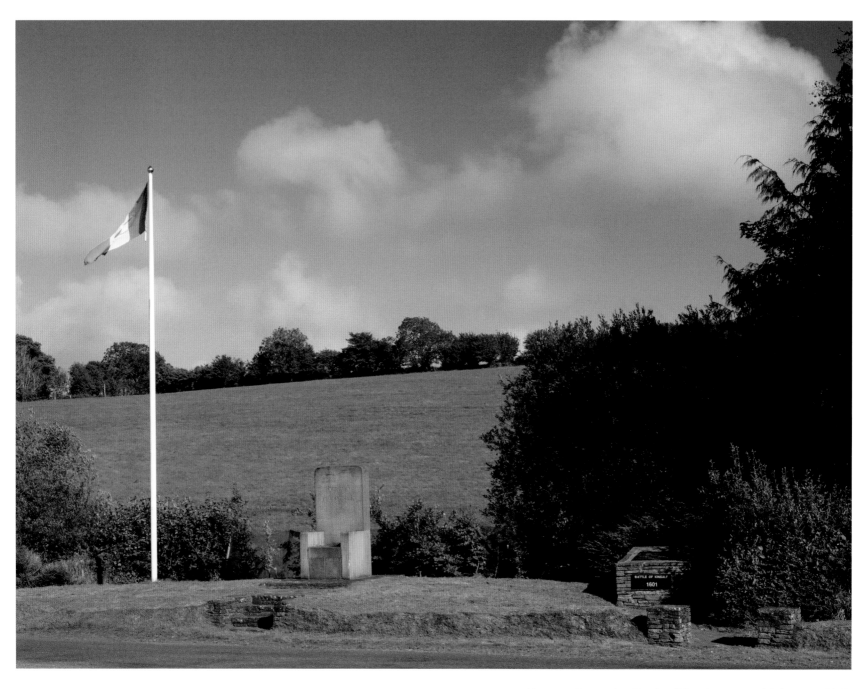

**Above and opposite:** Battle of Kinsale memorial, Milewater, 2020.

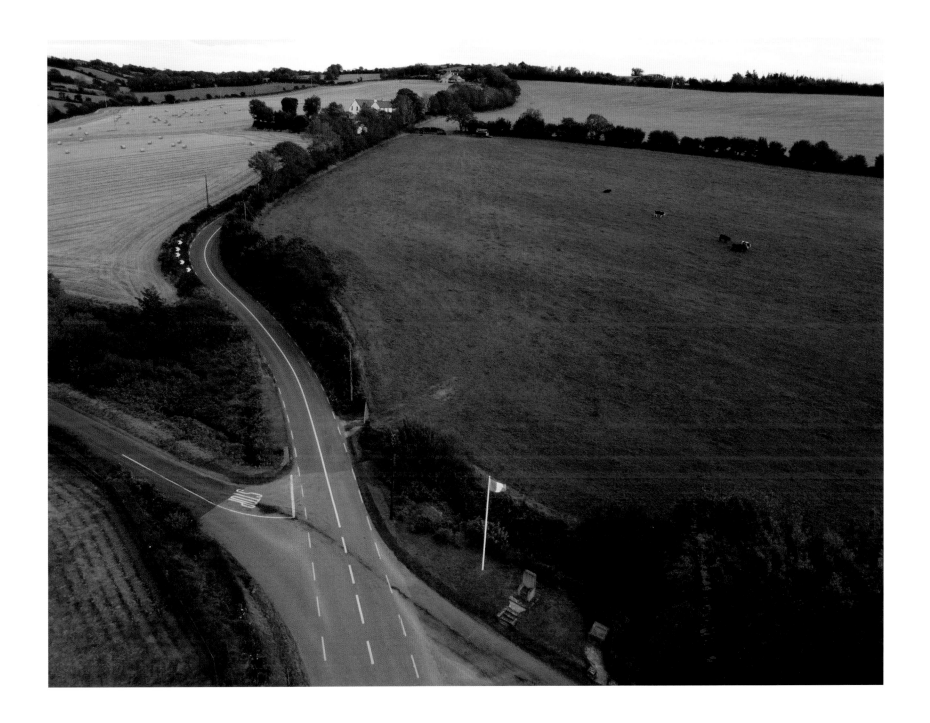

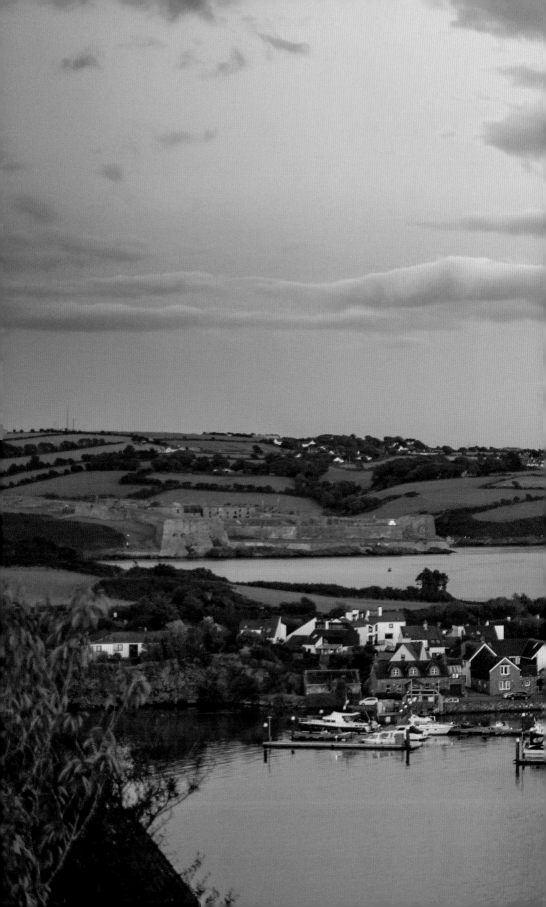

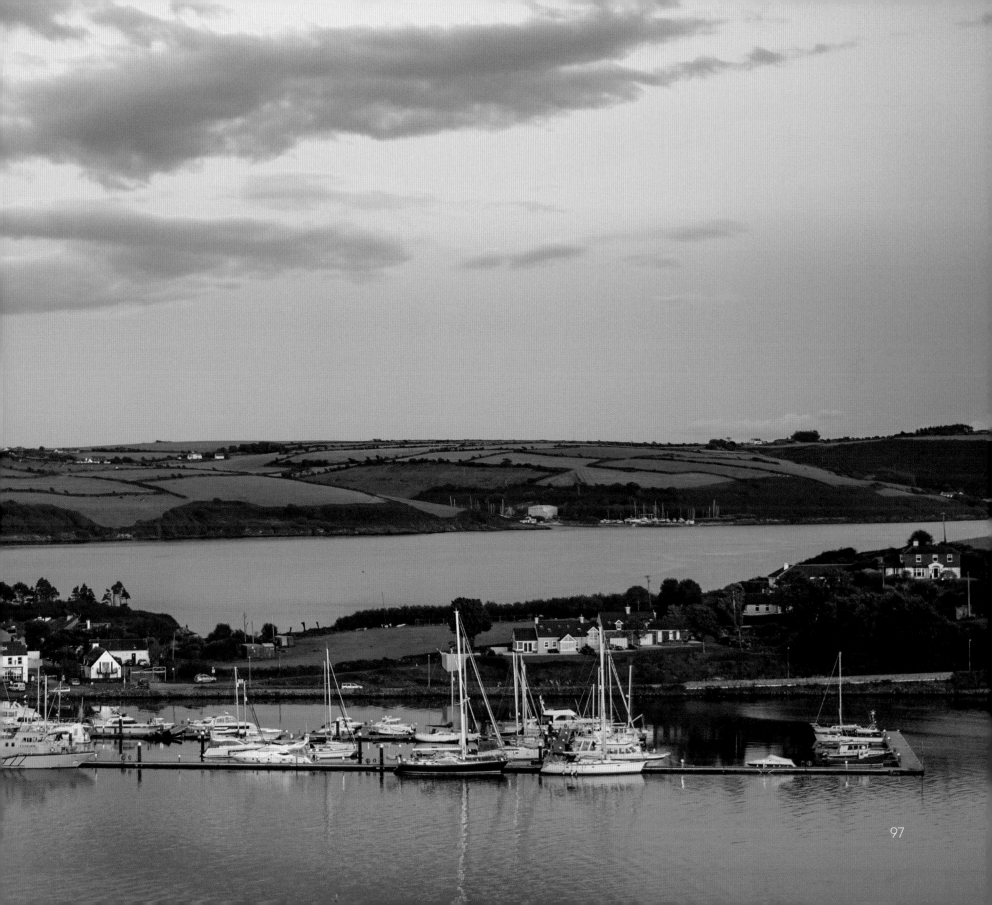

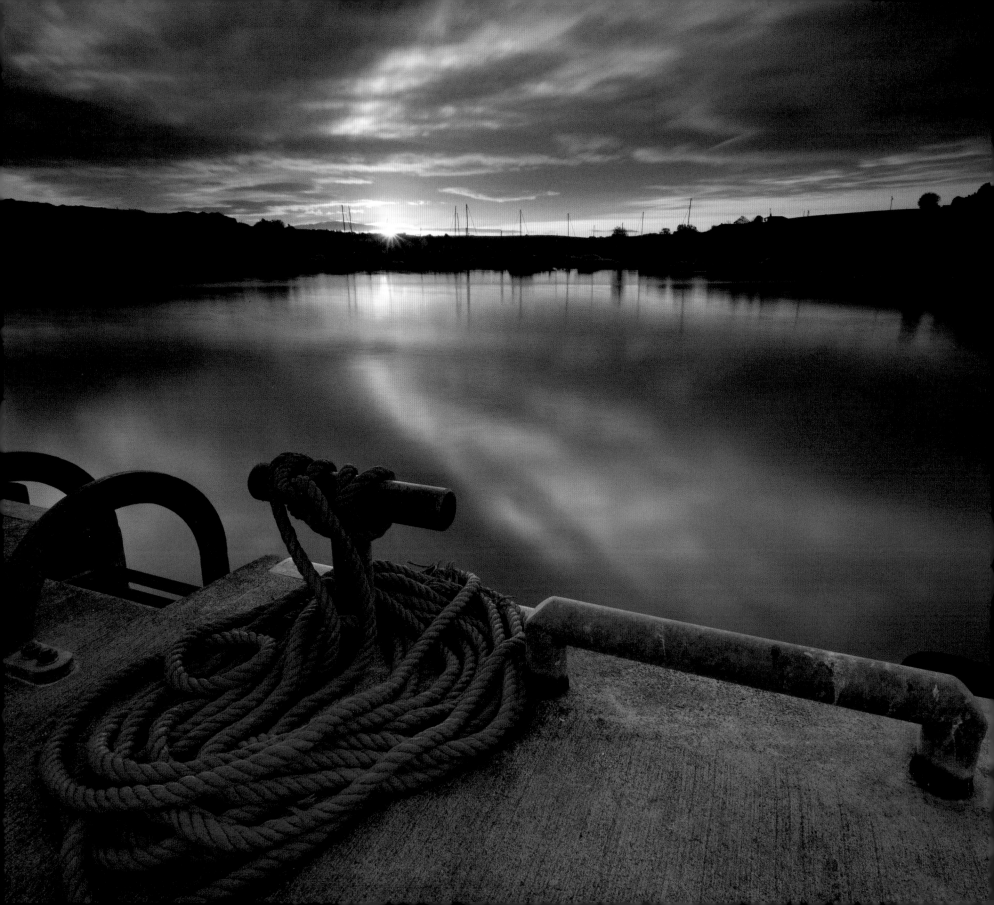

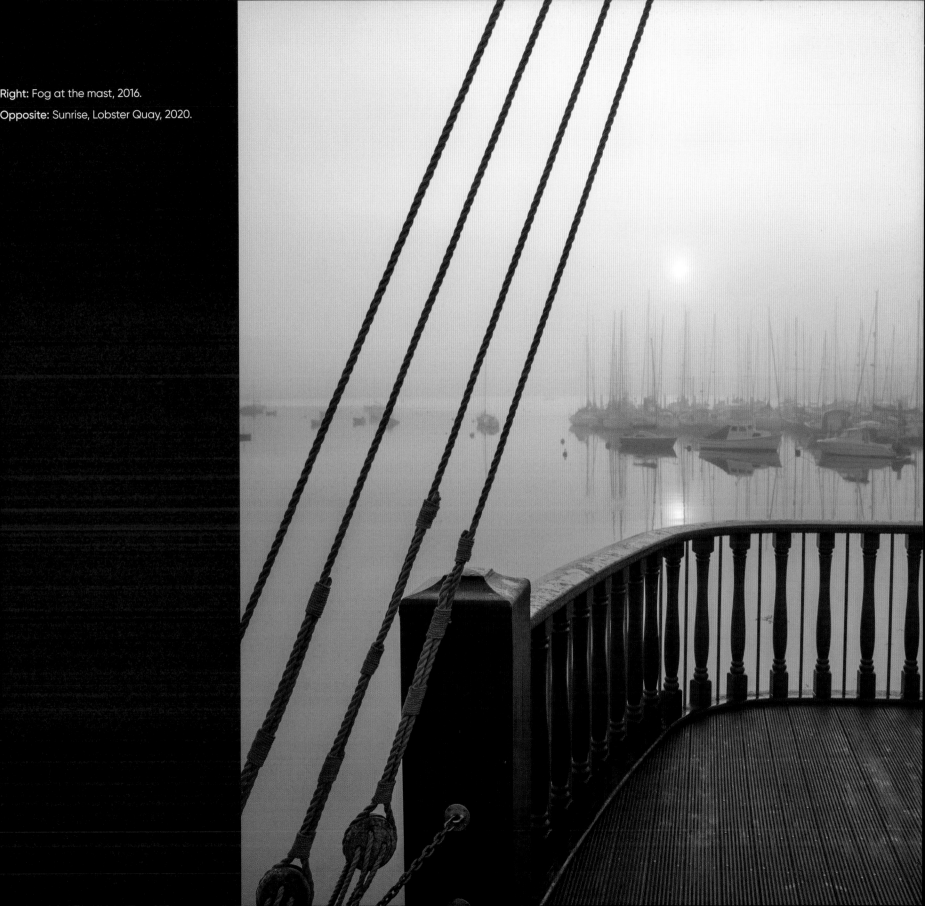

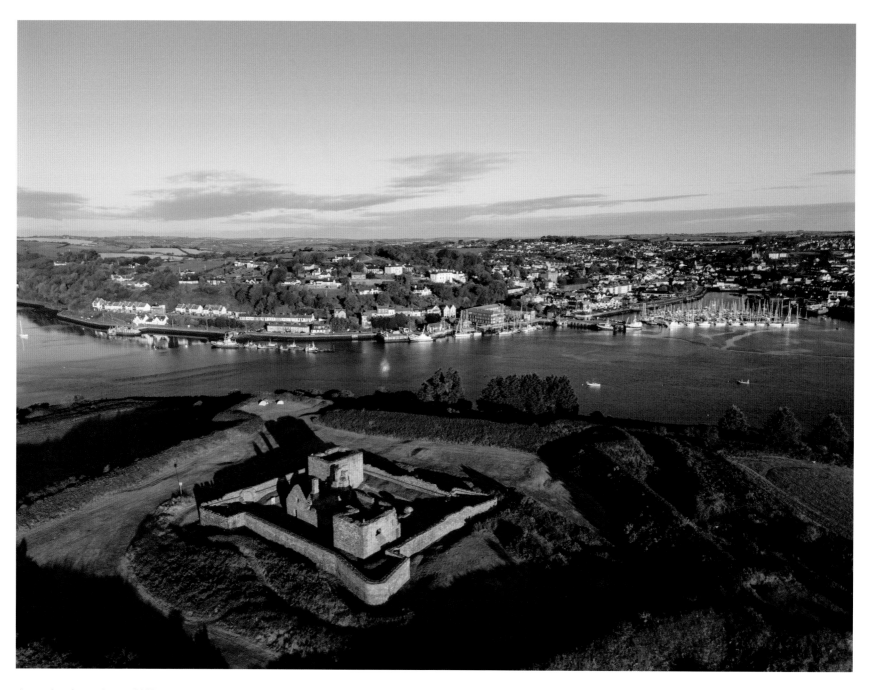

Jamesfort from above, 2021.

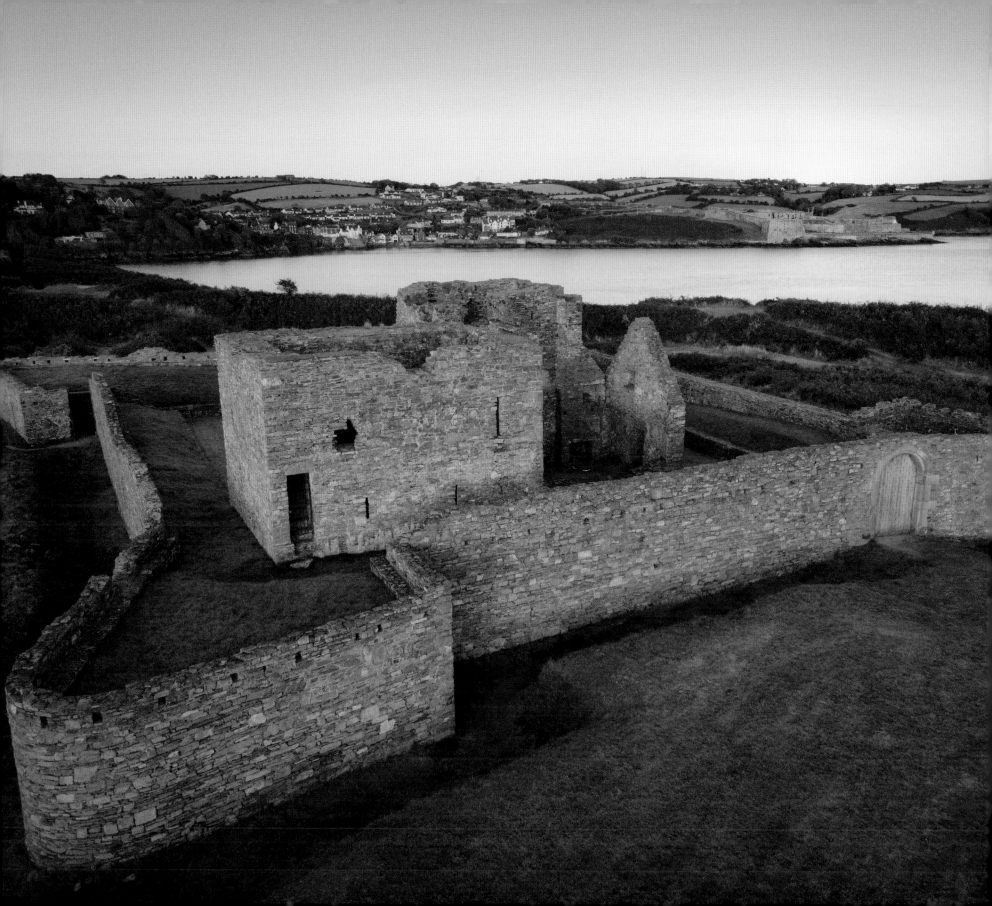

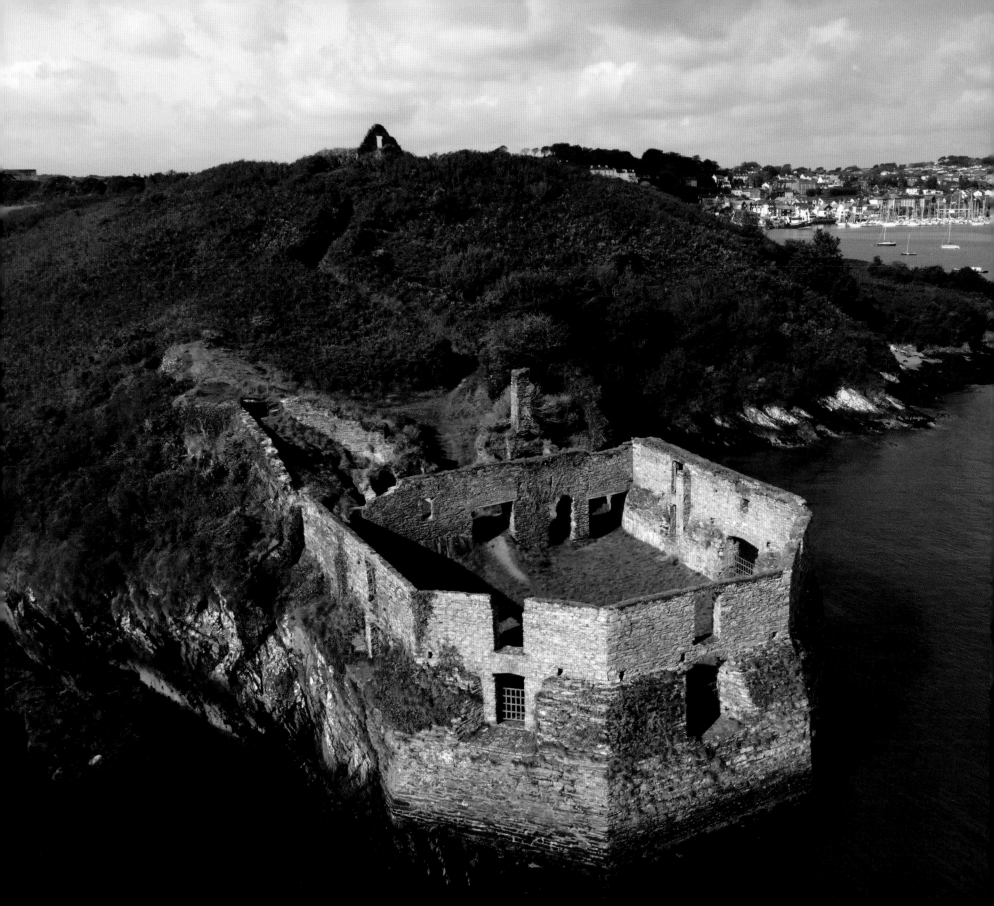

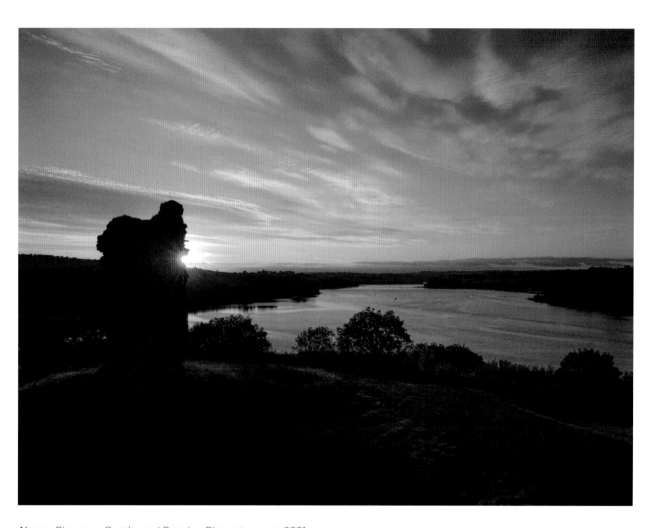

**Above:** Ringrone Castle and Bandon River at sunset, 2021.

**Opposite:** The Blockhouse, Jamesfort, 2021.

*To take photographs is to hold one's breath when all faculties converge in the face of fleeting reality. At that moment, mastering an image becomes a great physical and intellectual joy.*

Henri Cartier-Bresson
*The Mind's eye* (1976)

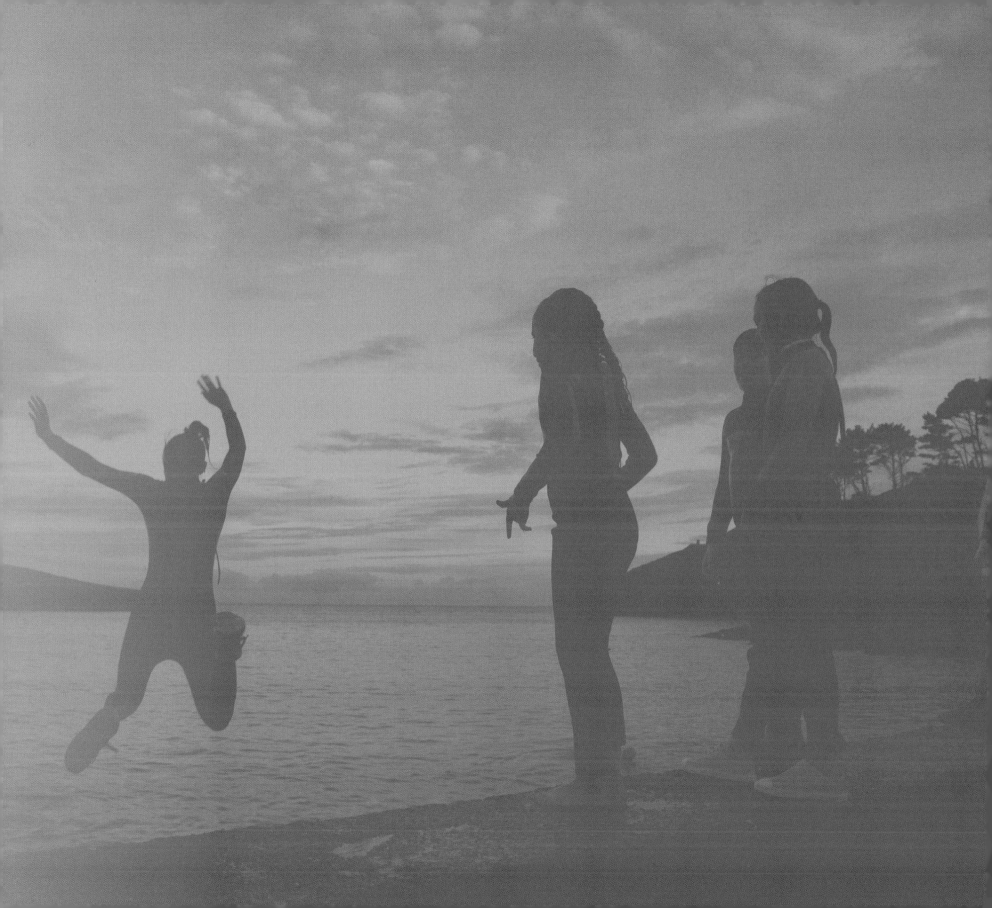

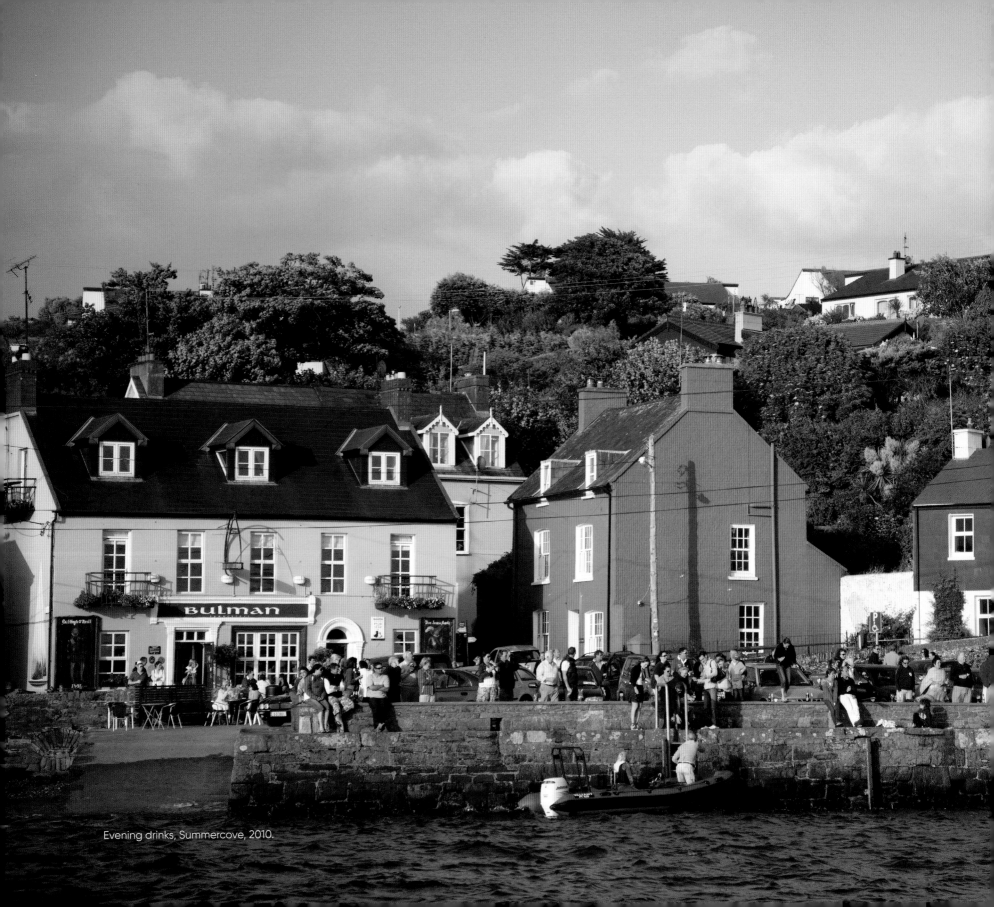

Evening drinks, Summercove, 2010.

# 05

## Light and Life

'But sure, it always rains for the Regatta,' I was assured. The sun shone as families gathered for the children's races and GAA skills demonstration up at the pitch – the day's first activity. Timmy, master of the loudhailer, got things going. 'OK, we'll start with the toddler's race. Can we have all toddlers to the starting line, please.' I glanced up at the blue sky as the toddlers were ushered to the line-up. It did not go unnoticed by my pessimist friend. 'You wait. It'll be down before the Water Carnival this afternoon,' I was told in short order, arms folded for emphasis. I was about to ask if she was thinking of having a go at the greasy pole when 'on your marks, set, go' got the race underway.

How we mingle says much about our communities. The people of Kinsale have welcomed both visitors and those who would live and work among them for centuries. On this August bank holiday weekend, there were families from all over – parents enjoying a casual chat while children cantered about. It was a scene that recalled countless others throughout human history and echoed a summer Renaissance visit to Kinsale 500 years earlier.

The racy tale of Archduke Ferdinand of Habsburg making an unplanned visit to Kinsale in June 1518 is a rare and fascinating account of Gaelic Ireland. It was written by Laurent Vital, a member of the Burgundian state household. He kept a detailed account of the voyage of Charles V, Holy Roman Emperor, to Spain from the Netherlands. The final part of this account describes the sea journey of Charles' younger brother Ferdinand back to the Low Countries. While the people of Kinsale were going about their business enjoying the early summer, an unplanned royal visit by a Renaissance prince was about to bring great excitement to the town.

A fleet of six ships carrying the 400-strong royal party set sail from Santander in northern Spain in fair May weather. It should have been a pleasant summer cruise north, but a violent storm was brewing out in the Bay of Biscay. Savage winds and seas threatened to submerge the ships, and such was the ferocity and fear it generated that the party's elites vowed to go on pilgrimage if they were spared. By the time the storm had eased, five of the six ships that had managed to stay together were blown out into the north Atlantic. Eleven days into the voyage, exhausted, hungry and thirsty, they made for Ireland and entered Kinsale harbour on Sunday, 6 June 1518.

By then, Kinsale was a well-established trading port and walled town. Soon after the Normans took over, a market began, leading to a charter in 1334. This copper-fastened its position as a key harbour for trade and commerce in south Munster. Vital's account of the four-day royal visit to Kinsale in 1518 is exceptionally engaging and human. It has the genuine curiosity of a traveller who writes about the people and scenes he encounters with humour and good nature. He describes the people and customs of the time and paints a vivid picture of Gaelic society before the Tudor invasions and dark centuries that were to come.

To Vital's eyes, the dress of the Irish was of particular interest. His role in the royal household appears to have been in wardrobe, so he was in tune with the distinctive fashion of the townspeople. He goes to considerable lengths to describe the dress and hairstyles of both men and women of different ages. He sees this as exotic and strange, but shows enough humility to note that 'we seemed as strange to them as they to us' and that there are 'as many different fashions and customs as there are countries'. In describing the women's dress, he notes the long chemises open to the waist and the custom of bare chests being the norm. Besides this fascination with women going bare-breasted, Vital regards them as virtuous and beautiful, in sharp contrast to disparaging English accounts of the time, which often describe the Irish as dirty and half-naked. Vital also describes hearing a high mass sung in the Irish style and witnessing an early morning clandestine marriage in St Multose churchyard. While walking in the graveyard, he saw a couple – 'a savage and young girl' –approach. The man then seized the girl and dragged her into the churchyard, where he led her to the door, making the sign of the cross and forcing her to do the same after a scuffle. They then continued on their way hand in hand, and Vital assumed that he had seen some sort of bizarre wedding.

As word spread of the presence of the fifteen-year-old prince and his noble entourage from Europe, the town council and local lord arranged entertainment with singing, harp music and a swimming display, reminiscent of the regatta tradition that would evolve centuries later. This story shows how visitors were welcomed and offered a *céad míle fáilte*, a tradition of hospitality which continues today.

The account of the voyage, and particularly the unplanned stopover in Kinsale, laid the groundwork for a later Spanish expedition that would alter history. Often referred to as the 'last armada', a fleet of thirty-five ships left Lisbon in September 1601, destined for Ireland. Earlier armadas, starting in 1588, had proved disastrous for the Spanish in their attempts to gain a stronghold in Britain. This fleet was under the command of Don Juan Del Águila, a veteran general who was presented to King Philip II with the words, 'Your Majesty, meet a man born without fear.'

The aim was to take the port of Cork – the most important maritime base on the south coast. But again, the weather had other ideas. A strong gale swept the fleet as they neared the island of

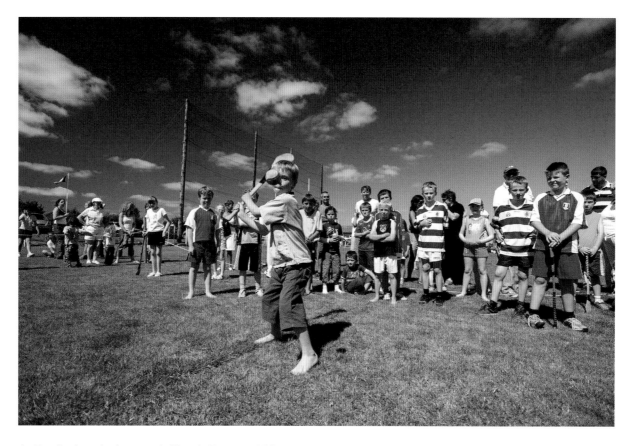

*An Puc Fada* – the long puck, Kinsale Regatta, 2006.

Ouessant, off the western tip of Brittany, and they were dispersed. Eight or nine ships returned to Spain with 650 soldiers and much of the provisions, while the remaining fleet continued and landed in Kinsale in early October. The sight of twenty-six Spanish warships entering the harbour must have had local jaws agape. The 3,000-strong expeditionary force quickly took control of the town, meeting

little English resistance. When news reached Queen Elizabeth I ten days later, she rapidly dispatched Charles Blount, Lord Mountjoy, her veteran commander in Ireland. He had been sent to deal with rebellious Irish chieftains, especially Hugh O'Neill and his son-in-law Red Hugh O'Donnell, both now on the march to join the Spaniards.

After a 100-day siege during a bitterly cold winter, the stage was set for a tragedy of Shakespearean proportions. On Christmas Eve, the Irish made to move against the English – to be joined by the besieged Spanish – but the English were prepared. Poor communication between O'Neill and O'Donnell's men led to badly coordinated skirmishes, and the agreed signal for d'Águila to join the battle never came. Mountjoy's superior tactics and cavalry subsequently routed the Irish on open ground, and the battle was over in three hours.

A few days later, having realised the extent of the Irish defeat, d'Águila offered parley and agreed terms with Mountjoy. The English gave the Spaniards an honourable surrender, and they set sail to A Corûna with their military colours intact. The Irish chieftains were scattered – O'Donnell also headed to Spain but died there soon after. O'Neill was pursued back north by Mountjoy, eventually surrendering in 1603. The numerous accounts of the characters and events of this time show how the battle of Kinsale changed the course of history, and are endlessly riveting to read.

As the regatta activities continued up at the GAA field, hurlers lined up for the *Puc Fada*, the long puck – a competition to see who could drive the *sliotar* ball furthest in a single stroke. My attention remained on the toddlers' race, which was just underway. Our two-year-old daughter – new to the concept of a running race – delighted in the shouts of encouragement from the sidelines. She slowed to wave and savour the applause, oblivious to the dash towards the finishing line. The shared laughter and high-pitched excitement brought communal joy. I turned to my friend to have a final stab at converting her to optimism. 'Did you watch the fireworks last night?' I asked. 'Weren't they fantastic?' I further enthused. 'Not a patch on St Patrick's Day,' she replied, 'come on, the *Puc Fada* is on next.'

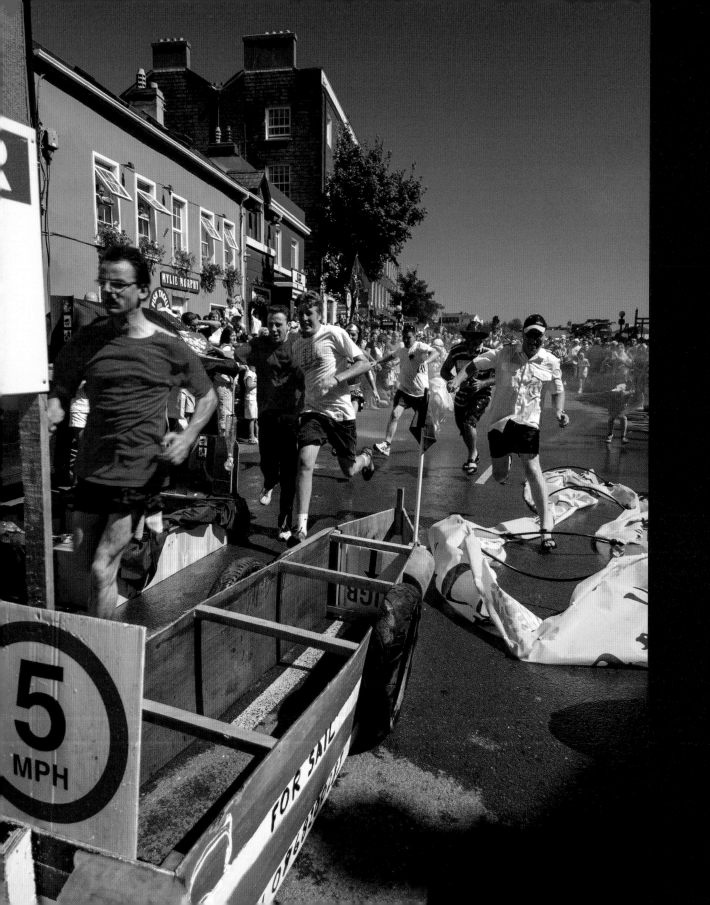

Road raft race, 2006.

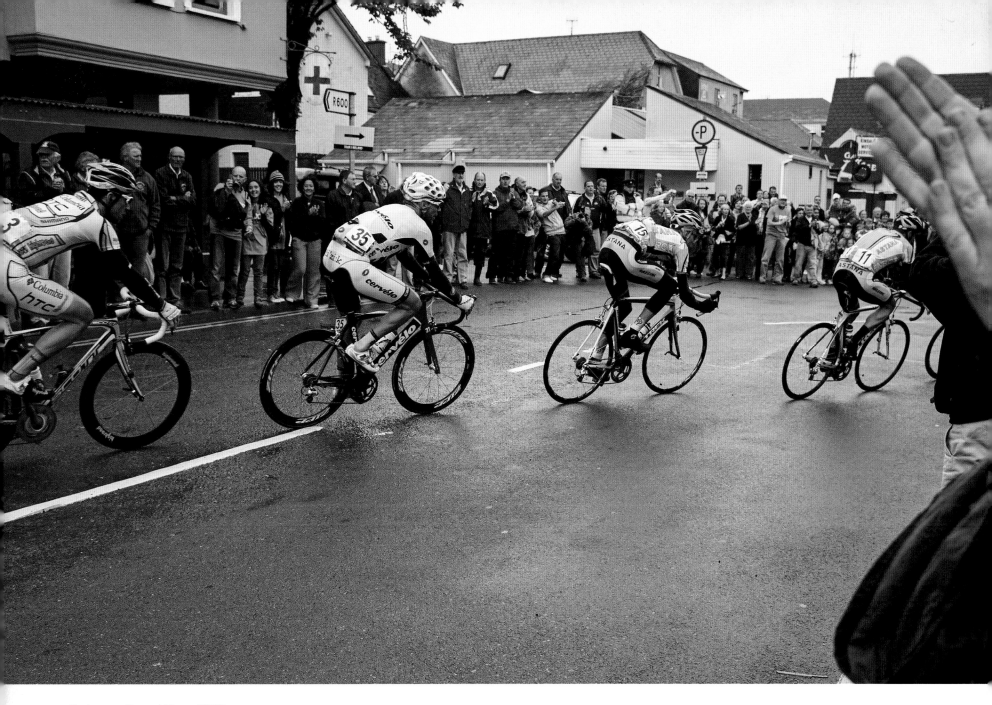

Cycle race, Emmet Place, 2009.

113

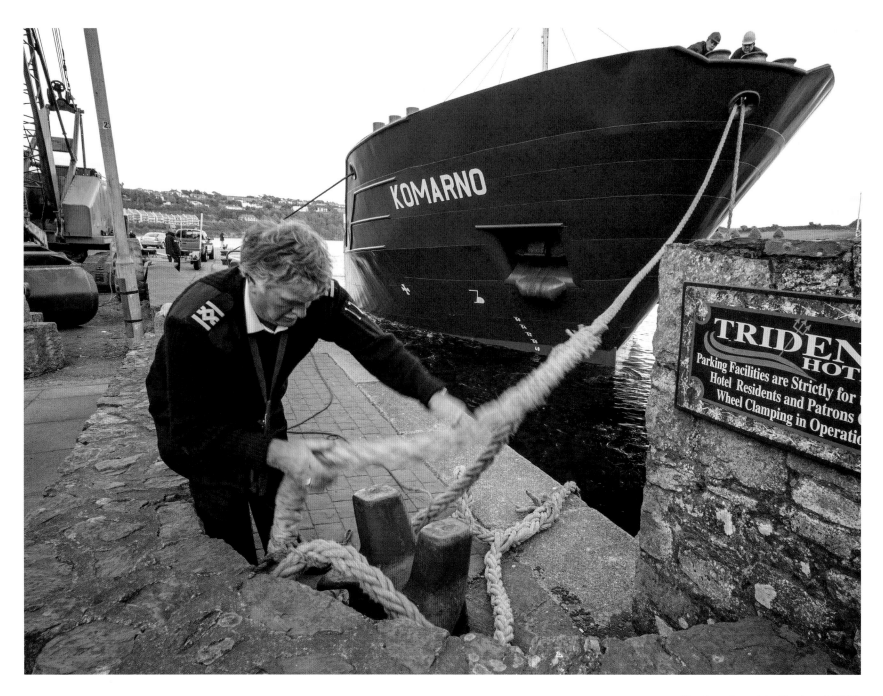

Coming alongside, Pier head, 2008.

Slipping past, 2009.

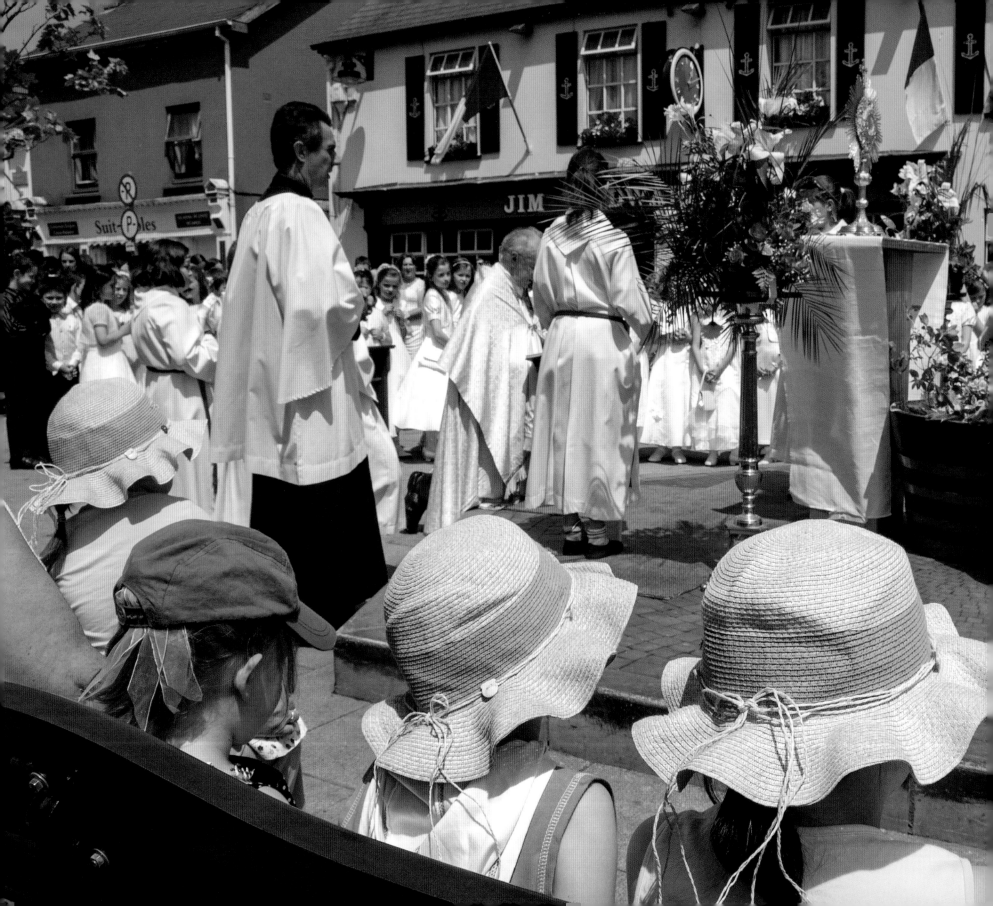

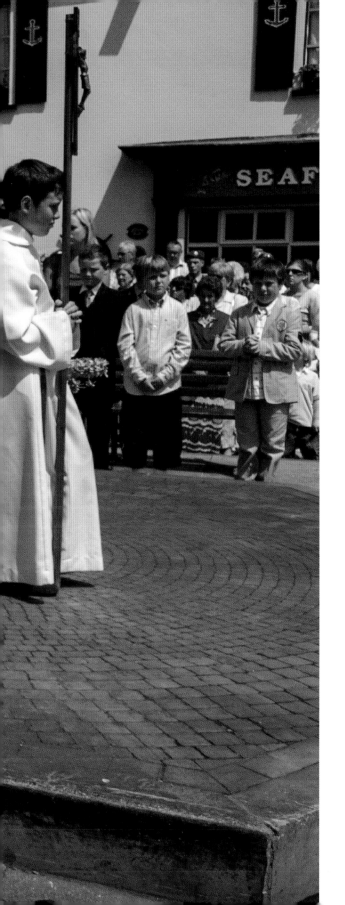
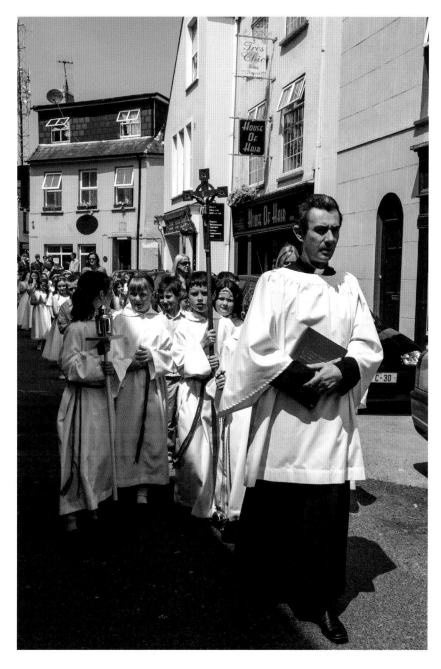

Corpus Christi procession, 2007.

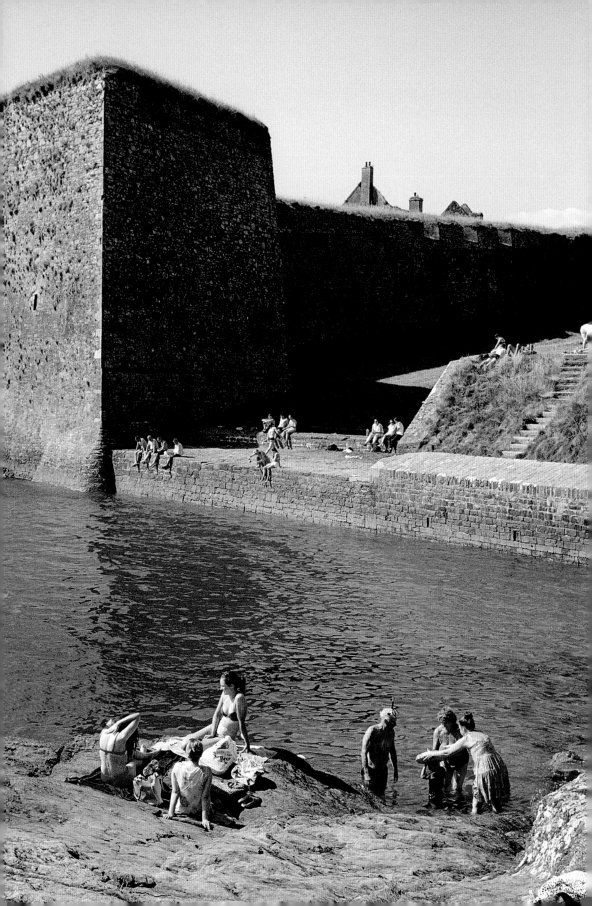

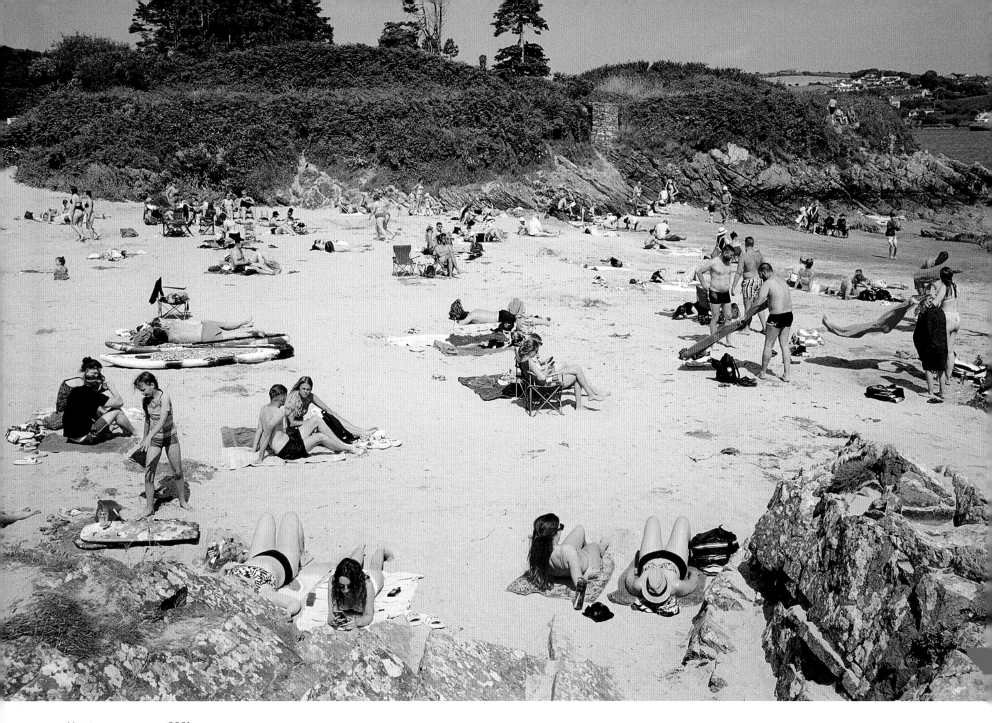

Heatwave, summer 2021.

Winter, Garretstown beach, 2022.

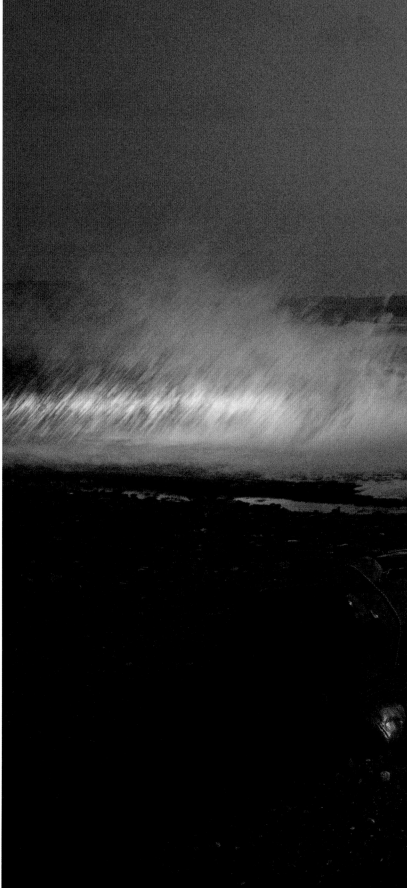

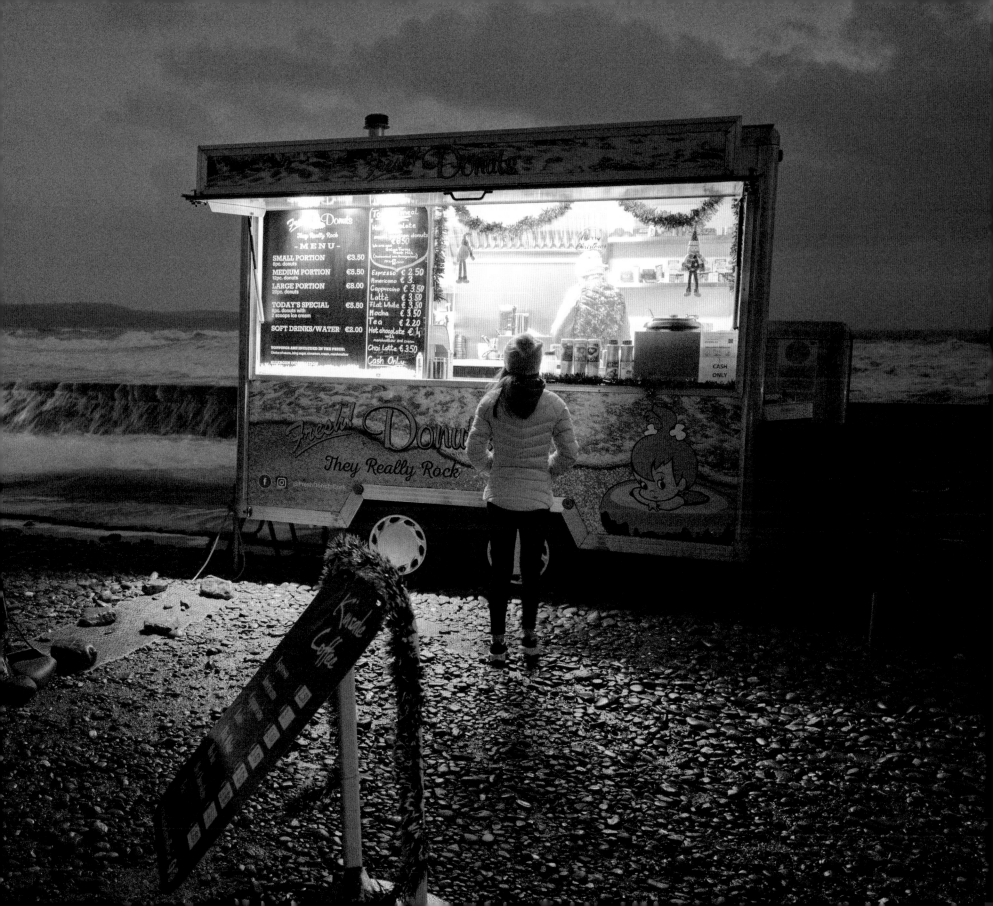

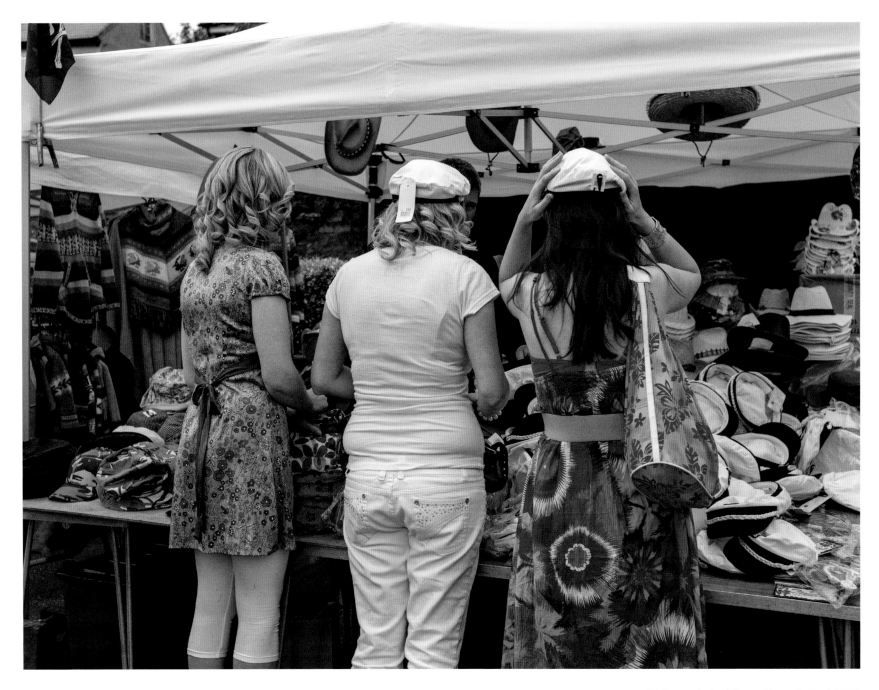

Trying on hats, Clipper Race festival, 2010.

Fish 'n chips at the bridge, 2021.

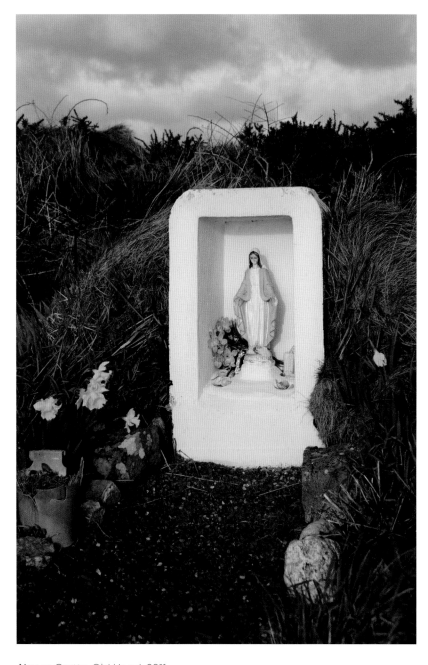

**Above:** Grotto, Old Head, 2011.

**Opposite:** Ballinspittle grotto, 2007.

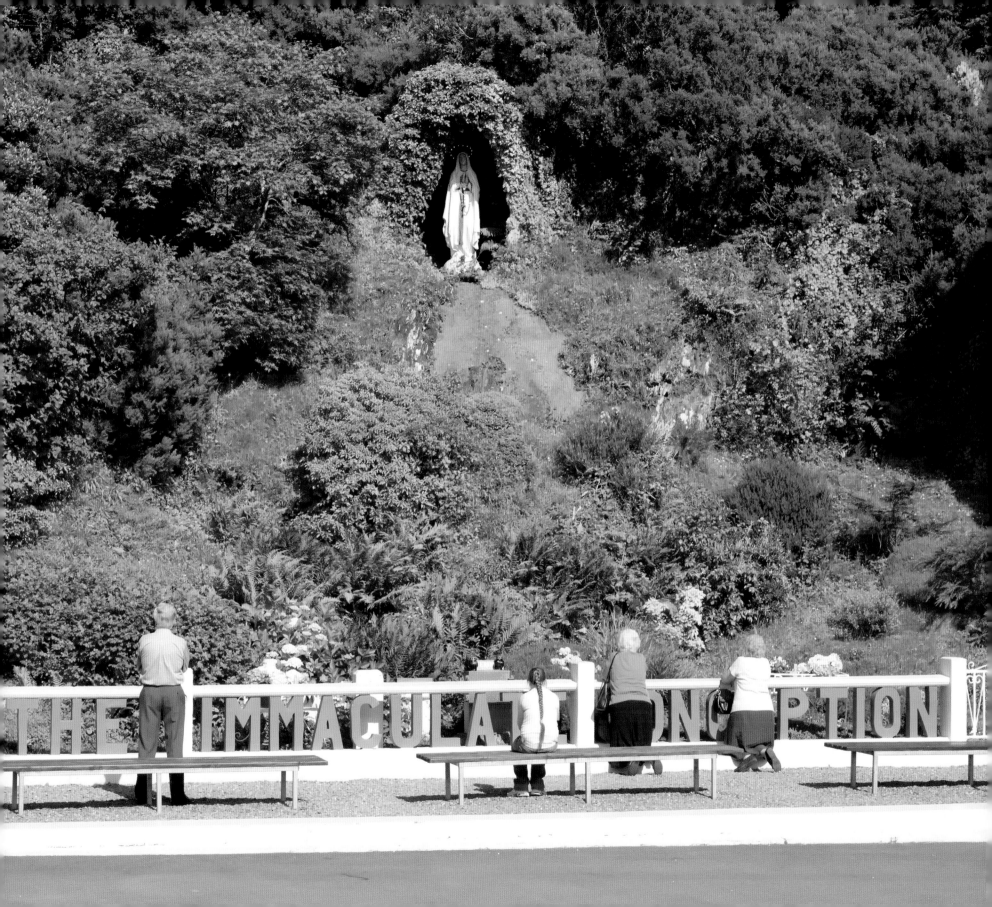

Discount store, Pearse Street, 2021.

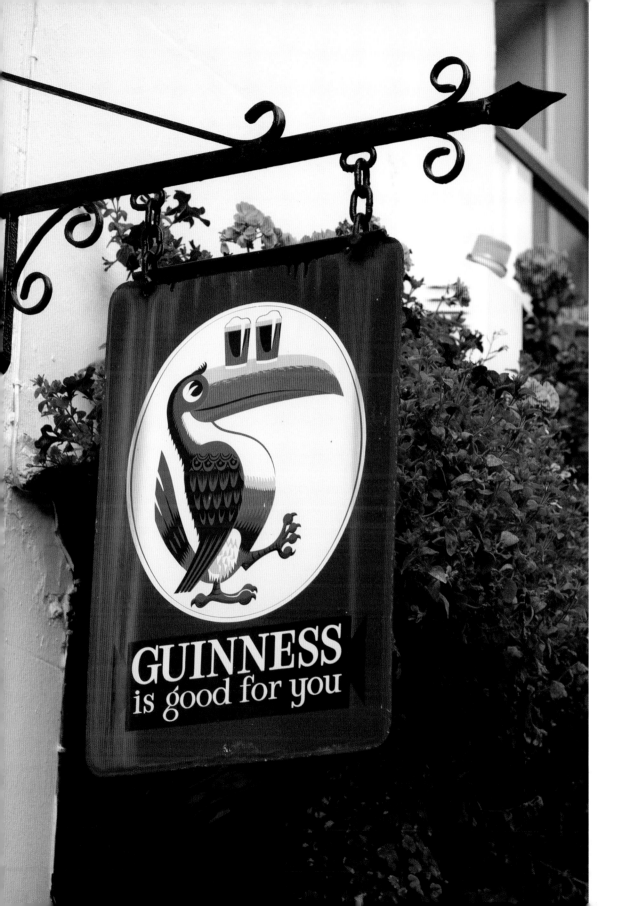

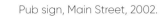
Pub sign, Main Street, 2002.

127

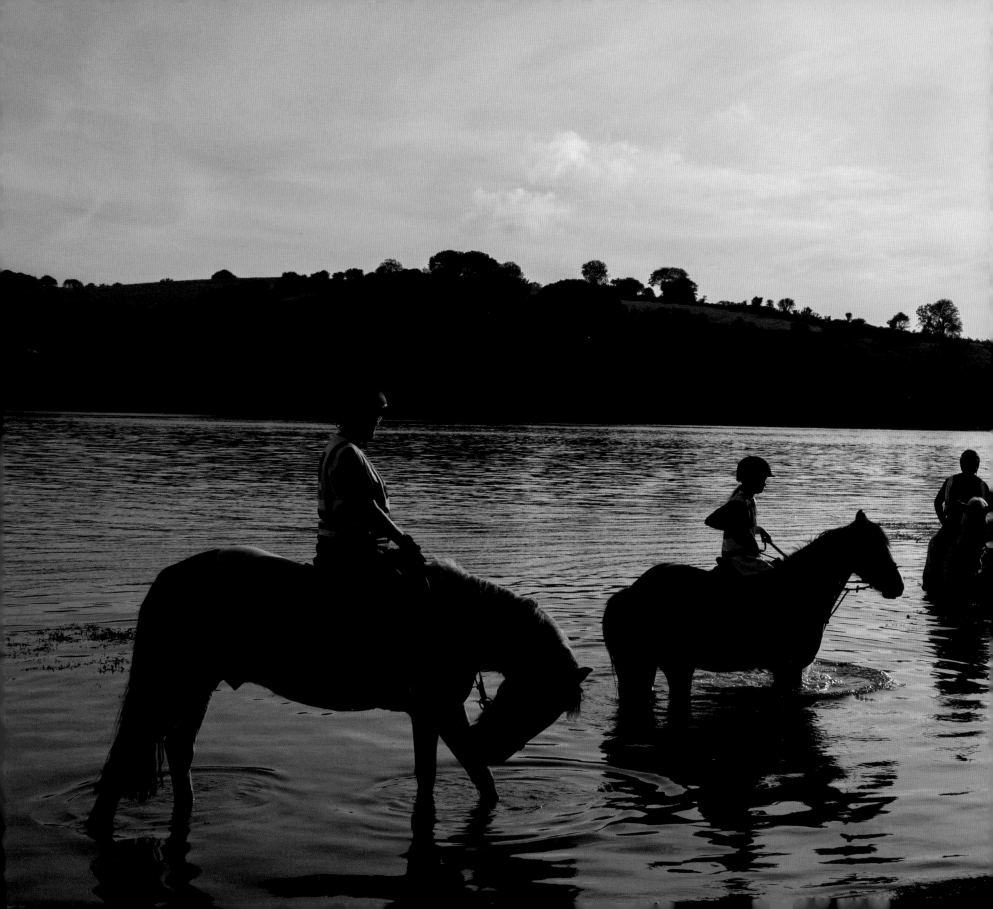

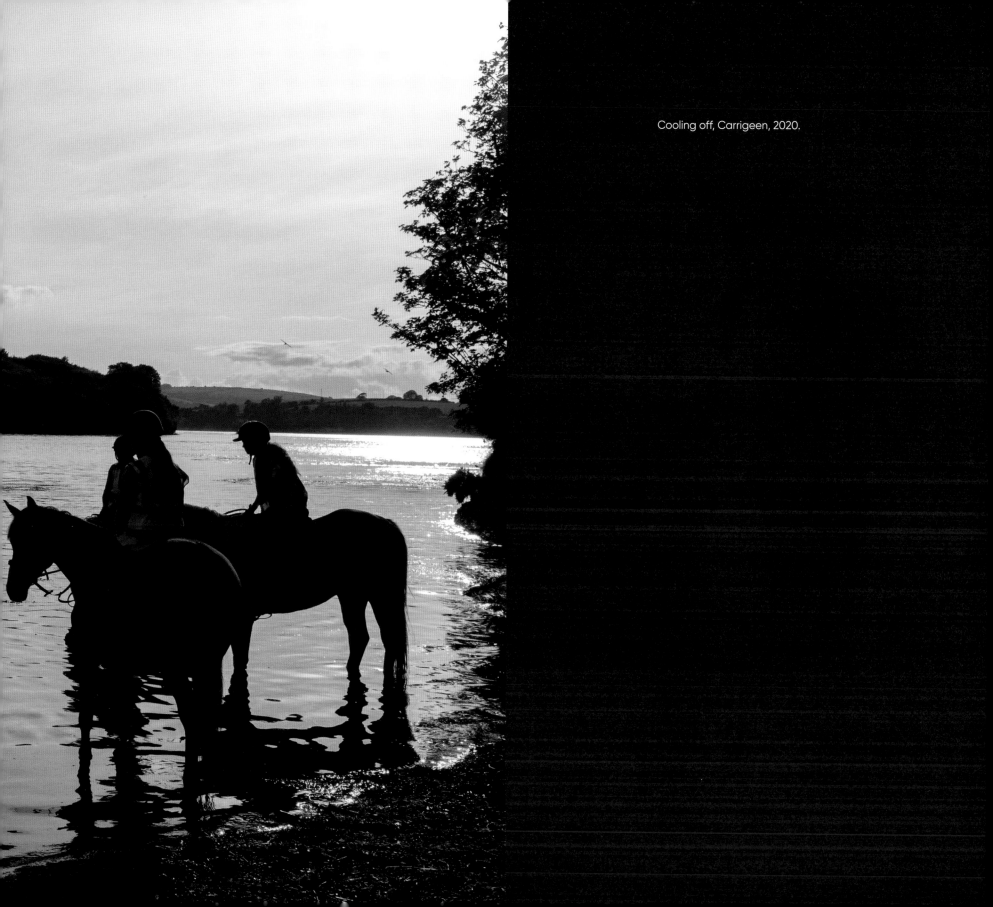

Cooling off, Carrigeen, 2020.

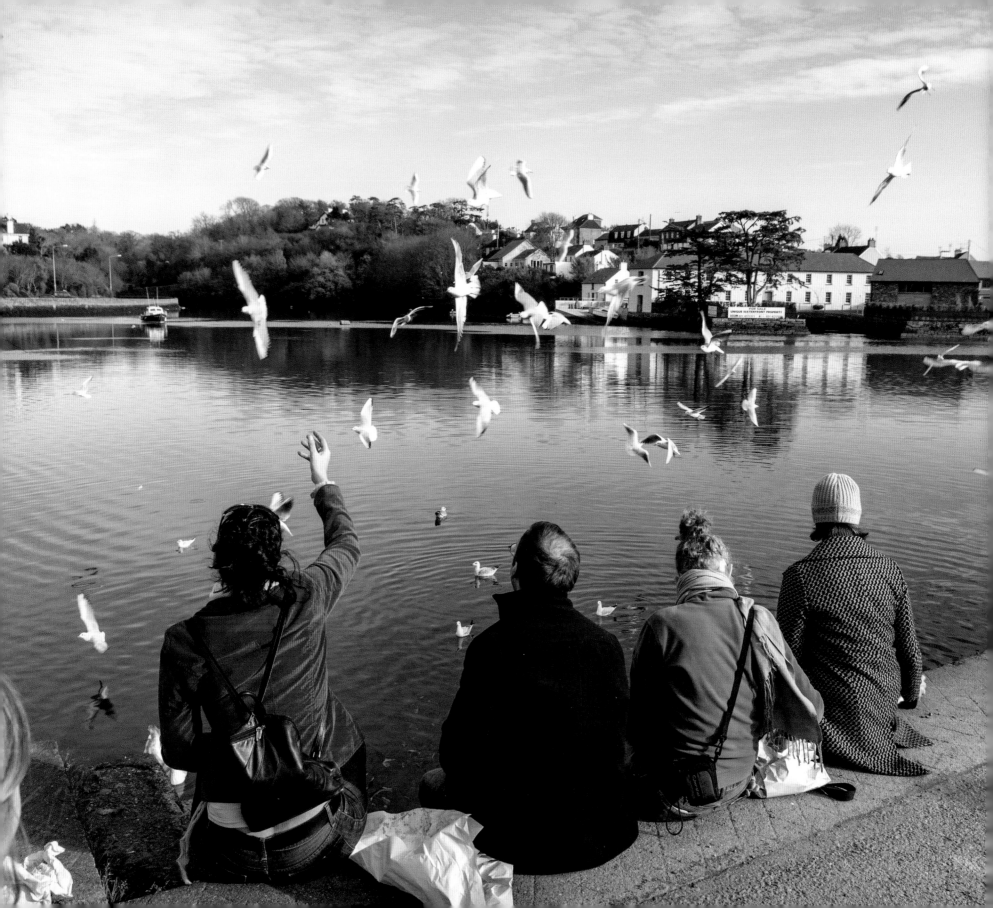

Right: Dinghies and flowers, Pier Head, 2012.

Opposite: Fish 'n chips on the pier, 2005.

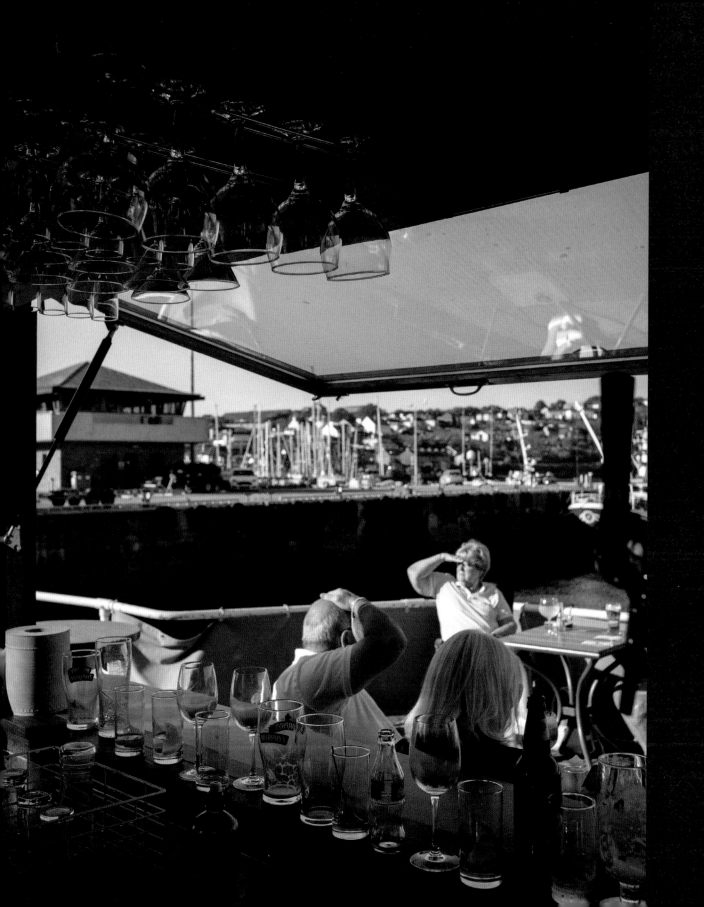

Summer drinks at the Trident, 2021.

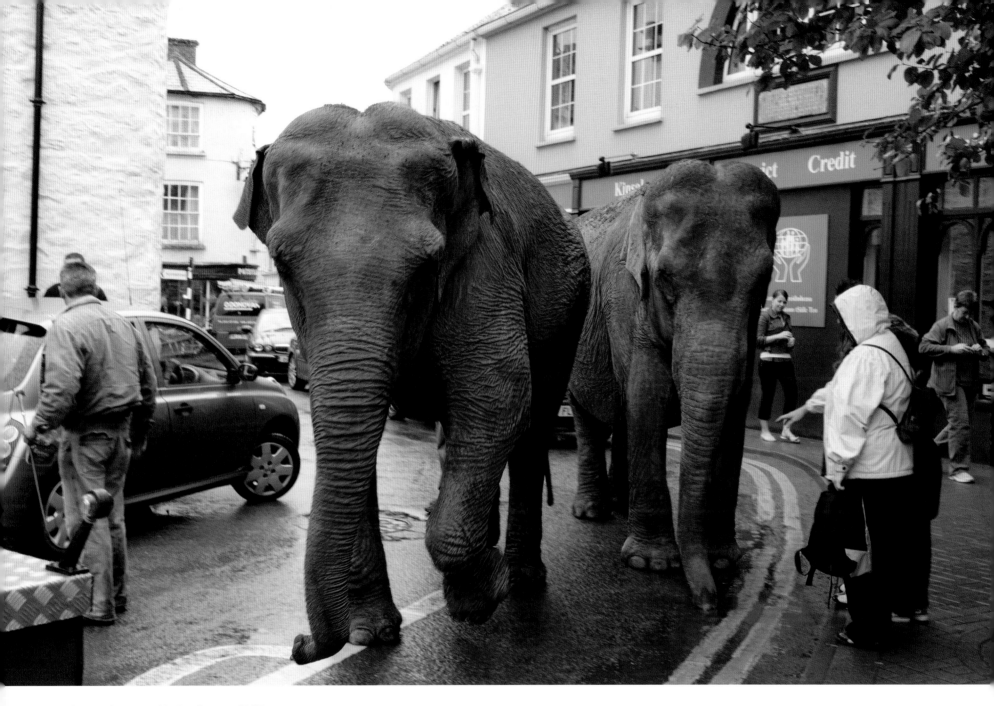

Circus elephants, Market Square, 2007.

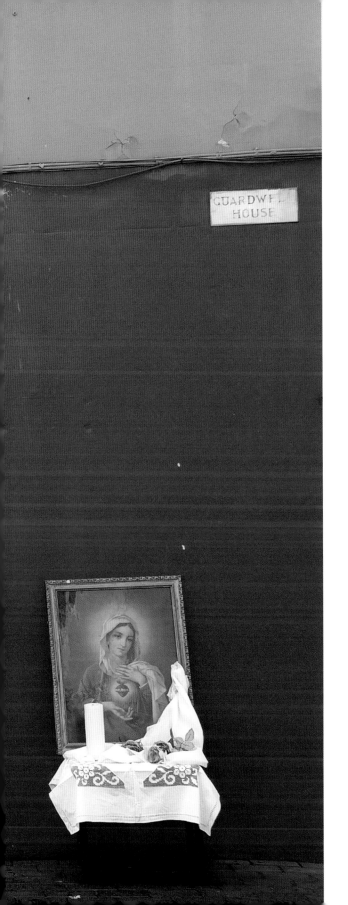

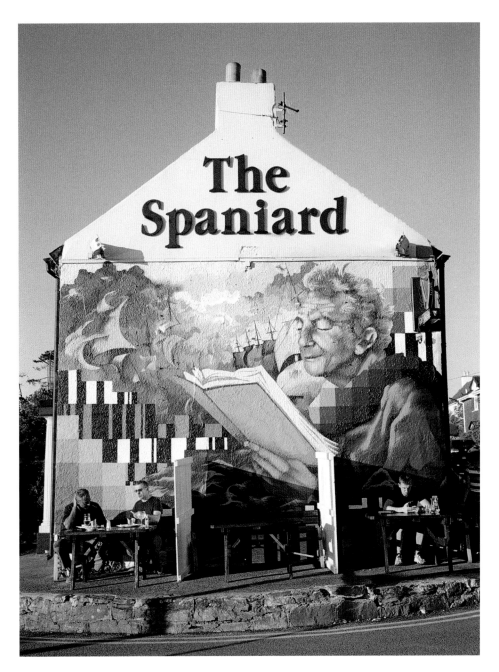

**Above:** Desmond O'Grady mural, The Spaniard, 2021.

**Opposite:** Corpus Christi Sunday, 2007.

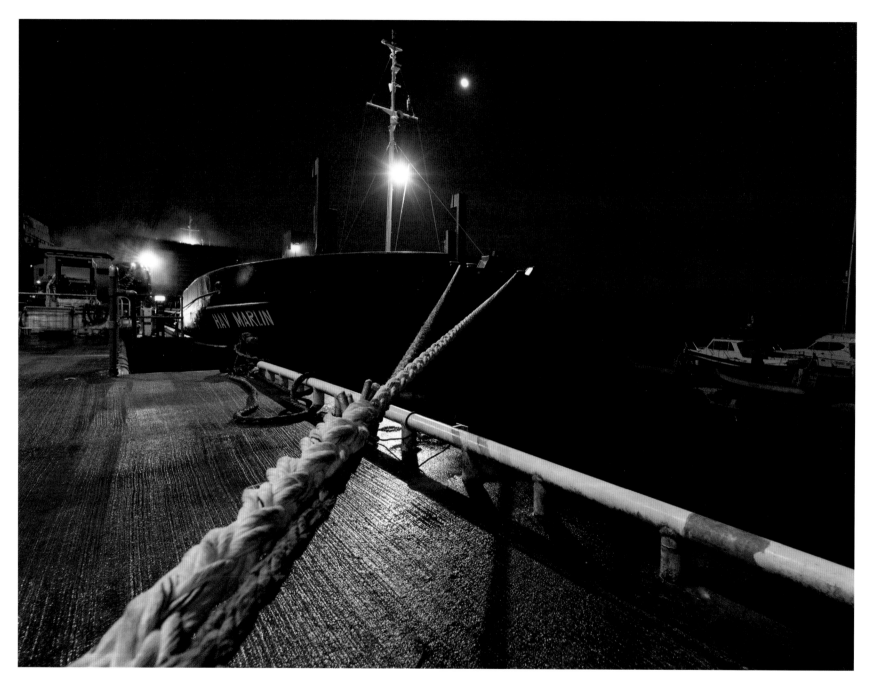

Coaster unloading at night, 2021.

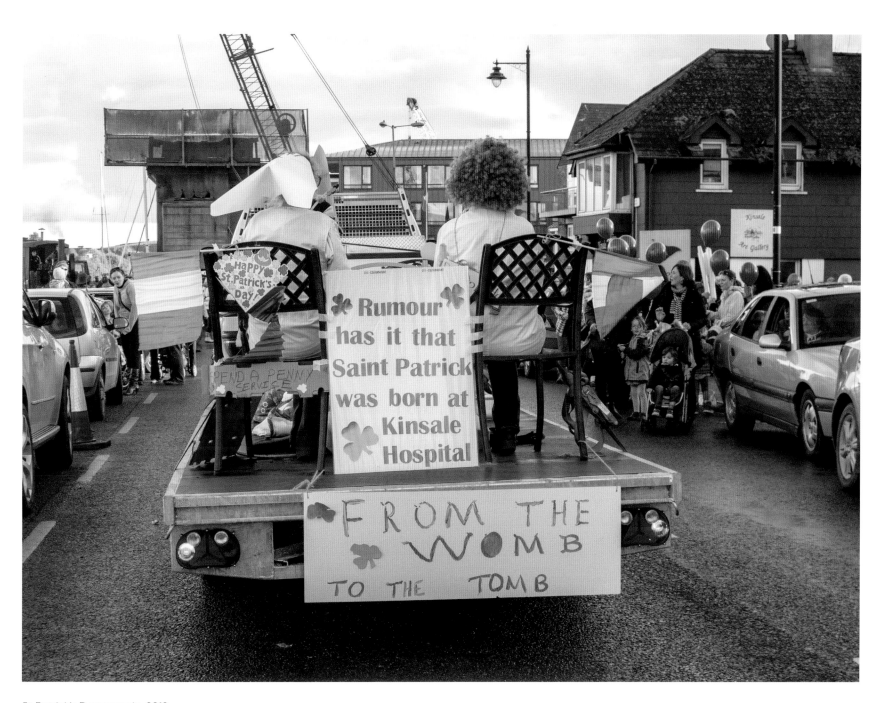

St Patrick's Day parade, 2012.

Jumping in at high tide, Sandycove, 2012.

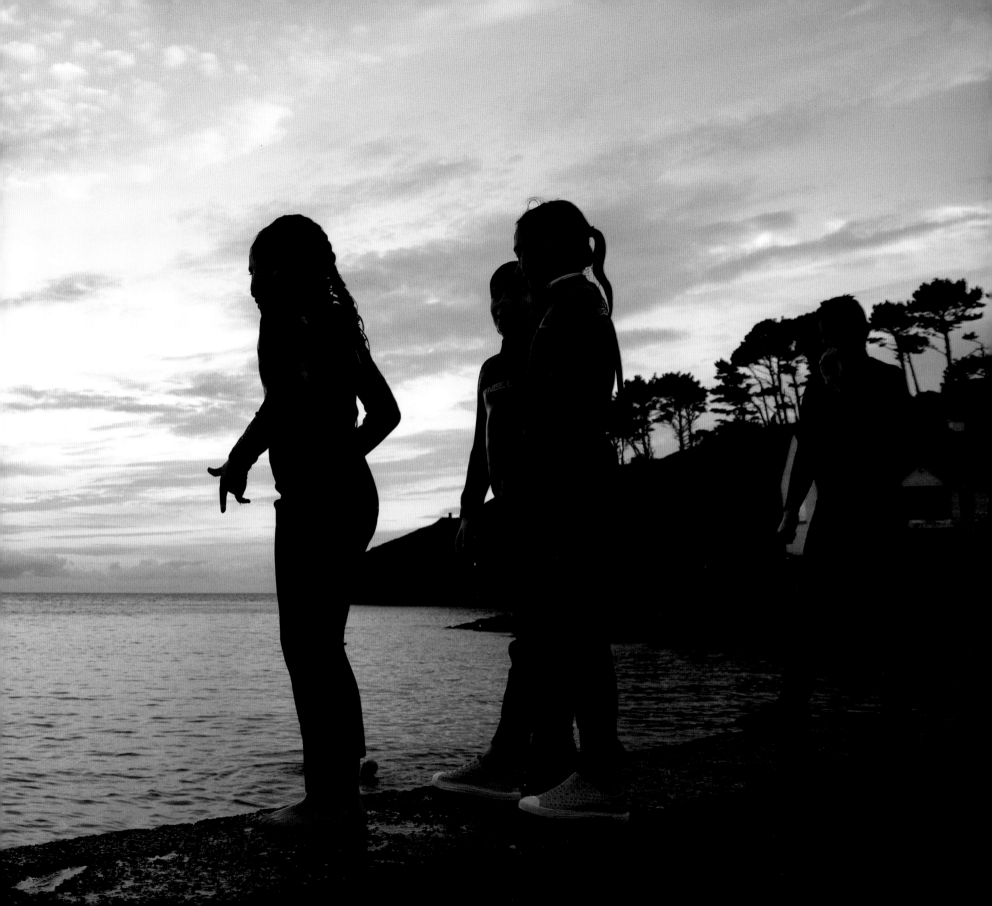

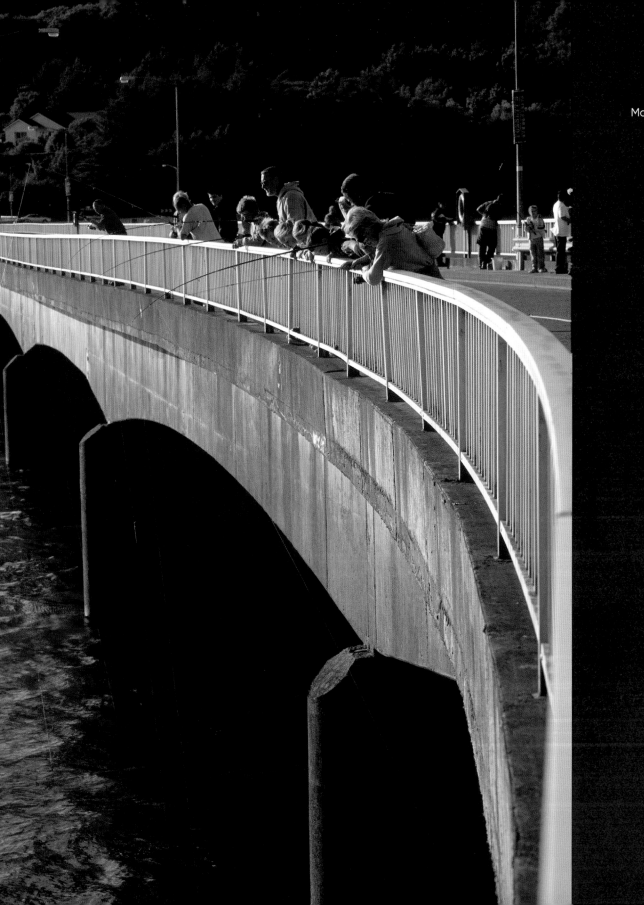

Mackerel fishing at the bridge, c. 1997.

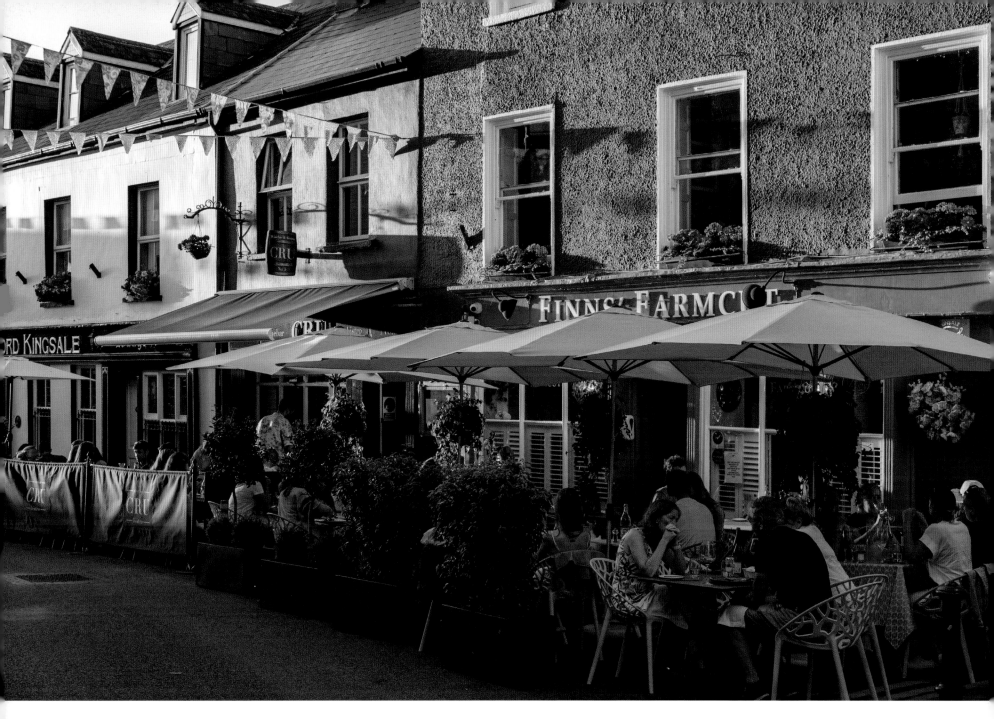

Outdoor dining, Main Street, 2021.

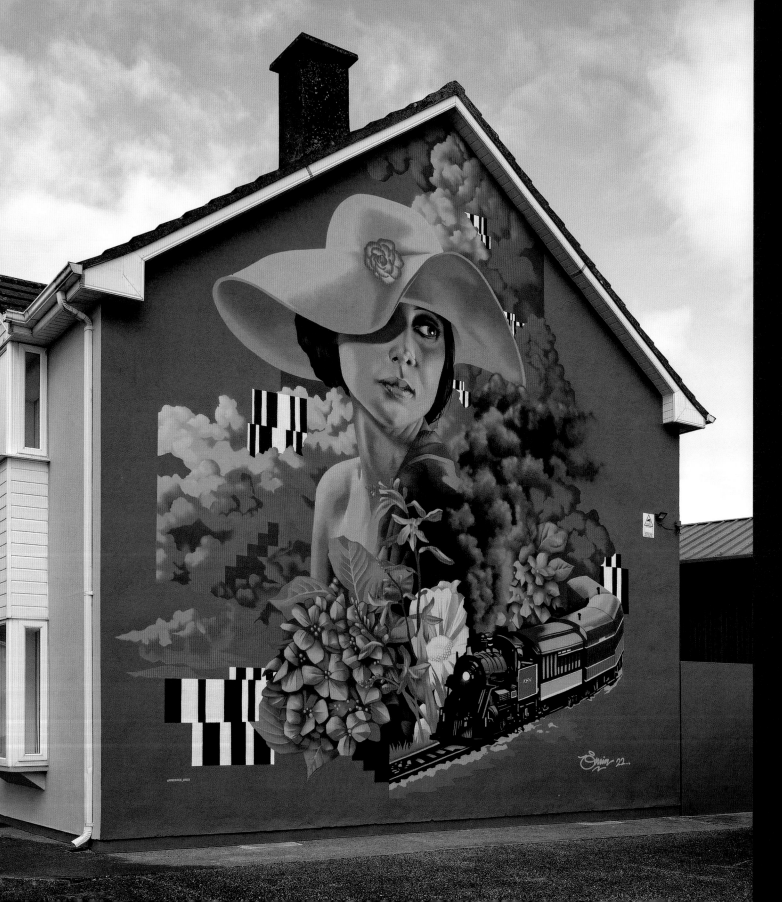

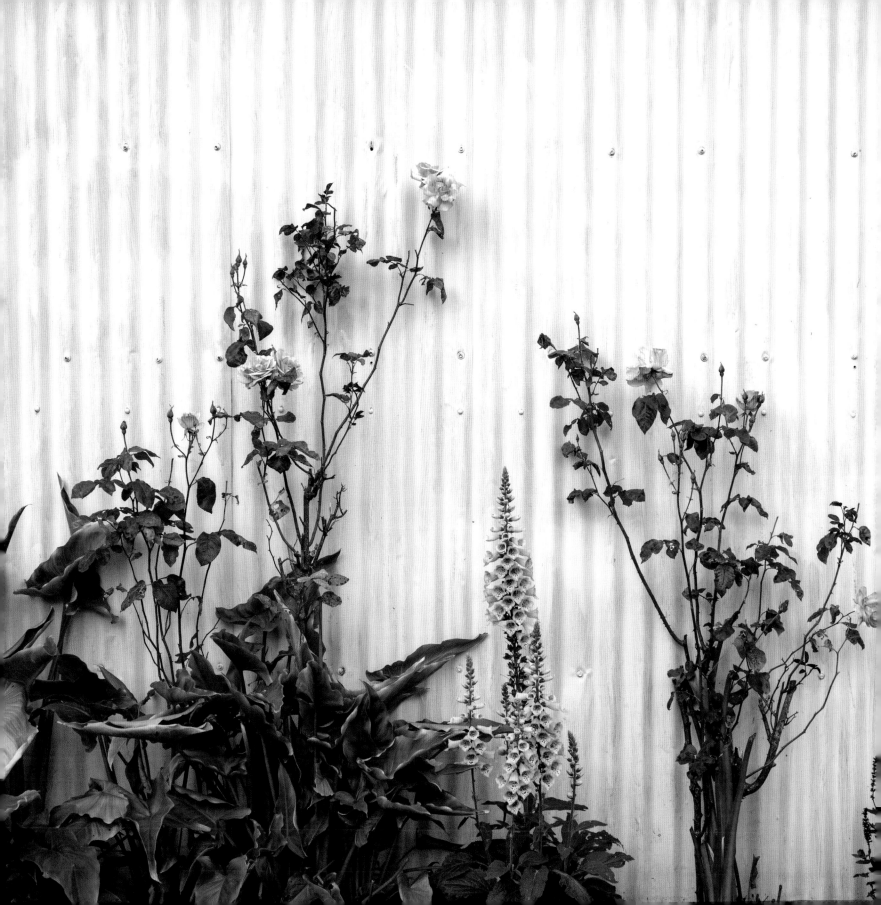

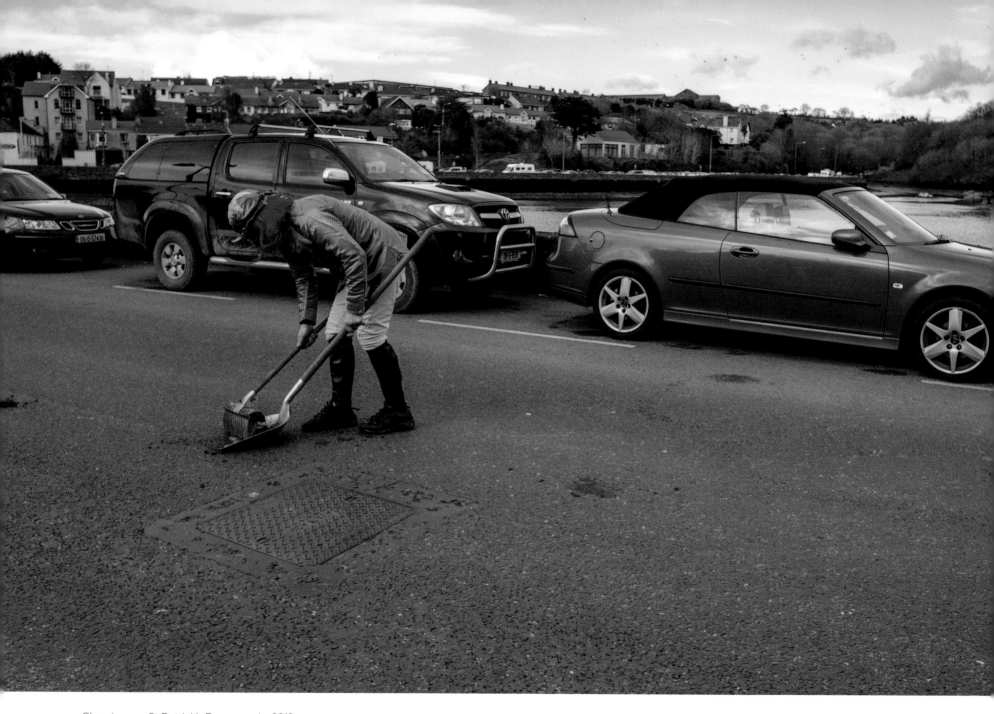

Cleaning up, St Patrick's Day parade, 2012.

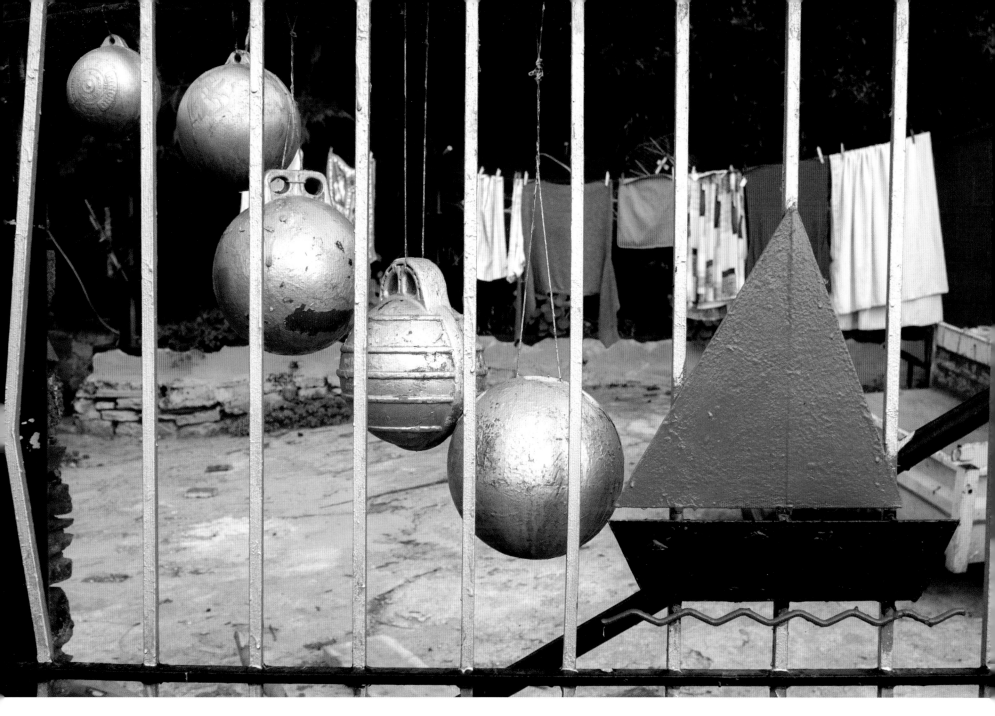

Buoys on a gate, World's End, 2010.

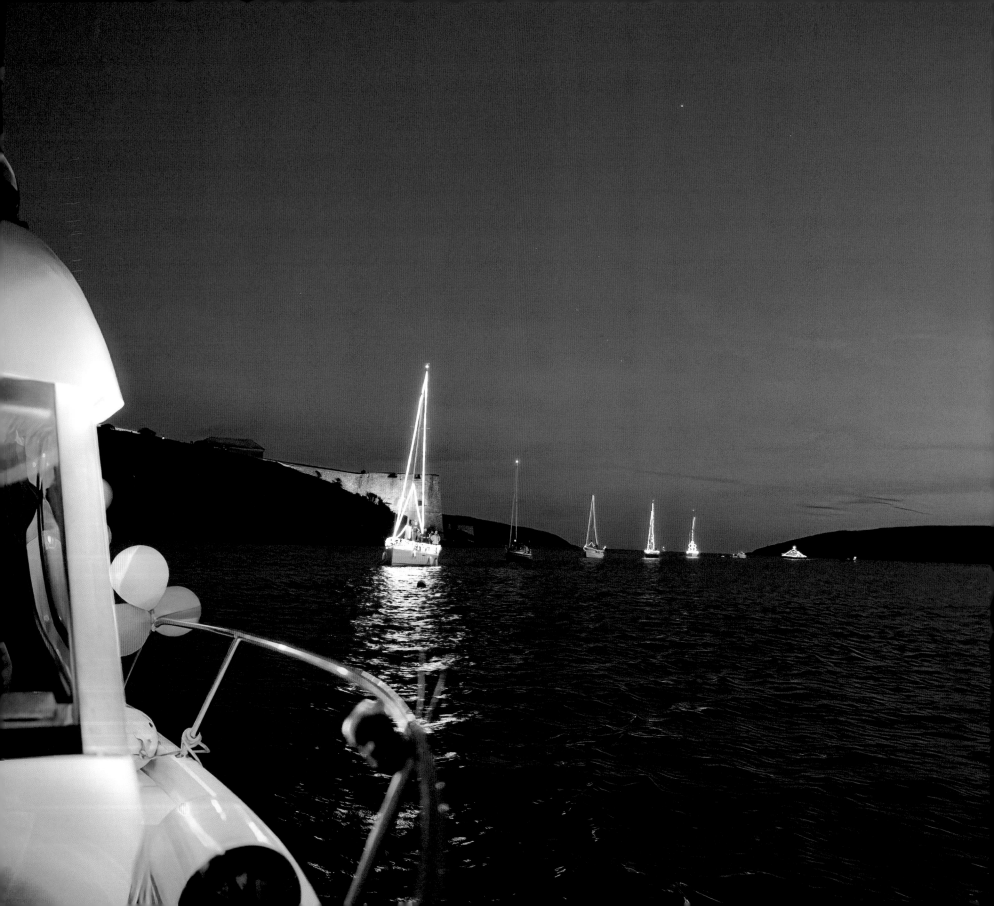

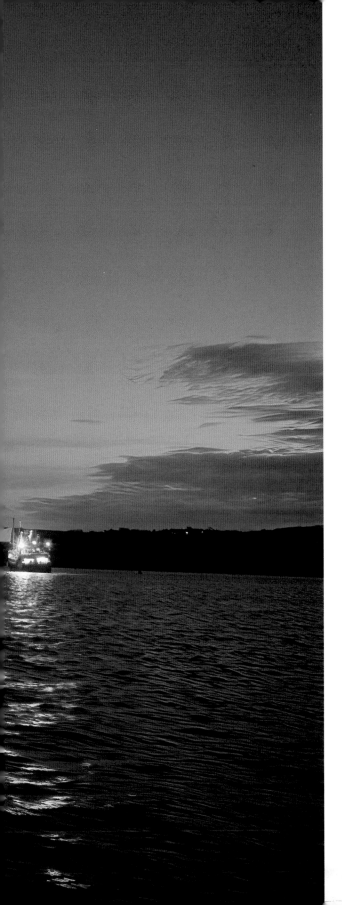

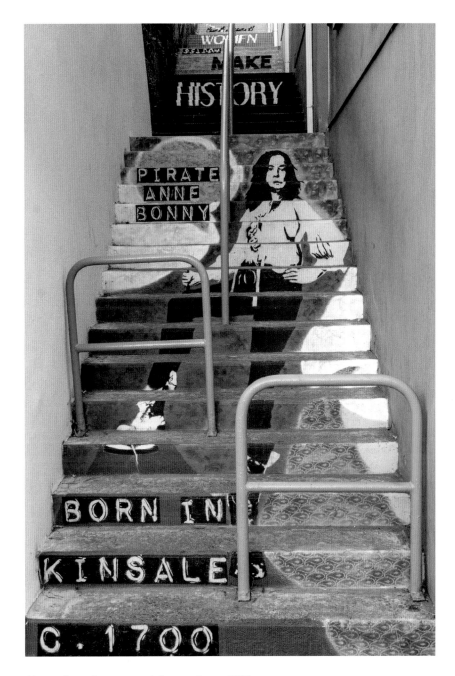

**Above:** Anne Bonny mural, Stoney Steps, 2021.

**Opposite:** St Patrick's Day maritime parade, 2013.

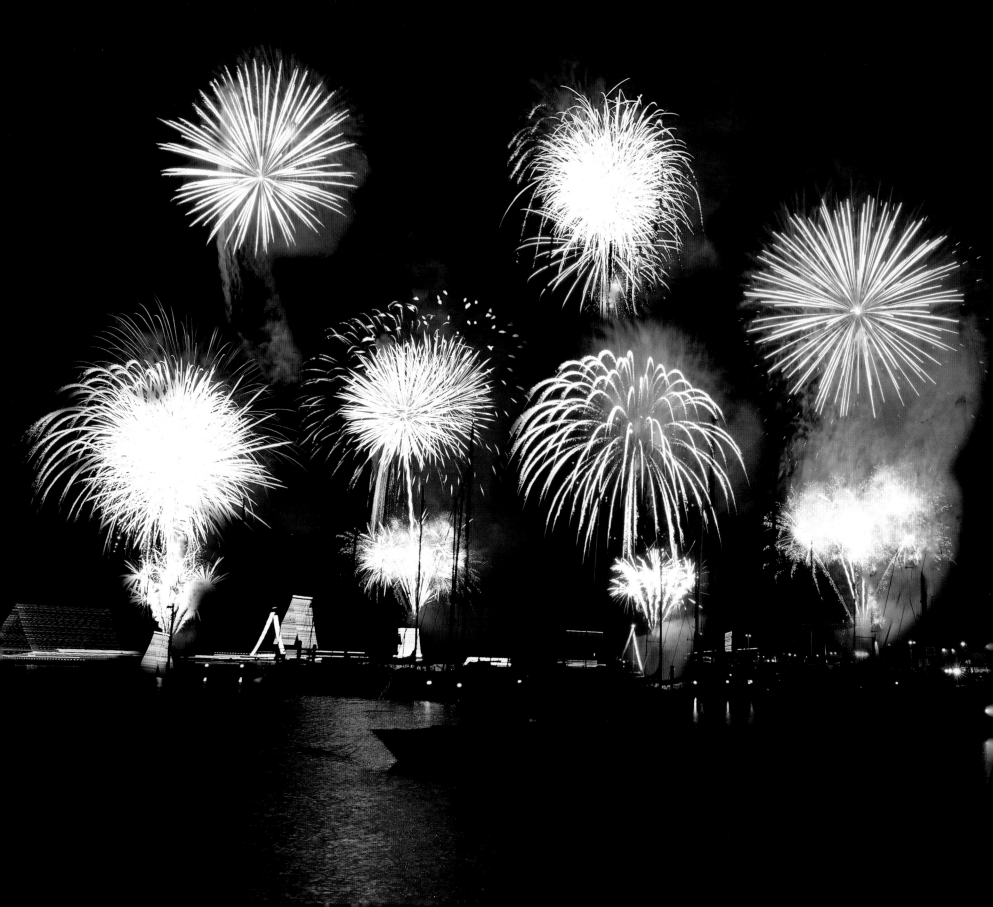

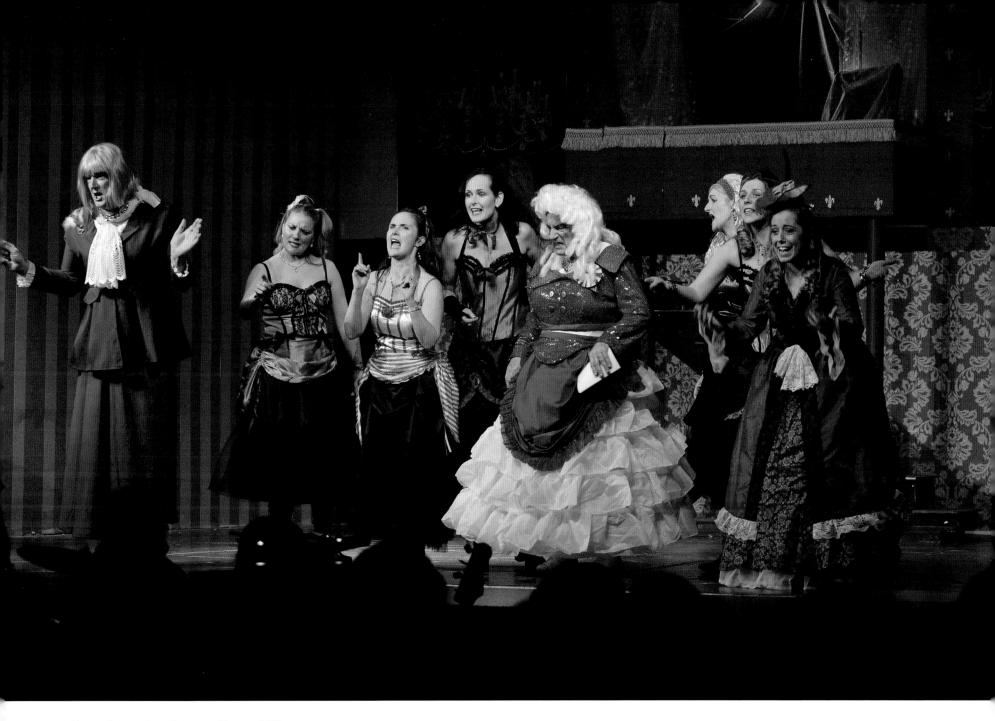

**Above:** Pantomime, Rampart Players, 2016.

**Opposite:** Fireworks, St Patrick's Day maritime parade, 2018.

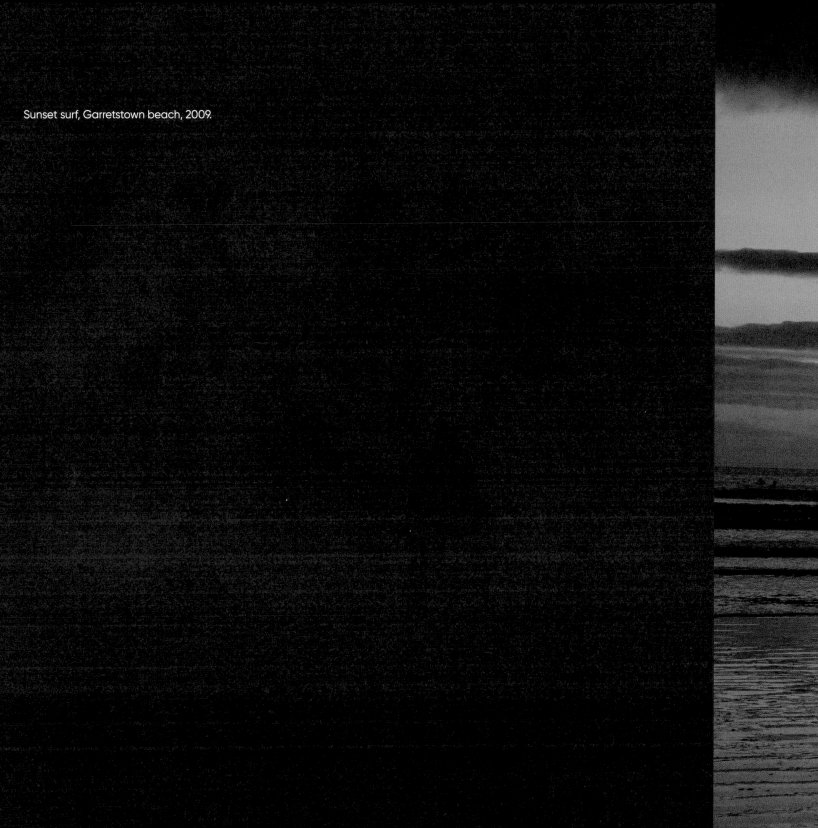

Sunset surf, Garretstown beach, 2009.

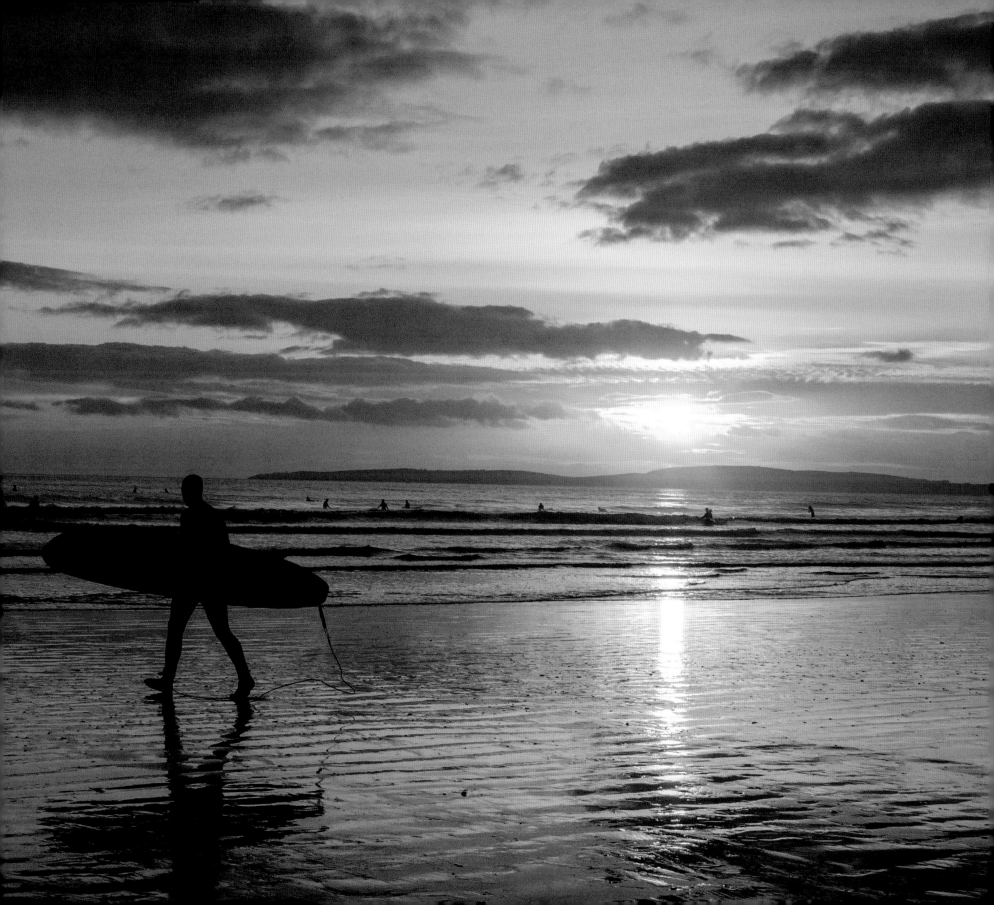

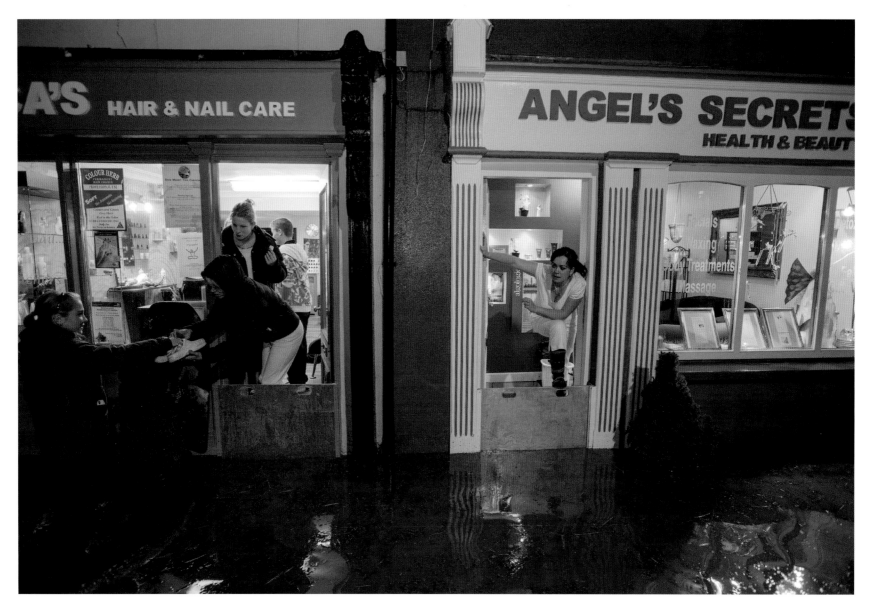

Flooding, Market Quay, 2009.

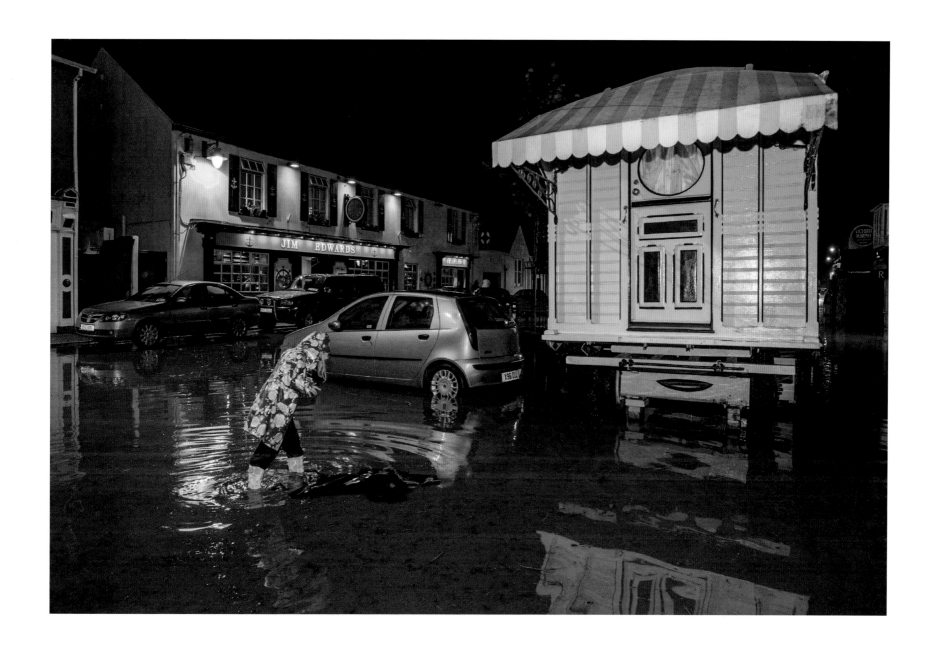

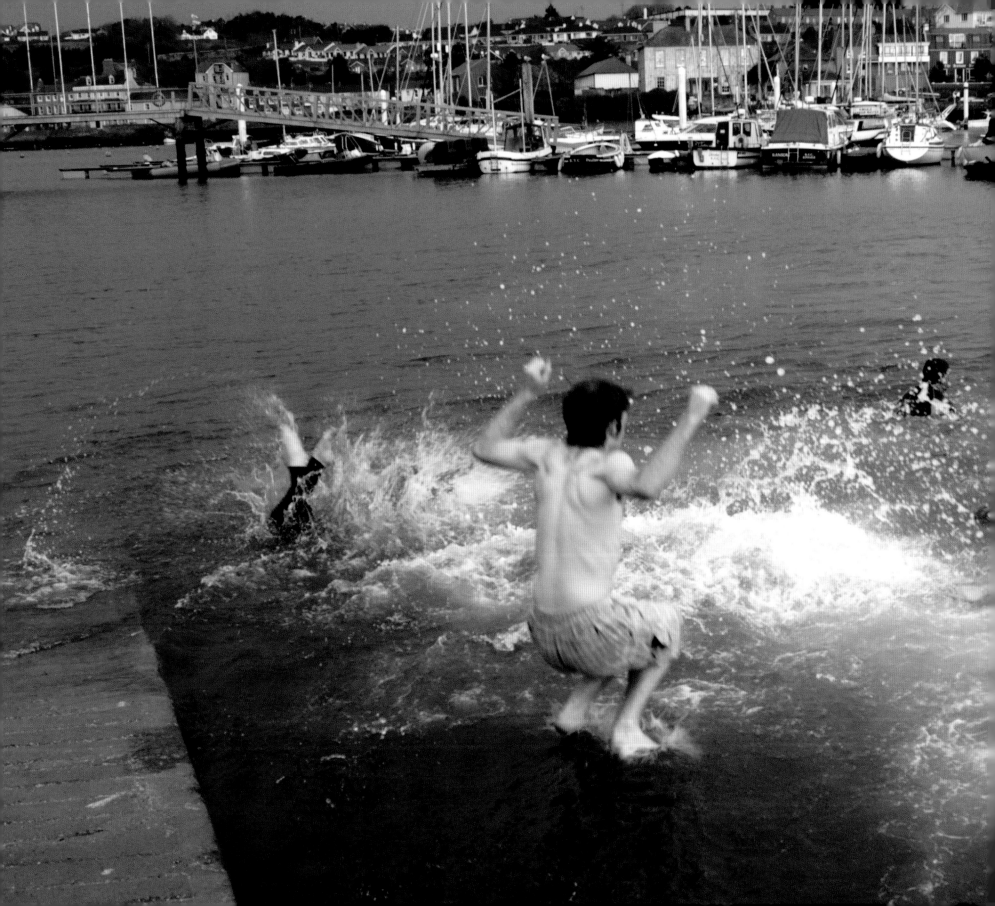

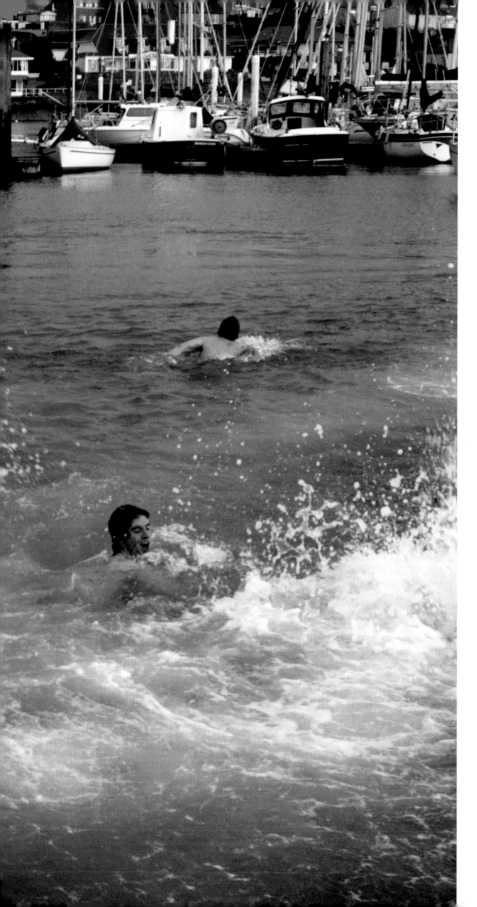

Christmas Day swim, 2004.

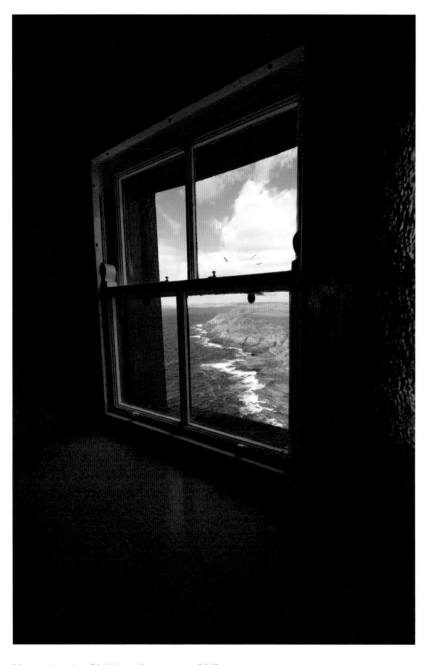

**Above:** Interior, Old Head lighthouse, 2015.

**Opposite:** Sunset, GAA pitch, 2010.

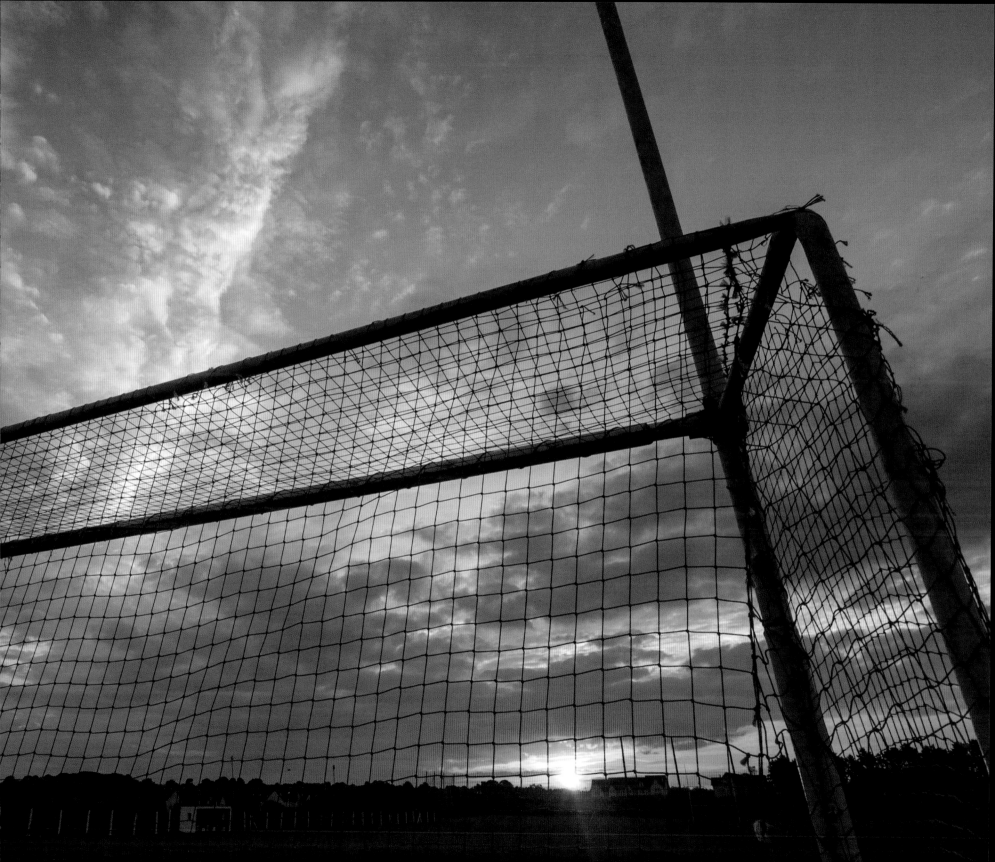

*Photography takes an instant out of time,
altering life by holding it still.*

Dorothea Lange

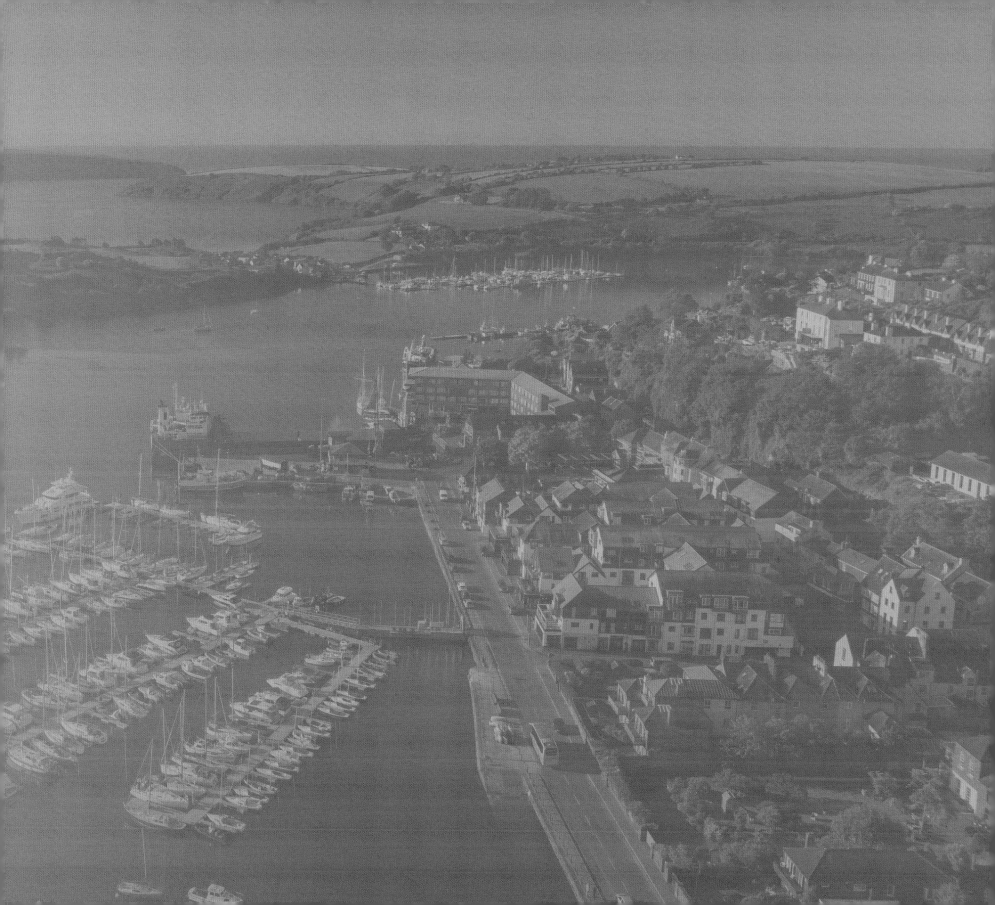

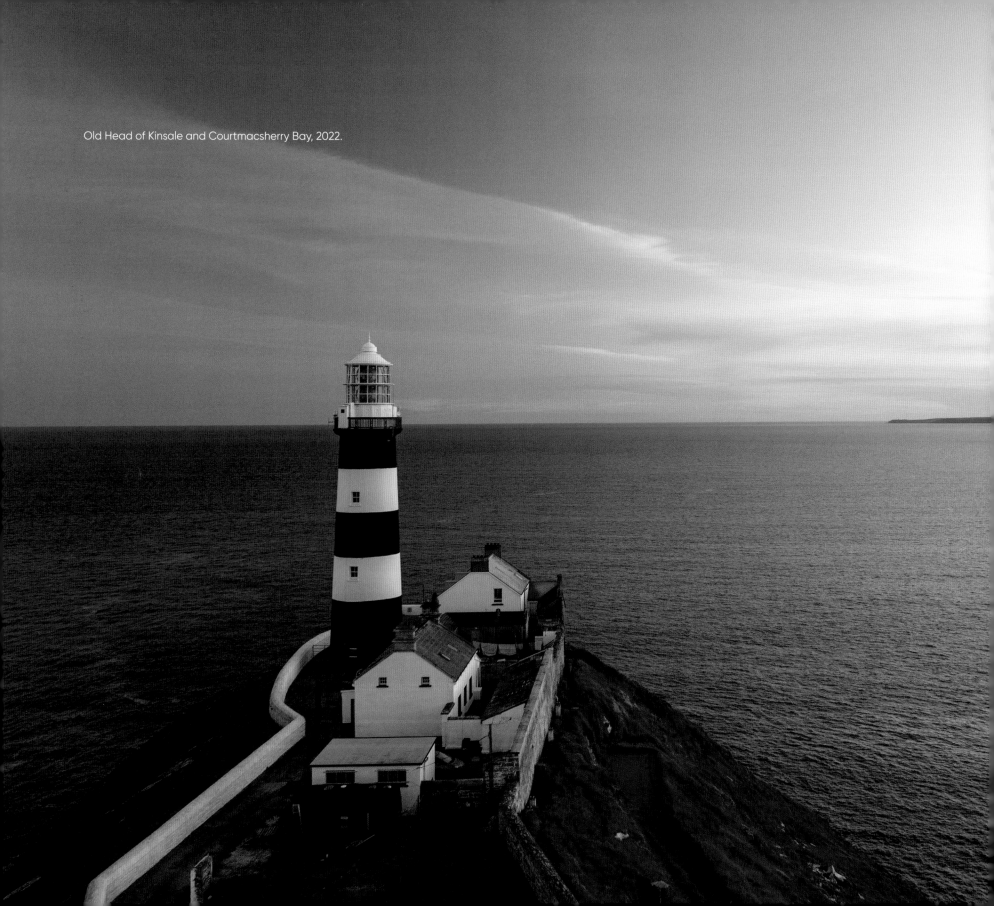

Old Head of Kinsale and Courtmacsherry Bay, 2022.

# Greyhound of the Seas

It was approaching 2 p.m., and a small group had gathered in St Multose's churchyard. The occasion was the 106th anniversary of the loss of the passenger liner *Lusitania*, 10 miles southwest of the Old Head of Kinsale. I stood near a grave with the stark inscription: 'An unknown victim (woman) of the *Lusitania* outrage, 7 May 1915'. It was familiar to me, as I had made a photograph of it back in the 1980s, and its mystery had never waned in my mind.

The early years of the twentieth century were the peak of transatlantic sea travel. During the second wave of the Great Atlantic Migration, between 1880 and 1910, some 17 million migrants from these islands, eastern and southern Europe

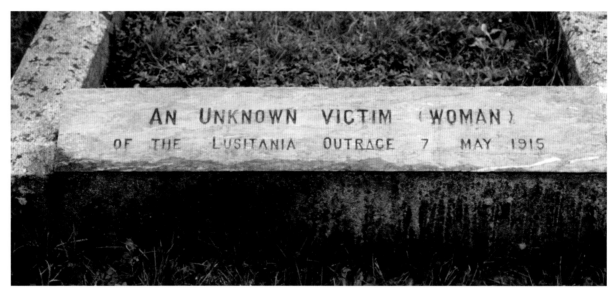

*Lusitania* grave, St Multose churchyard, 1989.

packed their hope and belongings and boarded a ship bound for the new world. However, these statistics often lose individual life stories, and a single human experience is more telling.

Margaret MacKenzie emigrated to America from her home in Shieldaig, Scotland – a remote fishing village north of the Isle of Skye. In the modern era of the fast steamship, the goodbyes to her family were not as final as they would have been for those who had left on sailing ships in the previous century. Technology had reduced the time of crossing the Atlantic from weeks to days, and a booming demand led to larger, faster and more luxurious ships. *Lusitania* was the Cunard Line's flagship, a 785ft, 32,000-ton behemoth, whose speed earned her the nickname 'Greyhound of the Seas'. Margaret found work on a ranch near Oil City, Wyoming – modern-day Casper – on arrival in America. She met and fell in love with an American from Illinois, James Shineman, and their romance quickly blossomed into a marriage proposal and engagement.

The afternoon in the Kinsale churchyard was a bright, crisp May day – conditions not unlike the same day in 1915. Traffic hummed by, making its way to and from the town centre while passing gulls and crows made their calls overhead. Some of the group - primarily members of the Kinsale History Society – were in quiet conversation, others reading inscriptions on the gravestones. The identity and personal story of the unfortunate soul interred in the grave beside me remained a mystery for a hundred years. A history society member briefly recalled the events of 1915 before a minute's silence

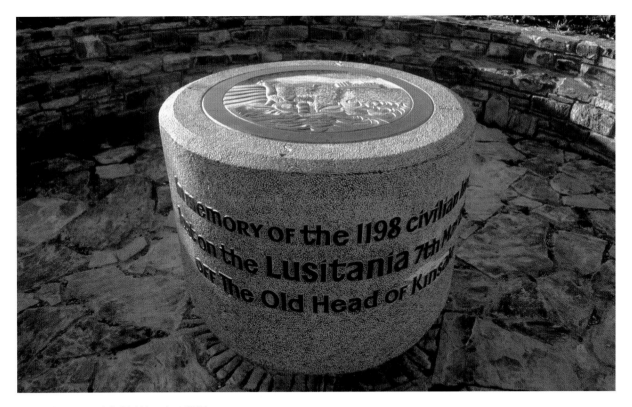

*Lusitania* memorial, Old Head, *c.* 1997.

was observed at 2:10 p.m., the moment the torpedo detonated and unleashed tragedy and loss on an unprecedented scale. First, I thought of the people on deck seeing the torpedo trail racing towards the ship. Then, the sheer terror of the explosions and the ensuing chaos. Finally, as the prayer service began, our thoughts turned to a very different Mayday in 1915.

Margaret and James were married on 19 April 1915 and planned their honeymoon around a surprise visit to Margaret's family in Scotland. They had booked their passage on the steamship *Cameronia*, which made regular transatlantic crossings between Glasgow and New York. This Anchor Line ship was smaller and slower than the pride of the Cunard Line and was due to depart on the same day as *Lusitania* – 1 May. That morning, the British government took control of *Cameronia*, requisitioning it as a troopship in the war effort. Passengers were transferred to *Lusitania*, increasing her numbers significantly and delaying the departure by two and a half hours. The newlywed Shinemans were upgraded to a second-class cabin aboard *Lusitania* – they, like most of *Cameronia*'s passengers, were 'enormously pleased' with the transfer. They had been moved to a more luxurious ship that would get them to Liverpool four days early. As the tugboats moved *Lusitania* off Pier 54 and turned her east to begin her 202nd transatlantic crossing, Margaret, James and the other *Cameronia* passengers were oblivious to the notice placed by the Imperial German Embassy in that morning's newspapers. It warned passengers of the dangers of wartime travel aboard a ship flying the flag of Great Britain or any of her allies.

After a smooth Atlantic crossing, the ship entered the declared war zone on the western approaches to Great Britain. The unescorted *Lusitania* slowed to take bearings from the Old Head of Kinsale and fix her position after hours of steaming blind in fog. The German submarine *U-20*, low on fuel and supplies, was about to begin the journey back to her home port when lookouts spotted a four-funnel steamer on the horizon. The transcendence of war was about to visit the 2,000 passengers and crew aboard *Lusitania*.

The unknown woman was one of five bodies landed in Kinsale and buried soon after. Only 289 – fewer than a quarter of those who perished – were recovered. As the centenary of the sinking approached in 2015, a group of researchers related to the survivors began a project to identify the woman interred in Kinsale. Through meticulous archive work, they identified her as Margaret

MacKenzie Shineman. Her husband James' body was also recovered after the tragedy, many weeks after the sinking. Tides and currents had swept him up the west coast of Ireland to where he was found, between Doolin and the Aran Islands. Officials identified him by tracing his pocket watch back to its maker in Wyoming. He was laid to rest in Carrigaholt, County Clare, in July 1915.

One hundred and one years after the loss of *Lusitania*, an elegant marble gravestone was added to the mysterious crypt in St Multose churchyard. It reads 'Margaret MacKenzie Shineman, 25 December 1888 – 7 May 1915'. She was twenty-six years old.

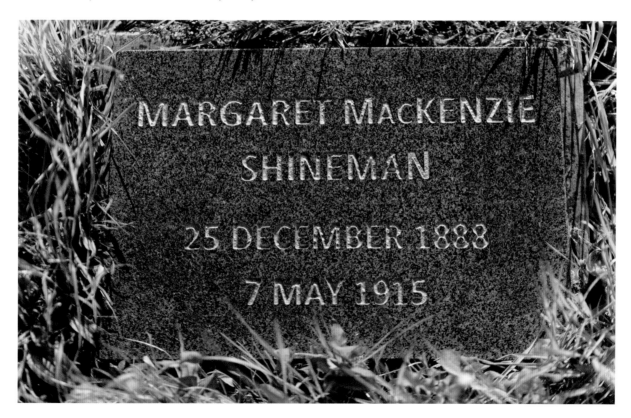

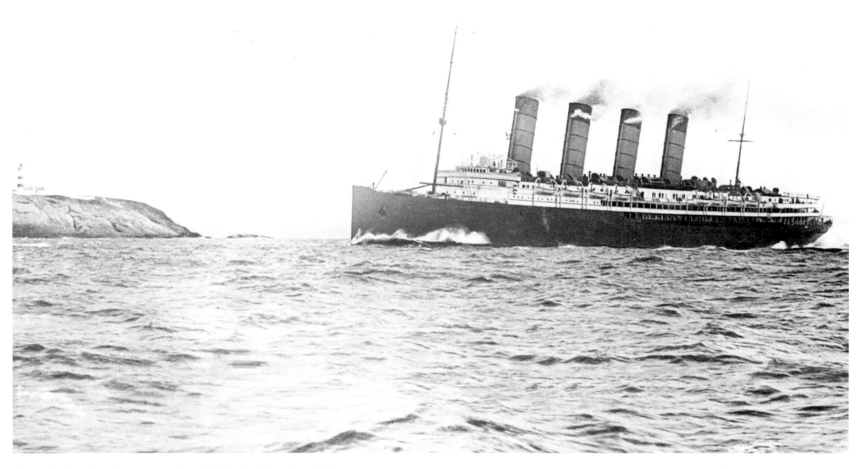

**Above:** *Lusitania*, outbound, passing Old Head of Kinsale, *c.* 1912.

**Opposite:** *Lusitania* sinking, painting by Stuart Williamson.

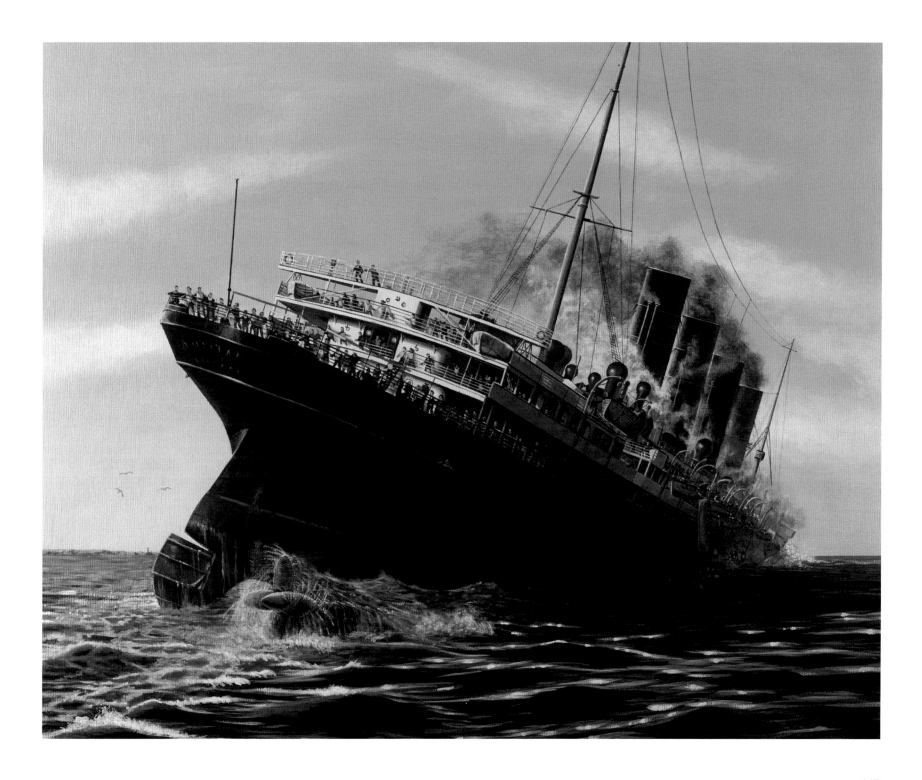

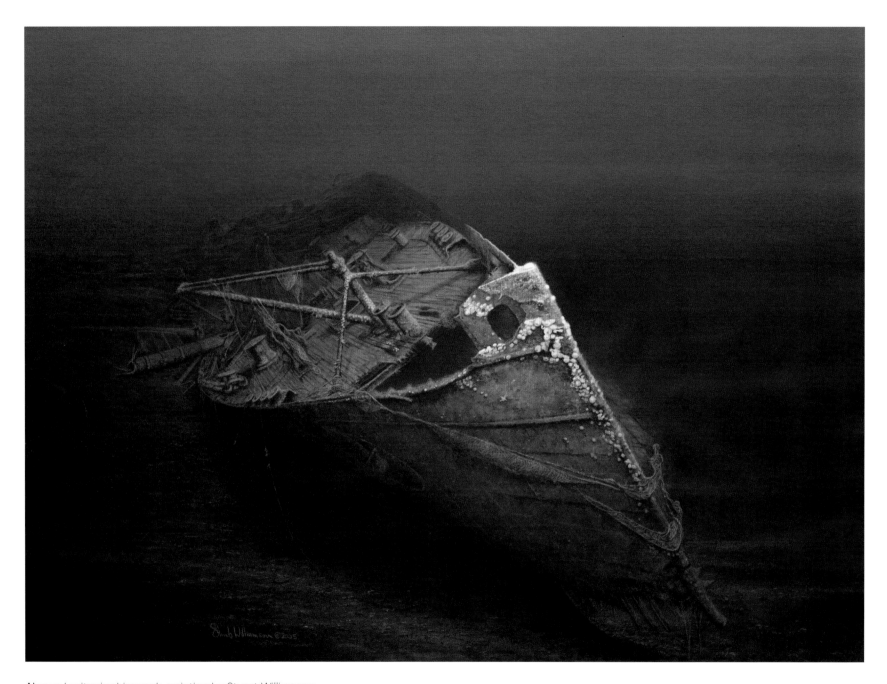

**Above:** *Lusitania* shipwreck, painting by Stuart Williamson.

**Opposite:** Holeopen Bay West, Old Head of Kinsale, 2023.

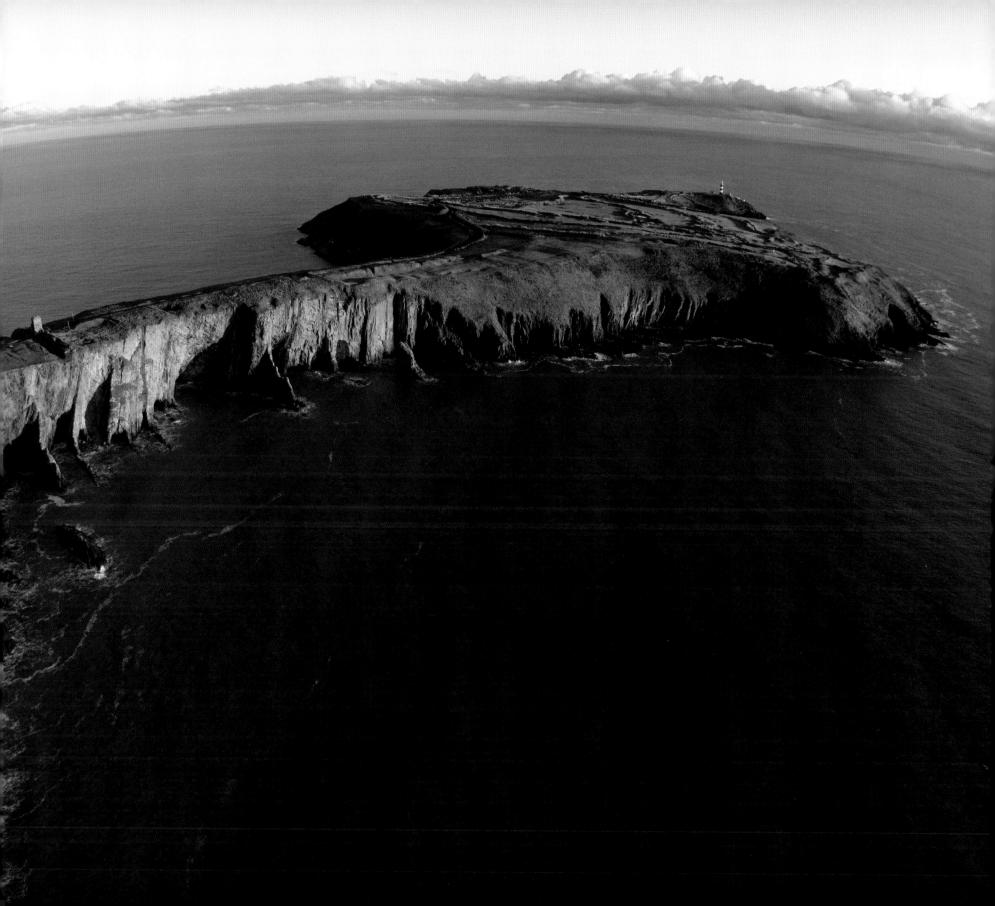

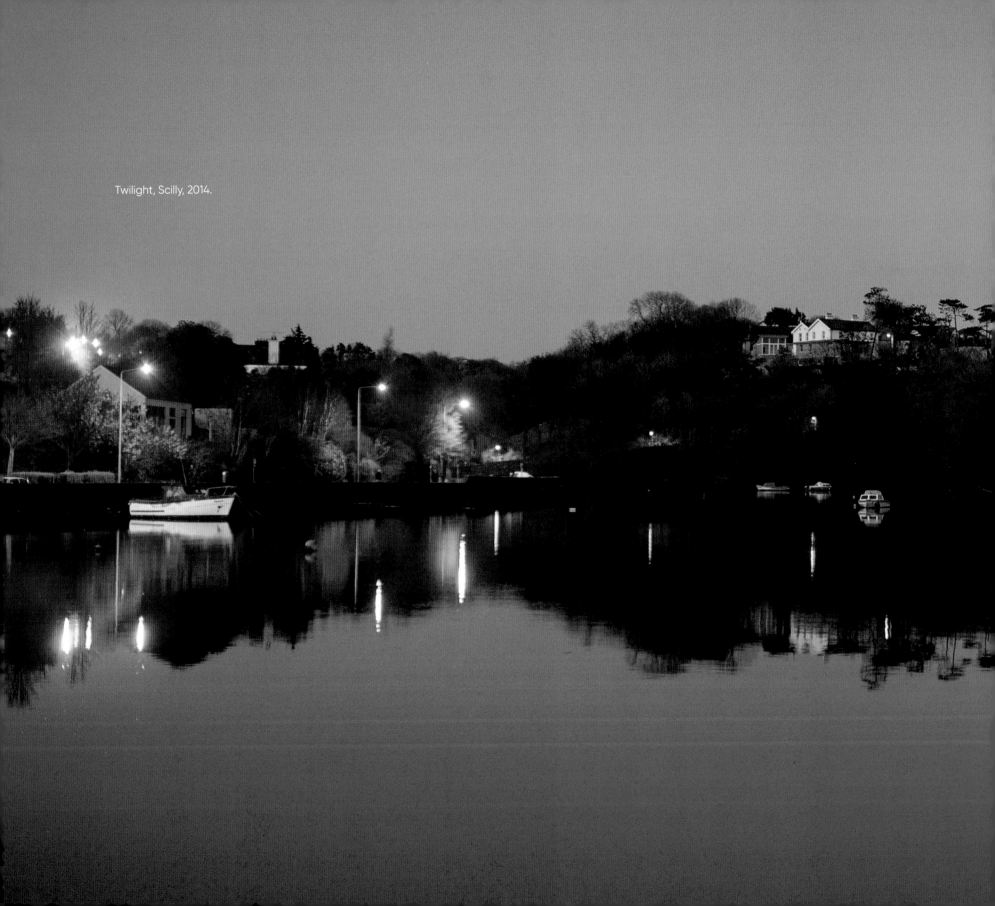

Twilight, Scilly, 2014.

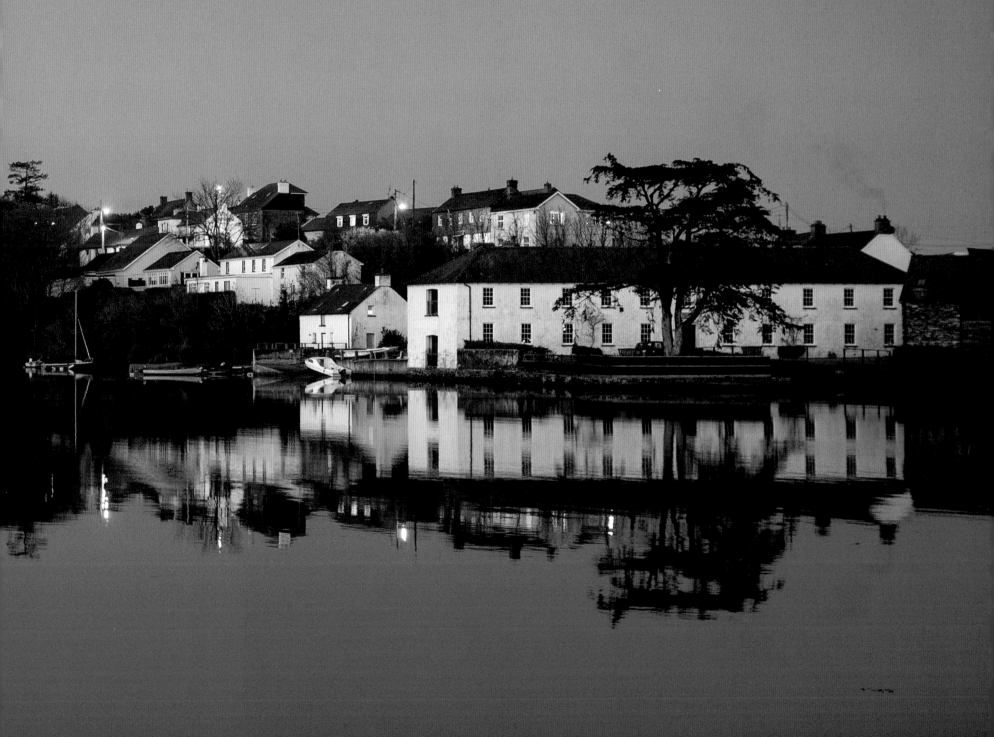

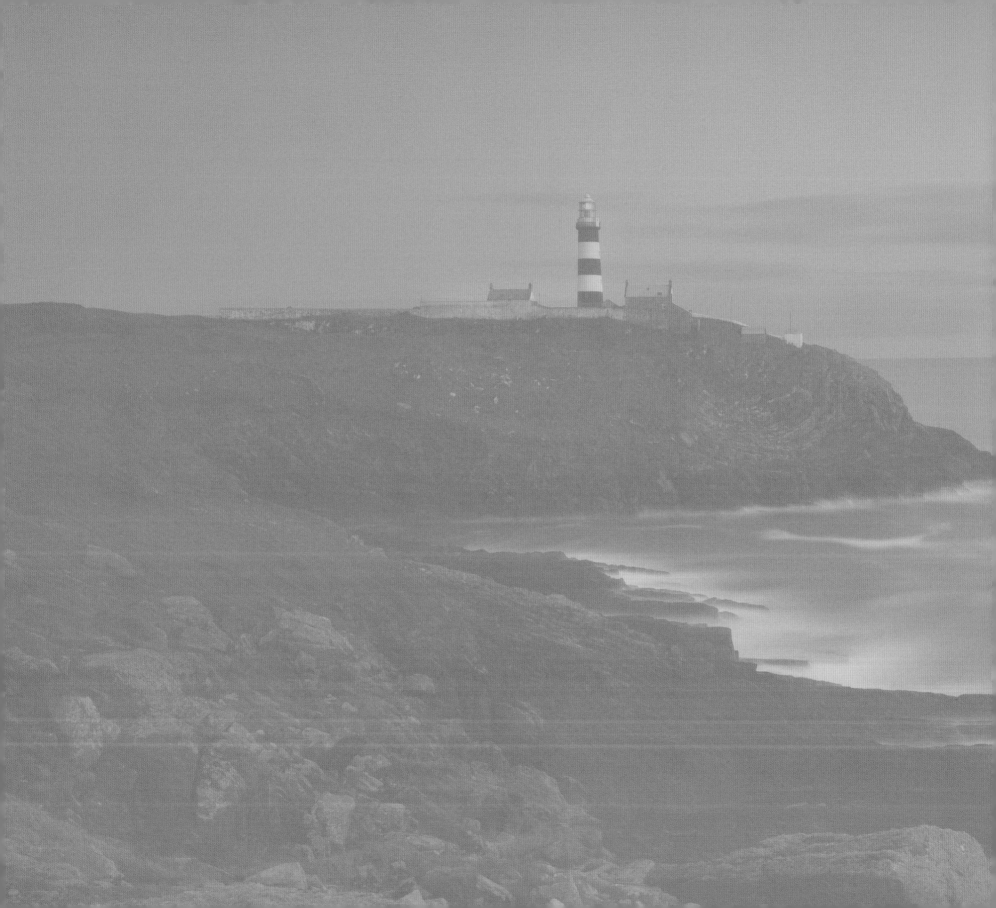

*... Fottrell and a silk umbrella with gold handle with the engraved initials, crest, coat of arms and house number of the erudite and worshipful chairman of quarter sessions sir Frederick Falkiner, recorder of Dublin, have been discovered by search parties in remote parts of the island respectively, the former on the third basaltic ridge of the giant's causeway, the latter embedded to the extent of one foot three inches in the sandy beach of Hole Open Bay near the Old Head of Kinsale.*

James Joyce
*Ulysses* (1922)

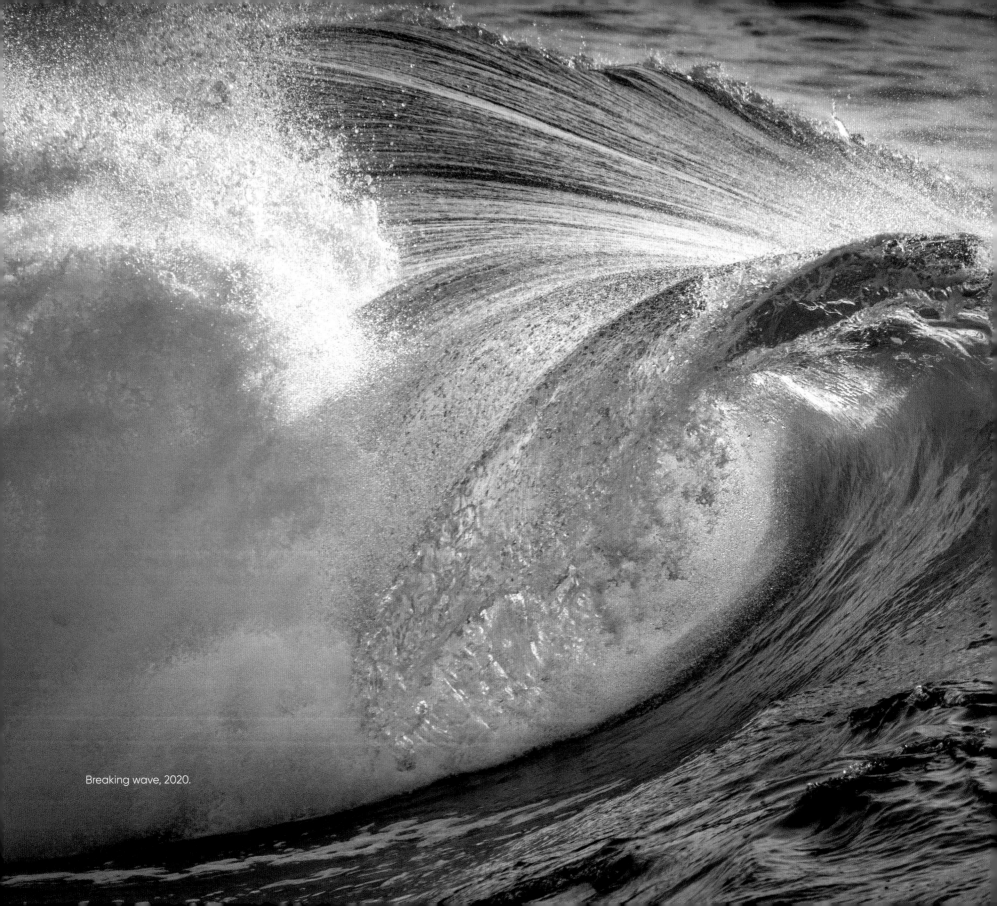

Breaking wave, 2020.

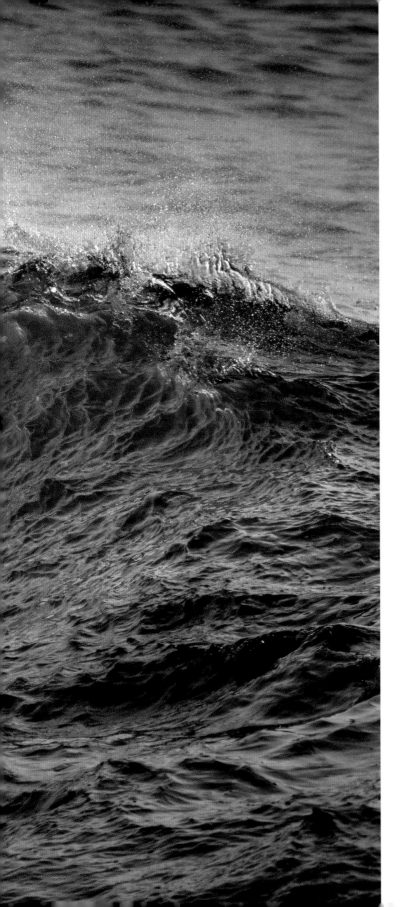

# 07

## Within the Wild Atlantic

'Make sure ye have everything,' the dive boat skipper announced as we cast off the lines. Divers made a quick mental check that they had put what they needed on board. It was a perfect day, with a light wind off the land and a calm sea. We would get to the west side of the Old Head today.

Passing the new RNLI lifeboat station, I waved to fellow crew members, washing down the boat after an exercise, and then we passed the marina in front of the Trident Hotel – the site of a naval dockyard for centuries. It saw the comings and goings of many ships throughout Kinsale's long history as a trading port. We continued across the harbour, passing the pier and yacht club marina, moving into the final bend of the

Bandon River. The imposing blockhouse, right on the edge of James Fort, then Charles Fort, came into view. After the battle of Kinsale, harbour defences were strengthened, which added security to shelter, making this port even more attractive for seventeenth-century shipping. We increased our boat speed on leaving the harbour limits and set course for the Old Head.

The powerful engine and sleek hull skipped across the small wavelets smoothly, and I made acquaintance with my dive buddies for the day – fellow photographers from the Netherlands. Soon, we passed Hake Head and the open expanse of Bullen's Bay, the lowest part of the peninsula. Some treacherous rocks guard the way to shore at *An Doras Breac*, the speckled door. Next was Black Head, a favourite dive site, the northernmost point of Hole Open Bay East. As the land rises to cliffs, this horseshoe-shaped bay offers shelter from the prevailing southwest and westerly weather. We manoeuvred towards the cliffs at the centre of the bay to show our visitors the sea arches that cut right through the headland. The light suddenly breaks through several openings, some large enough to snorkel or paddle in calm weather. Then, without hanging around for too long, we made our way south again, past the shelter of *An Cistin*, the kitchen, the most sheltered part of the head, where generations of fishermen have pulled in to boil a kettle.

Some fishing boats were visible out to sea – they were up and out long before us and had their nets set. They continue a long fishing tradition out of Kinsale, going back to the fifteenth century. As well as sustaining local needs, fish were processed and exported widely. Fishing was especially valuable after the darkness of the famine years. Starting in the 1860s, fleets of fishing boats from the Isle of Man, Cornwall, Scotland and France arrived in Kinsale for the spring mackerel. It was a thriving industry for the town, employing many locals and seasonal workers. A century later, a different kind of fishing would bring Kinsale out of the economic doldrums of 1950s Ireland. An angling centre was established on the site of the old dockyard. Local waters had gained a reputation through competitions hosted by Kinsale Anglers Club. Soon, anglers from England, the Netherlands and Germany began to arrive. Naturally, they needed accommodation and meals, and a burgeoning tourist resort began to emerge, ably driven by an active Kinsale development group that would become the Kinsale Chamber of Tourism.

We skipped through the gap between Bream Rock and the cliffs, and soon the lighthouse came into view. It is always an impressive sight, especially from the water. The distinctive black and white stripes that identify it in daylight were striking in the early summer sunshine. Slate grey folds of sandstone dropped sheerly from the headland's point, where there was just a light swell. It was a stark contrast to the procession of intense winter storms that had battered it over the previous months. This was our first opportunity of the season to get to the west side of Old Head in calm weather.

As we rounded the headland, the twisted tip on which the lighthouse stands became clear. Completed in 1853, this is the last of many lights built on the Old Head peninsula. The earliest is thought to have been further inland, built by the Celts, and several more followed over the centuries. The ruins of some of the earlier structures survive on the eastern part of the headland. The current light had to be wound every forty minutes, the clockwork mechanism then turning the paraffin lantern. It was eventually electrified in the early 1970s and fully automated in 1987, ending the presence of generations of lightkeepers. The cove to the north of the lighthouse, *Cuas Gorm*, is a beautifully sheltered and fabulous dive site, but it was not in our sights for today's dive. We carried on to Hole Open Bay West, where the calls and screeches of birdlife dominate, their breeding grounds nestled along the sea cliffs and the pinnacle of Minane Rock. We viewed the opposite side of the sea arches seen earlier, before turning into Ringurteen point over the shipwreck of the *City of Chicago*.

While *Lusitania* is the most famous wreck off the Old Head, it is too deep and dangerous for sport-diving. Numerous ships have foundered on these shores over the centuries, often bringing great tragedy. Most are completely broken and have disappeared, but the wreckage of the *Chicago*, as divers refer to it, is a delight to dive and a story with a happier ending than most. It was a passenger liner and steamed straight into the Old Head in dense fog in 1892, its bow becoming wedged in the cave where we were now kitting up for the dive. All passengers and crew were rescued, either to local boats or to the cliffs above, while the engine was kept running to keep the ship in situ. After four days, the ship broke in half, spilling much of the cargo into the sea. This was a bonanza for locals who gathered the debris, including sides of cured bacon that fed local families for weeks.

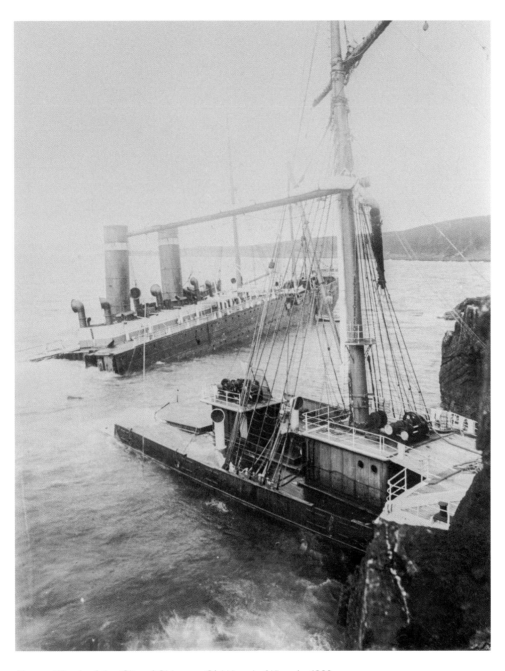

**Above:** Wreck of the *City of Chicago*, Old Head of Kinsale, 1892.

**Opposite:** Wreckage of the *City of Chicago*, Old Head of Kinsale, 2014.

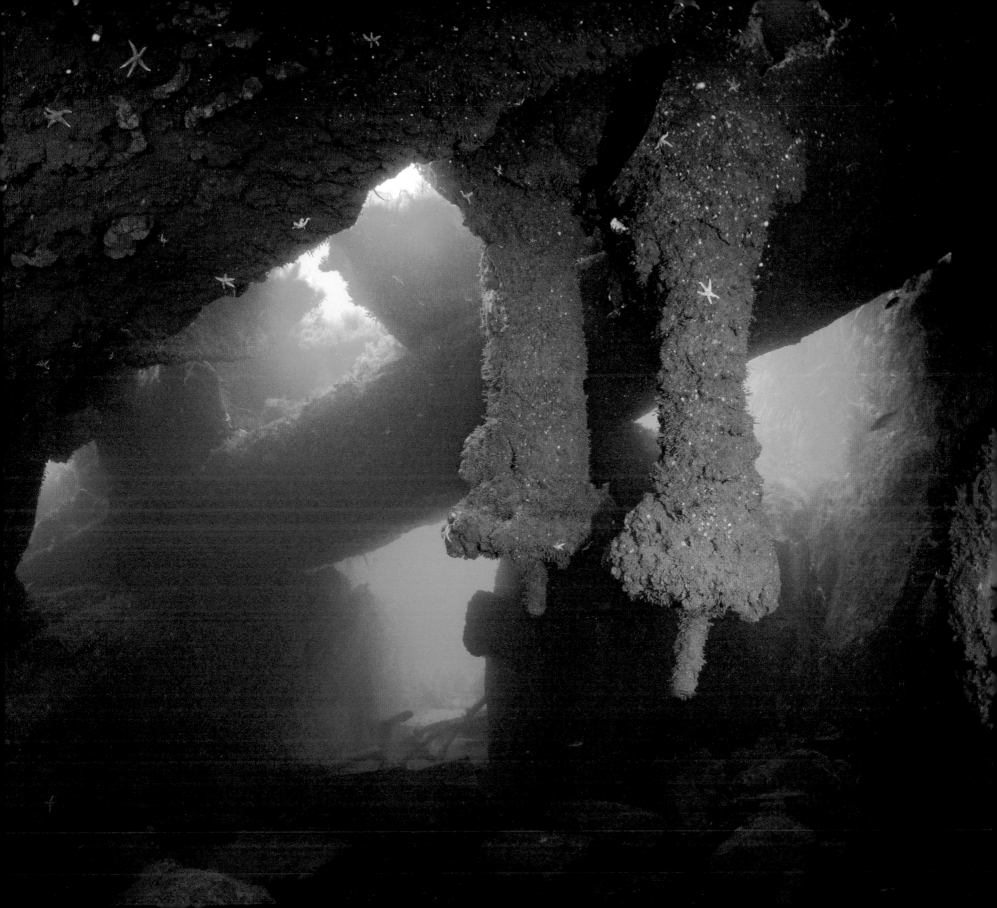

Rolling backwards over the side of our boat, we let gravity take us into the clear Atlantic. After the splash of bubbles cleared, we could see that the visibility in the water was fantastic. Exchanging hand signals to begin the dive, we released the air from our buoyancy jackets and become weightless, slowly dropping into the embrace of the emerald sea. After a minute or two in shallow water to adjust cameras and lighting, we made our way along the rock walls to deeper water. Kelp gently swayed in the sunlight and we soon came to the metal beams of the twisted wreckage, now part of the sea bed and covered with marine life. Some sections are large enough to swim through and project a ghostly image. I shone my dive light around the structure, and some fittings and valves emerged from the shadows. The jigsaw of parts only adds to the mystery of what the ship might have looked like in its day.

After our exploration of the wreckage, we continued the dive to deeper water, following a long gully blanketed in brightly coloured soft corals, their feeding polyps grasping for food in the current. We were beneath the kelp beds now at a depth of 18 metres, where the rock walls twist and turn in ever-changing shapes, each with a different colony of jewel anemones. Pollack and wrasse swam lazily by, only darting away when we got close. All too soon, we checked our dive time and gas supply and agreed, through hand signals, that it was time to turn the dive and head for the surface.

Back on the boat, we excitedly exchanged impressions of the dive and agreed to do a second dive, this time in a different location further south, near the lighthouse. The skipper briefed us on a rocky channel that looked good on the echo sounder. We dropped once more through the clear water, down a wall of life to a stony seabed. Winter storms had cleared away the kelp that usually covers the bottom. I could see a cluster of round white objects in the distance, and wondered if they were small sea urchins. Up close, we made bubbled laughs as they turned out to be lost golf balls from the links course on the headland above. I took out my dive slate and wrote a note to my buddy – 'they need lessons!'

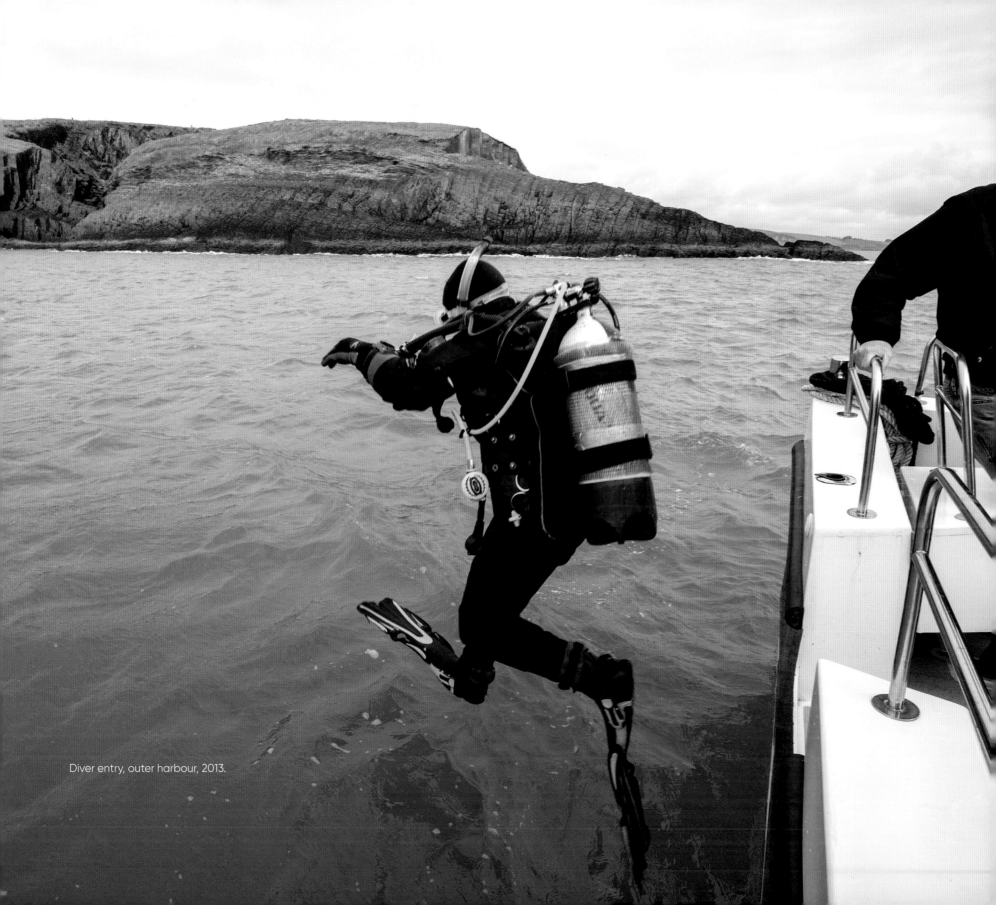

Diver entry, outer harbour, 2013.

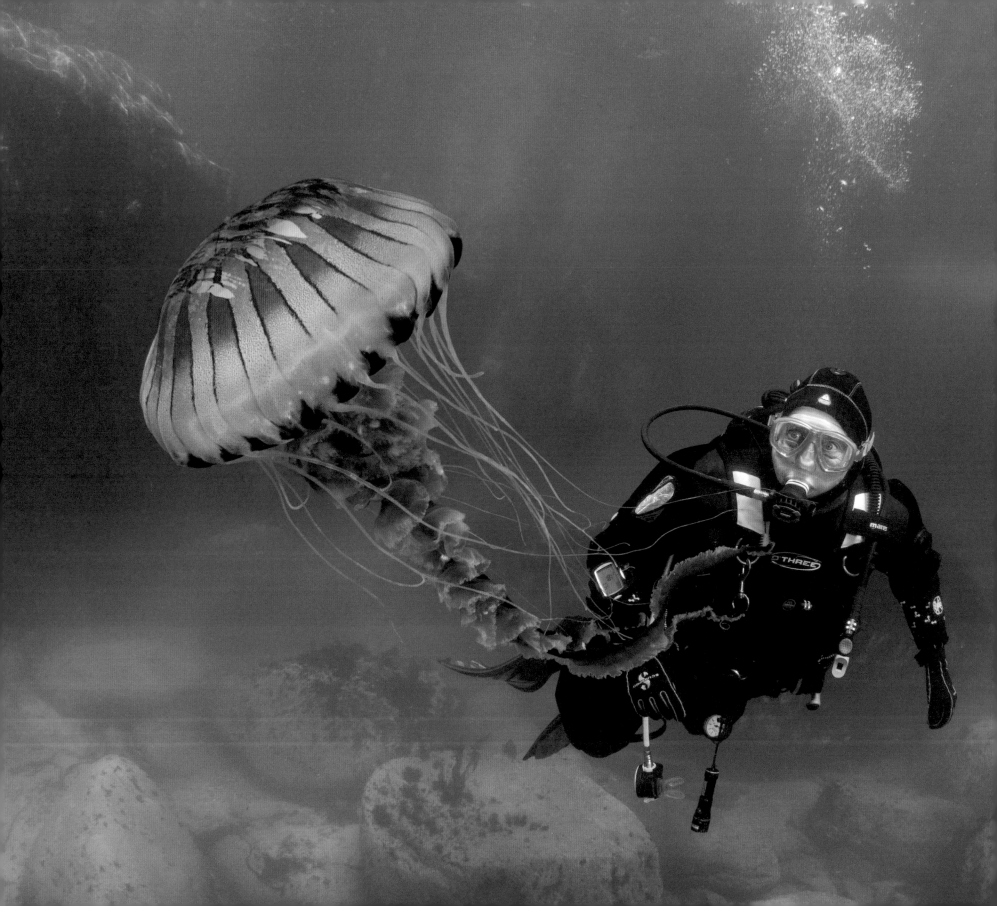

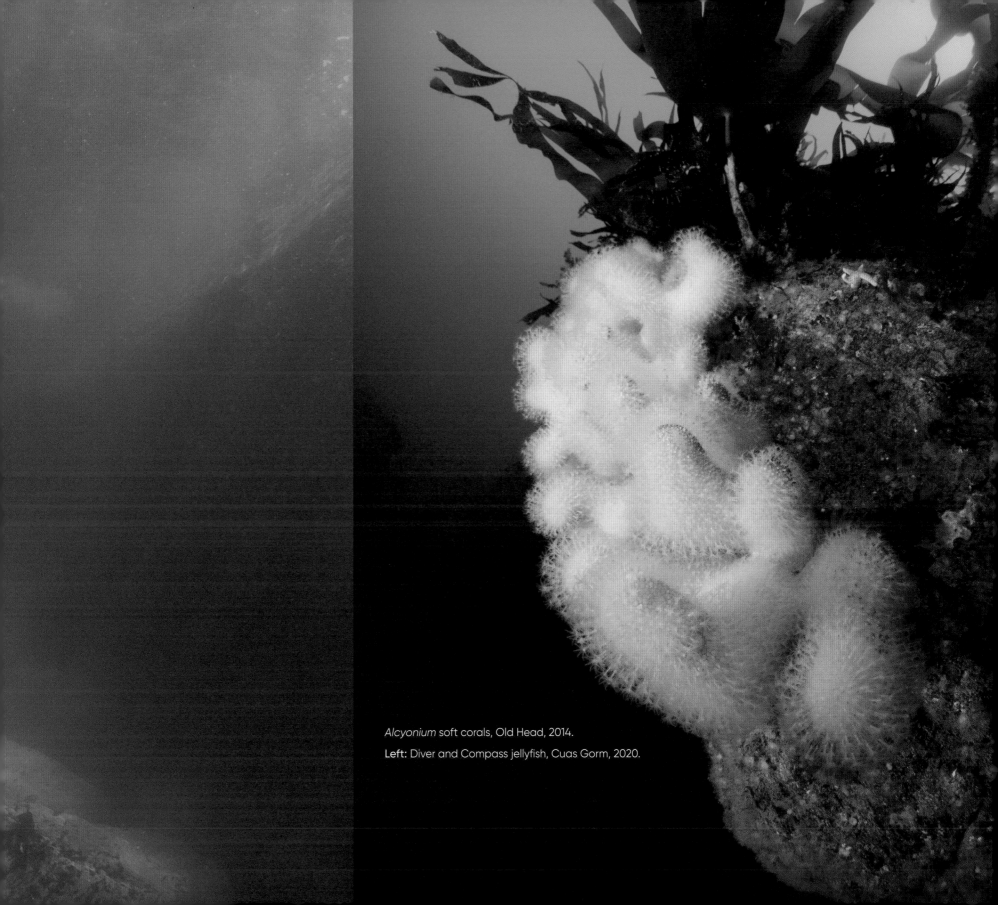

*Alcyonium* soft corals, Old Head, 2014.

**Left:** Diver and Compass jellyfish, Cuas Gorm, 2020.

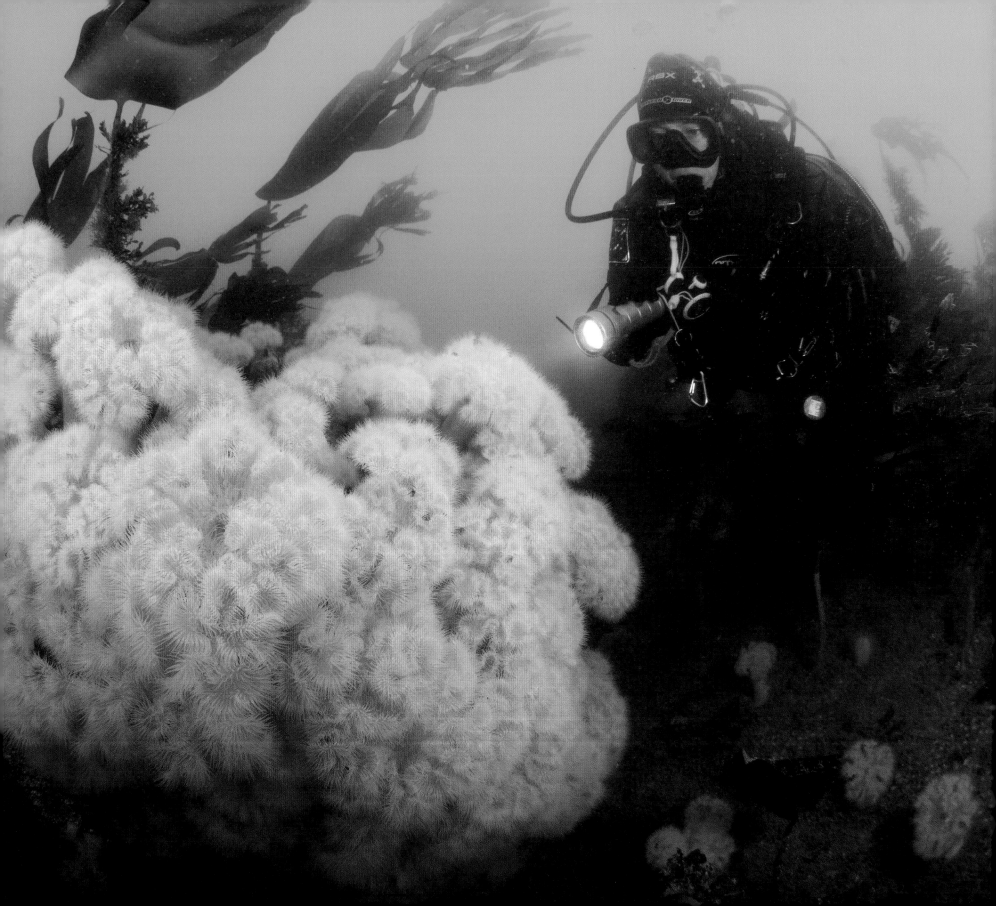

**Right:** Lost golf balls, Old Head, 2014.

**Opposite:** Plumose anemones,
Bream Rock, Old Head, 2014.

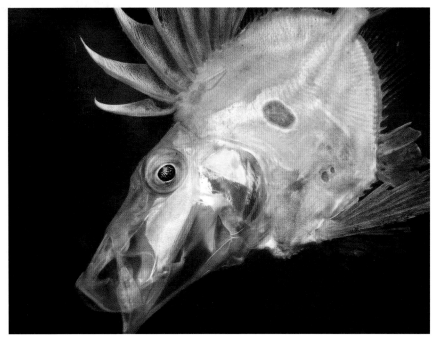

**Right:** Above and below, Old Head, 2020.

**Left:** Prawn close-up, Bullen's Bay, Old Head, 2014 (top). Juvenile John Dory feeding, Bullen's Bay, Old Head, 2014 (bottom).

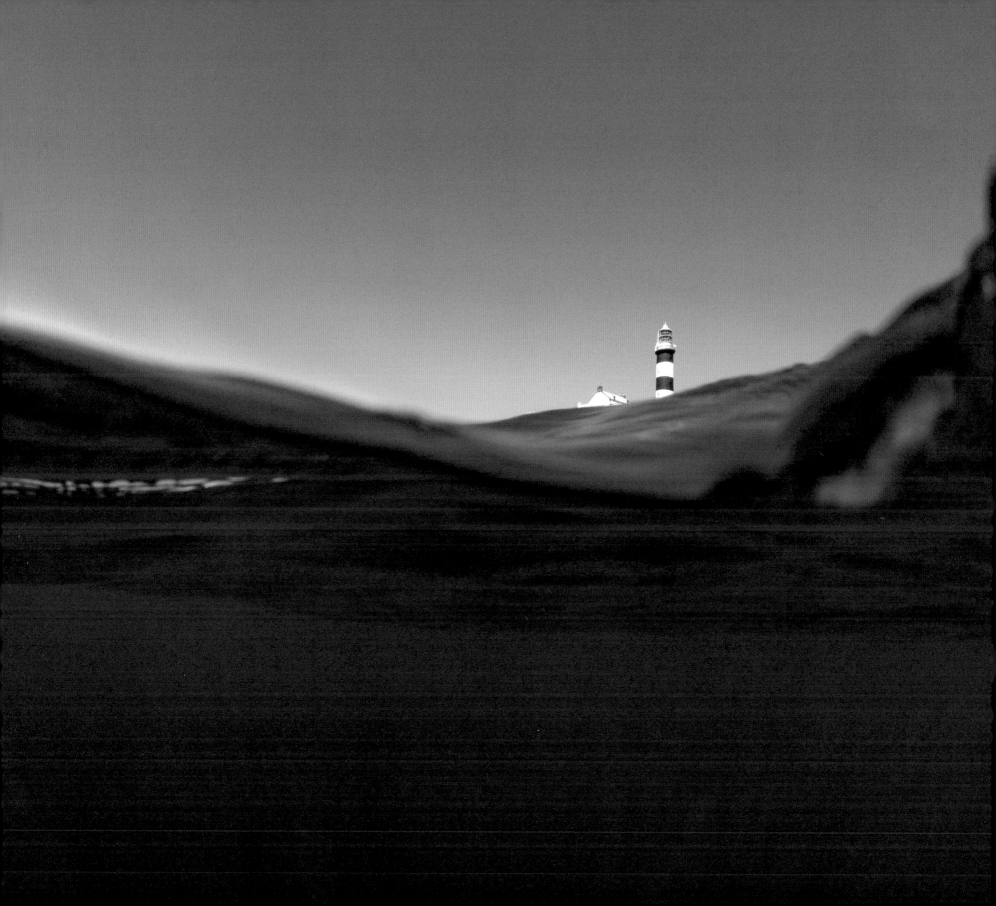

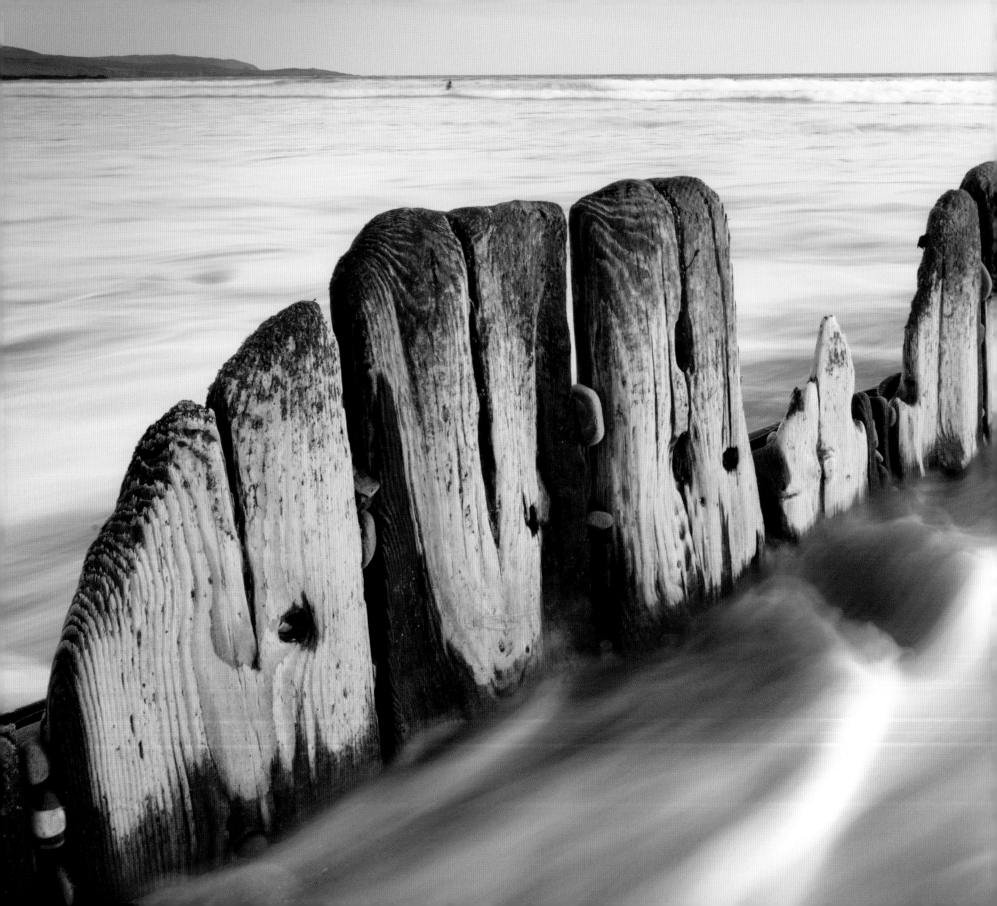

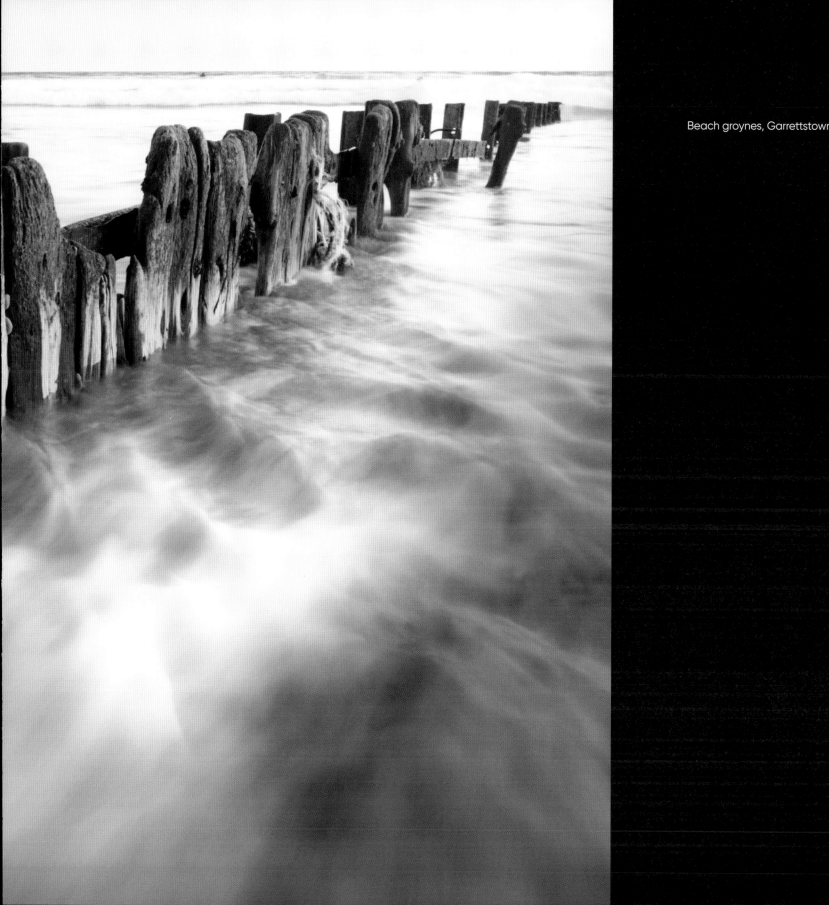

Beach groynes, Garrettstown

*Photography is a way of exploring the world outside myself and overlaying personal meaning on it. Likewise, writing is a way of exploring my inner thoughts and feelings and overlaying elements of the external world that elicit these thoughts and feelings.*

*Guy Tal, author and photographic artist.*

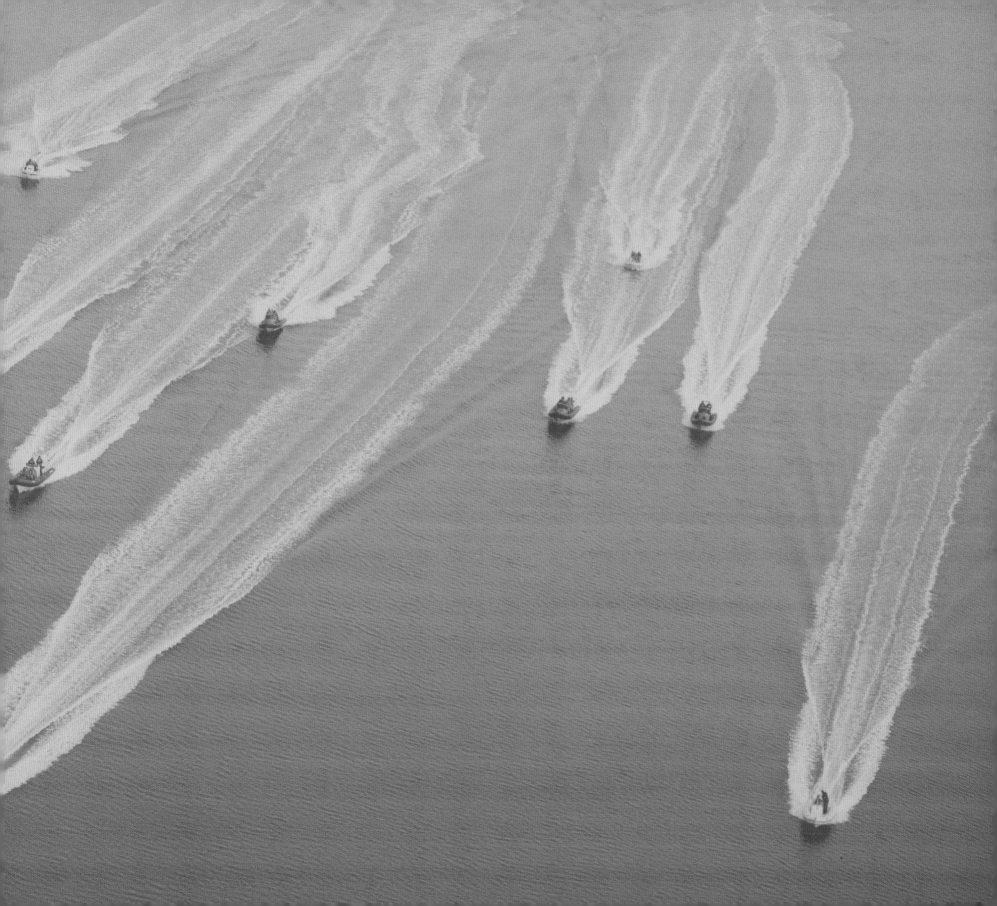

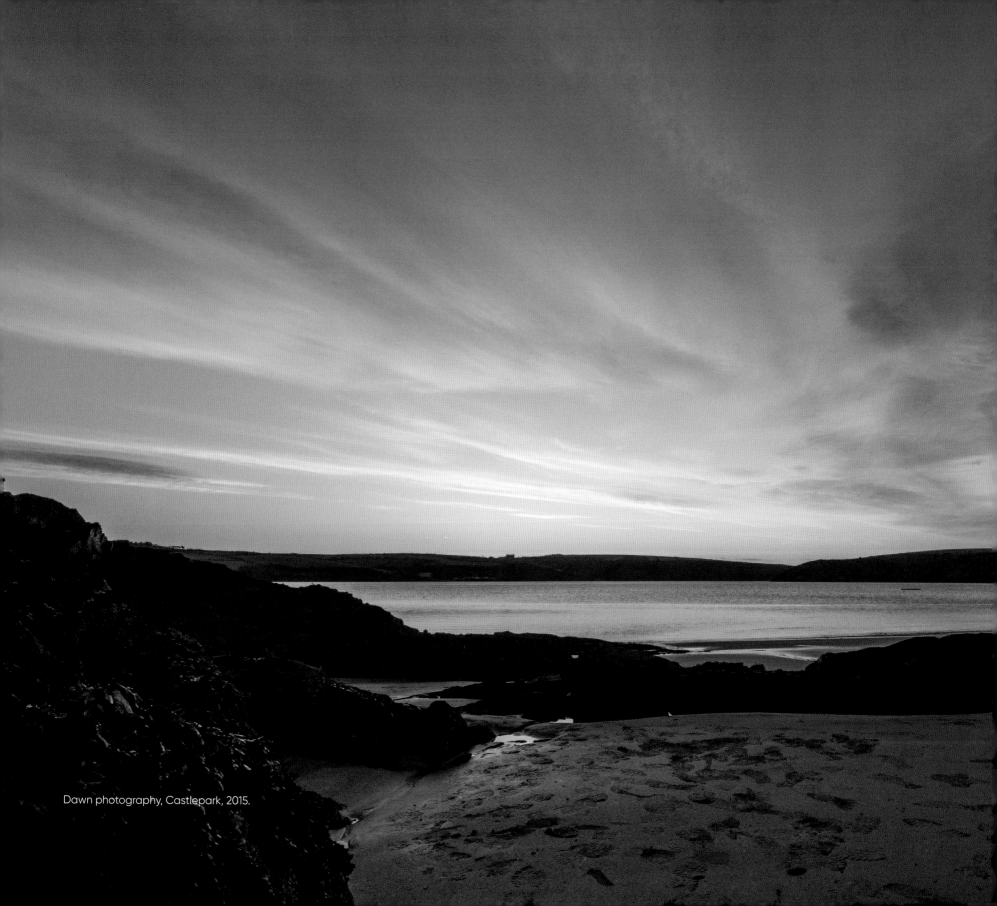
Dawn photography, Castlepark, 2015.

# 08

# On Making Photographs

In the late 1970s, when I first started in photography, the path was generally through the black and white darkroom. You sharpened your composition and camera skills by developing and printing your work. At the same time, colour photography was gaining popularity in documentary and contemporary practice. The attraction of colour seems obvious – we see the world in colour, so documenting it this way is more photo-realistic.

While photography is a dynamic medium, the generation of practitioners straddling the film and electronic eras have seen the most dramatic changes. Many of us were initially sceptical and unfamiliar with the vocabulary that

accompanied the digital technology. And while there were valid concerns around image quality and archival permanence, digital photography was a liberation.

I was an early adopter, mainly because working with film for underwater photography was hard. To go beyond the thirty-six exposure roll of film and get instant feedback on exposure was game-changing. Manufacturers brought increasingly capable cameras to market and quality skyrocketed, particularly in making photographs in low light.

But the materials and instruments available to us are only part of the story. As the poet Eavan Boland put it, the path to becoming and being a creative is 'a journey with two maps'. One is the familiar and predictable, while the other draws itself as you grow and find your expressive voice. Photography and writing revolve around our most precious resource – attention. We see, hear and observe throughout our lives and, as we look and listen closely, thoughts become words and dance with the scenes that become images. Instances reveal themselves through presence.

**Opposite:** Twilight, Bandon River, 2003.

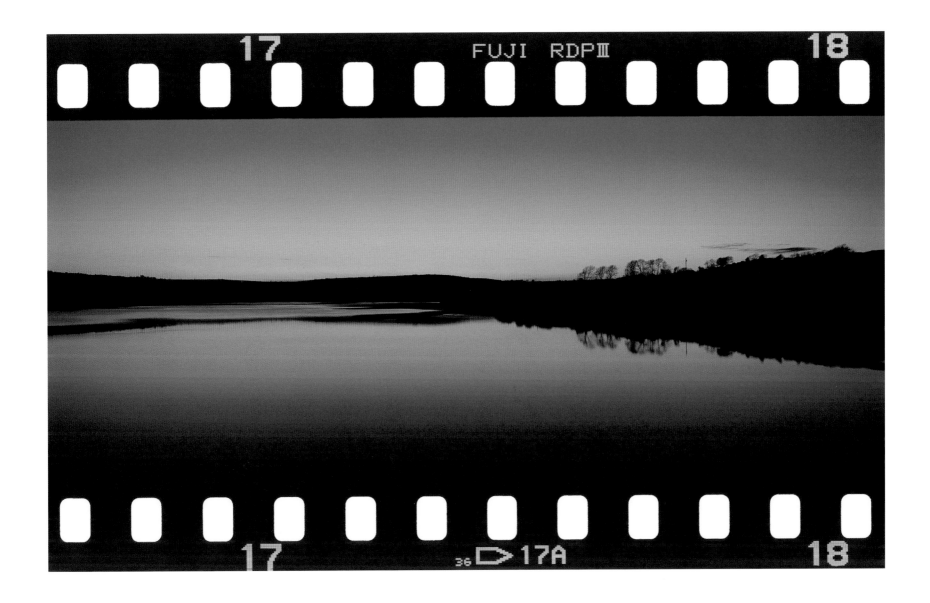

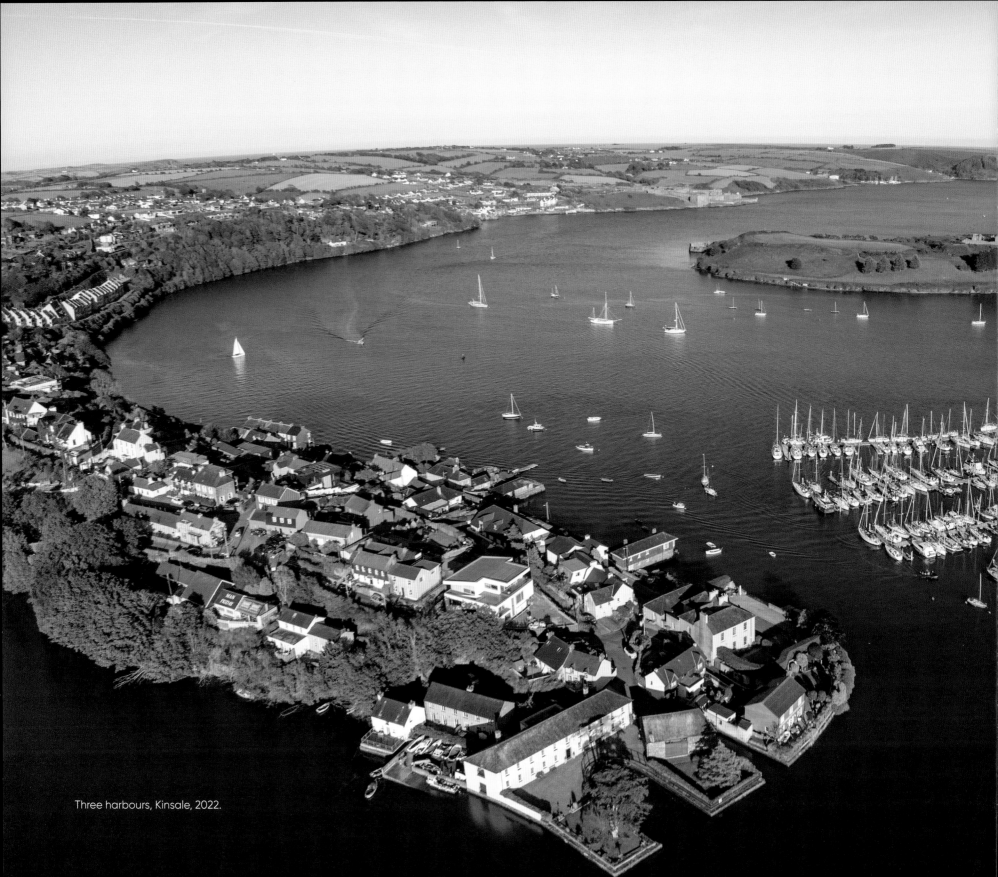

Three harbours, Kinsale, 2022.

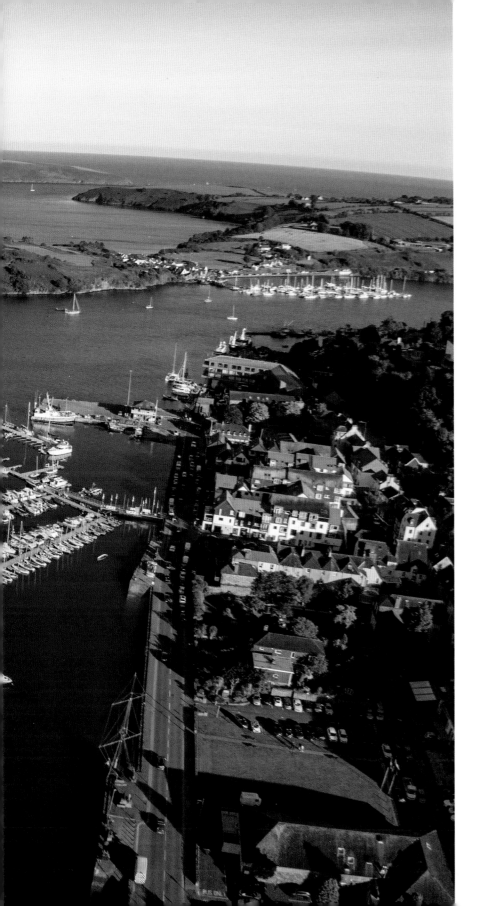

# Buíochas

Long-term projects are necessarily works of collaboration, and I am grateful to those who contributed to this book's journey to publication. In Kinsale, many friends and colleagues shared stories and observations, history and anecdotes – all of which enriched and clarified my thoughts as words and photographs came together. In helping to understand and get perspective on the past, I am grateful to Gerry McCarthy, Tony Bocking, Dermot Ryan, Jerome Lordan, Fergal Browne and Barry Moloney – keepers of our local history – and to Alan Hawkes for his knowledge of archaeology and Eddie Bourke for his knowledge of maritime history. In addition, it was a pleasure to hear stories of Kinsale's development from the 1960s from Hal McElroy and the late Denis Collins and of fishing from Eamonn O'Neill.

Diving and sharing the fascination of our marine heritage brought me to Kinsale in the 1980s. It opened lifelong friendships with Paddy O'Sullivan, Ray White and Brian Perrott, and with friends from Dublin University Sub Aqua Club, Chris and Niall Power-Smith. In addition, many

patient dive buddies have contributed to my underwater photographs, notably Graham and Anne Ferguson of Oceanaddicts, along with Mary Hunter, Aoife Brown and Rinie Luijkx, who appear in this collection. I am especially grateful to my fellow diver and marine artist Stuart Williamson for permission to reproduce his magnificent *Lusitania* paintings.

The human stories and people photographs were crucial to compiling this work. I am grateful to John Cowhey and my non-fiction writer friends made through the Irish Writers Centre in Dublin. Special thanks to those who appear in photographs, Michael Crowley, Pierce Healy, Duncan Sinclair, Phil Devitt, Pat Morrisey, Paul Mulcair, Fr Myles McSweeney, Hugh O'Connell, and my colleagues in Kinsale RNLI and Rampart Players. Oliver O'Connell kindly facilitated film scanning. I am grateful to the Daly family at Ballymacus, the O'Connor family at the Old Head Golf Links and Alan Boyers and his family at the Old Head lighthouse for access and patience with landscape and drone photography.

My sincere thanks to Cork University Press Editorial Board for considering and publishing this work and to the hardworking and supportive team at the press. A very special thank you to Maria O'Donovan for overseeing the development and production of the book and to Karen Carty and Terry Foley for their superb design.

I am grateful to the Tyrone Guthrie Centre at Annaghmakerrig, the Arts Council's Agility Award programme, and Katherine and Joachim Bueg for the creative space to complete this work. Finally, to my wife, Caoilfhionn, and daughters, Aislinn and Éadaoin, your endlessly loving and enthusiastic support of my creative work is a daily inspiration.

J.C. February 2023

# Photographs

**Page i**
Sunrise, Bandon River at Western bridge, Tisaxon, 2014.
Nikon D810, 14–24mm.

**Page ii**
Sea Pinks, Sandycove, 2014. Olympus OMD E-M1, 7–14mm.

**Page vi–vii**
Oysterhaven and Ballymacus, 2010.
Leica M9, 35mm.

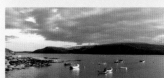

**Page viii–ix**
Low tide, inner harbour, 2021.
DJI Mavic Air 2 drone aerial.

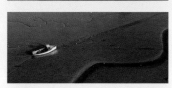

**Page 1**
Harbour sunrise over Compass Hill, 2020.
DJI Mavic Air 2 drone.

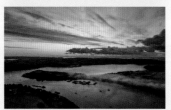

**Page 3**
Swans on the slipway, Pier Head, 1989.
Nikon FE, 50mm, Kodachrome 64 film.

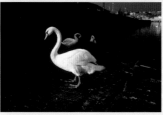

**Page 4**
Landing shrimp, Pier Head, 1989.
Nikon FE, 50mm, Kodachrome 64 film.

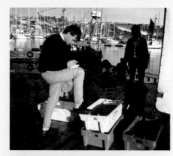

**Page 6**
Nets on quay wall, Scilly, 2006.
Nikon D200, 17–55mm.

**Page 7**
Dawn fog over Castlepark, from Scilly, 2016.
Nikon Df, 70–200mm.

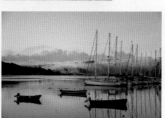

**Page 8**
Back door, Peter Barry's cottage, Scilly, c. 1994.
Nikon F90, 28–80mm, Fujichrome 100 film.

**Page 9**
Lobster quay from World's End, 1989.
Nikon FE, 50mm, Kodachrome 64 film.

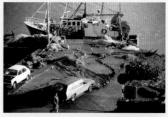

**Page 10–11**
Sunrise at the mast, Pier Road, 2020.
Fuji Panorama G617, Fujifilm Provia 100F film.

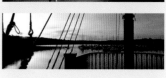

**Page 12**
Patsy's Corner cafe, Market Square, c. 1997.
Nikon F90, 24–85mm, Kodak Ektachrome 100 film.

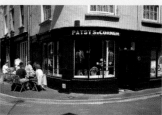

**Page 13**
Boat and oars, the slipway, Scilly, 2010.
Olympus E-P2, 14–42mm.

**Page 14**
'The Merries', Piper's funfair, Pier Road, 1998.
Nikon F90, 28–80mm, Kodak Ektachrome 100 film.

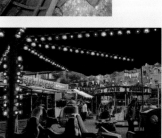

**Page 15**
Bumpers, Piper's funfair, Pier Road, 2012.
Canon EOS 5D Mark III, 24–105mm.

**Page 16**
Icicles on window ledge, Market Bar, 2018. Panasonic G9, 12–60mm.

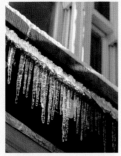

**Page 17**
Last leaf, Market Square, 1996. Leica R8, 28–70mm, Fujichrome 100 film.

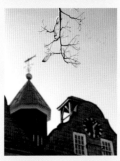

**Page 18**
Dolphins off World's End, Kinsale harbour, 2002. Fujifilm Finepix S1pro, 70–200mm.

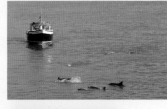

**Page 19**
Spiral staircase, interior of Old Head lighthouse, 2015. Nikon D810, 14–24mm.

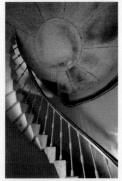

**Page 20**
Fresnel lens, lantern of Old Head lighthouse, 2015. Phase One IQ160, 28mm.

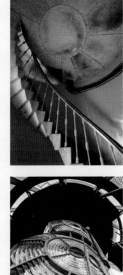

**Page 21**
Kinsale RNLI lifeboat on exercise, 2010. Nikon D3X, 80–400mm, Helicopter aerial.

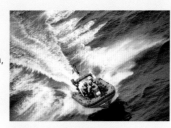

**Page 22**
Hazy harbour sunrise, Pier Road, 2016. Nikon Df, 24–85mm.

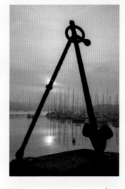

**Page 23**
Spring tide, Lobster Quay, c. 1997. Leica M7, 50mm, Kodak Ektachrome 100 film.

**Page 26–27**
Dawn, Bullen's Bay, Old Head of Kinsale, 2022. DJI Air 2S drone aerial.

**Page 29**
Six swans, Kinsale harbour, 1996. Hasselblad 503CXi, 80mm, Fujichrome Velvia 50 film.

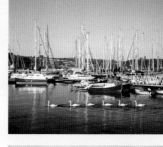

**Page 30**
Hand-coloured postcard, Valentine's series, c. 1920.

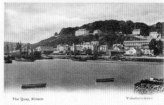

**Page 31**
Summer morning silhouette, Kinsale harbour, 1994. Mamiya 645 Pro, 80mm, Fujichrome Velvia 50 film.

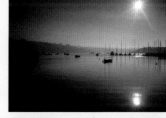

**Page 32**
Friary Lane, c. 1997. Leica M7, 35mm, Kodak Ektachrome 100 film.

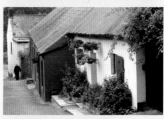

**Page 33**
Chairman's Lane, c. 1997. Leica M7, 50mm, Kodak Ektachrome 100 film.

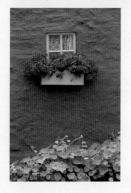

**Page 34–35**
Yacht Club marina and Kinsale Candle factory, Pier Road, from Ardbrack, 1995. Nikon F90, 70–200mm, Fujichrome 100 film.

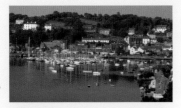

**Page 36**
Walking to the lighthouse, Old Head of Kinsale, *c.* 1993. Nikon FE, 50mm, Kodachrome 64 film.

**Page 37**
The Giant's Cottage, Chairman's Lane, *c.* 1997. Leica M7, 50mm, Kodak Ektachrome 100 film.

**Page 38**
Galway chapel, St Multose church, 1998. Nikon F90, 28–80mm, Kodak Ektachrome 100 film.

**Page 39**
Flower baskets, The Glen, 1998. Nikon F90, 28–80mm, Kodak Ektachrome 100 film.

**Page 40–41**
Hand-coloured postcards, early twentieth century.

**Page 42–43**
Moonrise over the Bandon River, Tisaxon, *c.* 2003. Hasselblad Xpan, 45mm, Fujichrome Velvia 50 film.

**Page 44**
Final approach, Kinsale harbour, *c.* 1998. Nikon F90, 70–200mm, Kodak Ektachrome 400 film.

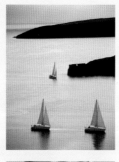

**Page 45**
Flowers, Vintage restaurant, *c.* 1997. Nikon F90, 28–80mm, Fujichrome 100 film.

**Page 46–47**
Postcards, John Hinde collection (with permission), *c.* 1970s.

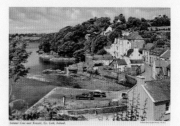

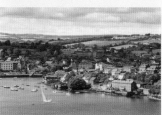

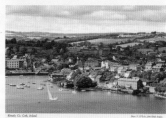

**Page 48**
Irish sail training vessel, *Asgard II*, entering Kinsale, *c.* 1997. Nikon F90, 70–200mm, Kodak Ektachrome 400 film.

**Page 49**
Mending nets on the pier, *c.* 1994. Nikon F90, 28–80mm, Fujichrome 100 film.

**Page 50–51**
Surfing at sunset, Garretstown beach, 2021. DJI Mavic Air 2 drone aerial.

**Page 52**
Dinghy racing, Charlesfort, *c.* 2003. Leica M7, 90mm. Kodak Ektachrome 100 film.

**Page 53**
John Coholan's, Market Street, *c.* 1995. Mamiya 645 Pro, 80mm, Fujichrome Provia 100 film.

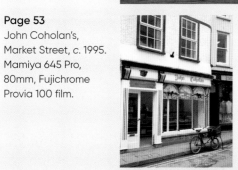

**Page 54**
Morning shadows, Main Street, 2007. Leica M8, 50mm.

**Page 55**
Fuchsias, Friary Lane, 1997. Leica M7, 35mm, Kodak Ektachrome 100 film.

**Page 58–59**
Beach dawn, Castlepark, 2015. Panasonic GM5, 15mm.

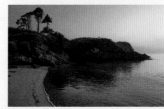

**Page 61**
*Leaba an Phrionsa*, the Prince's Bed dolmen, Ballymacus Point, 2020. Olympus OMD E-M5 Mark III, 8–18mm.

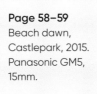

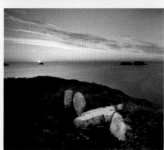

**Page 62**
Ballycatteen ringfort, Ballinspittle, 2022. DJI Air 2S drone aerial.

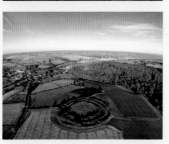

**Page 64**
Tallship *Astrid* sinking, Ballymacus Point, 2013. Nikon D4, 16–35mm.

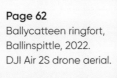

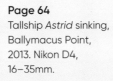

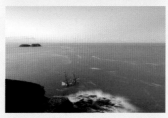

**Page 65**
The Dock beach, Castlepark, 2006. Nikon D2X, 16–35mm.

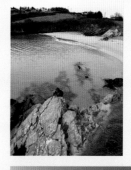

**Page 66–67**
Swan sunset, Bandon River, 2003. Nikon D100, 18–55mm.

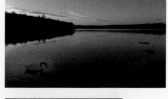

**Page 68**
Churchyard daisies, Oysterhaven, 2013. Nikon D4, 24mm tilt-shift.

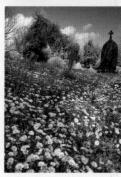

**Page 69**
Early lighthouse buildings, Old Head of Kinsale, 2022. DJI Air 2S drone aerial.

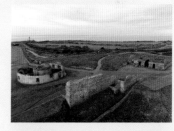

**Page 70**
Old Head and Cuas Gorm, 2020. Olympus OMD E-M5 Mark III, 8–18mm.

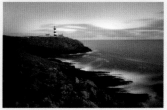

**Page 71**
Pier head silhouette,
2007. Leica M8, 90mm.

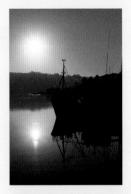

**Page 72**
Fog at sunrise,
Jamesfort, 2017.
Olympus OMD E-M1
Mark II, 40–150mm.

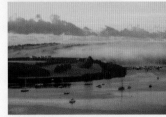

**Page 73**
Dusk, Old Head
lighthouse and
Courtmacsherry Bay,
2022. DJI Mavic 3
drone aerial.

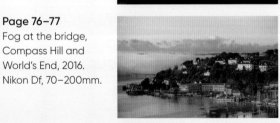

**Page 76–77**
Fog at the bridge,
Compass Hill and
World's End, 2016.
Nikon Df, 70–200mm.

**Page 80**
Old Head of Kinsale,
2006. Nikon D3X,
80–400mm,
Helicopter aerial.

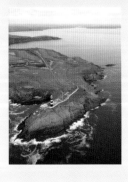

**Page 81**
Midsummer dawn,
the Bulman Buoy
and Sovereign islands,
2010. Nikon D3X,
70–200mm.

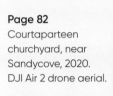

**Page 82**
Courtaparteen
churchyard, near
Sandycove, 2020.
DJI Air 2 drone aerial.

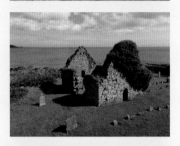

**Page 83**
*Fán na Tobraide*,
the Abbey Well, 2020.
Olympus OMD E-M5
Mark III, Laowa 7.5mm.

**Page 84**
Sunset, outer harbour,
2017. Olympus
OMD E-M1 Mark II,
7–14mm.

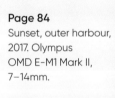

**Page 85**
St Multose church
and Market Square,
2022. DJI Mavic 3
drone aerial.

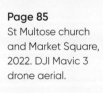

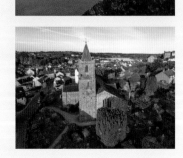

**Page 86**
Flowering rapeseed,
near Milewater, 2016.
Nikon D810, 24mm
tilt-shift.

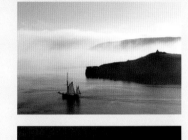

**Page 87**
The ketch *Ilen* in
morning fog, 2020.
Olympus OMD E-M1
Mark II, 40–150mm.

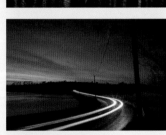

**Page 88–89**
Christmas lights in
the harbour, 2014.
Olympus OMD E-M1,
40–150mm.

**Page 90**
Twilight, the Gully
bridge, 2011.
Leica M9, 28mm.

**Page 91**
Lone tree,
Oysterhaven, 2022.
Leica SL2-S, 28–70mm.

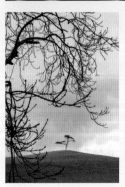

**Page 92**
Still dawn, Kinsale harbour, 2021. DJI Air 2S drone aerial.

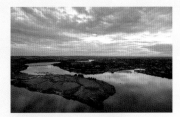

**Page 98**
Sunrise, Lobster Quay, 2020. Olympus OMD E-M5 Mark III, 8–18mm.

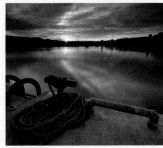

**Page 103**
Ringrone Castle and Bandon River at sunset, 2021. DJI Air 2S drone aerial.

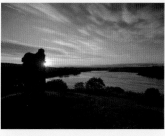

**Page 93**
Early morning bird in flight, Market Square, 2020. Ricoh GRiii.

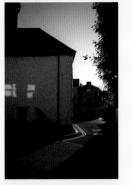

**Page 99**
Fog at the mast, 2016. Nikon Df, 24–84mm.

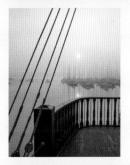

**Page 106**
Evening drinks, Summercove, 2010. Nikon D3X, 24–85mm.

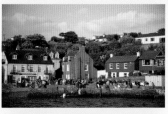

**Page 94**
Battle of Kinsale memorial, Milewater, 2020. Olympus OMD E-M5 Mark III, 40–150mm.

**Page 100**
Jamesfort from above, 2021. DJI Air 2S drone aerial.

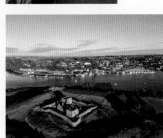

**Page 110**
*An Puc Fada* – the long puck, Kinsale Regatta, 2006. Nikon D2X, 12–24mm.

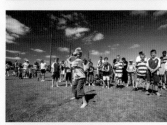

**Page 95**
Battle of Kinsale memorial, Milewater, 2020. DJI Air 2 drone aerial.

**Page 101**
Jamesfort from above, 2021. DJI Air 2S drone aerial.

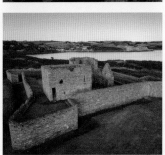

**Page 112**
Road raft race, 2006. Nikon D2X, 12–24mm.

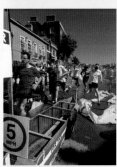

**Page 96–97**
Castlepark marina and outer harbour to Middle Cove. Nikon Df, 50mm.

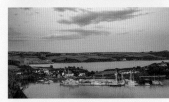

**Page 102**
The Blockhouse, Jamesfort, 2021. DJI Air 2S drone aerial.

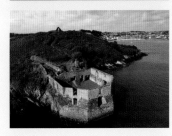

**Page 113**
Cycle race, Emmet Place, 2009. Leica M9, 24mm.

**Page 114**
Coming alongside,
Pier head, 2008.
Leica M8, Tri-Elmar-M
at 18mm.

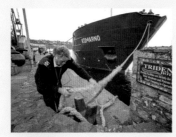

**Page 115**
Slipping past, 2009.
Leica M9, 24mm.

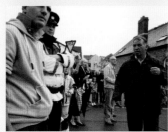

**Page 116**
*Corpus Christi*
ceremony, Market
Quay, 2007.
Nikon D200, 17–55mm.

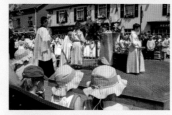

**Page 117**
*Corpus Christi*
procession, 2007.
Nikon D200, 17–55mm.

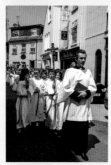

**Page 118**
Swimming at
Charlesfort, summer
2021. Leica M5, 50mm,
Kodak Pro Image
100 film.

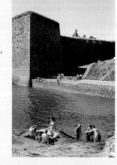

**Page 119**
Heatwave, Castlepark
beach, summer 2021.
Leica M5, 35mm,
Kodak Pro Image
100 film.

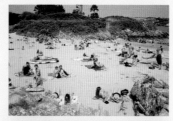

**Page 121**
Winter, Garretstown
beach, 2022.
Leica SL2-S,
28–70mm.

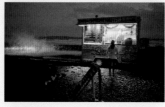

**Page 122**
Hat stand, Clipper
Race festival, 2010.
Leica M9, 35mm.

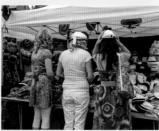

**Page 123**
Fish 'n chips at
the bridge, 2021.
Panasonic S5, Leica
35mm.

**Page 124**
Grotto, Old Head,
2011. Nikon D7000,
17–55mm.

**Page 125**
Ballinspittle grotto,
2007. Leica M8, 75mm.

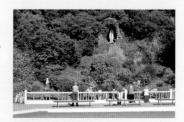

**Page 126**
Discount store,
Pearse Street. 2021.
Leica M5, Kodak Pro
Image 100 film.

**Page 127**
Pub sign, Main Street,
2002. Nikon D100,
70–200mm.

**Page 128–129**
Cooling off,
Carrigeen, 2020.
Fujifilm X100V.

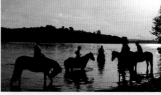

**Page 130**
Fish 'n chips on
the pier, 2005.
Nikon D2X, 17–55mm.

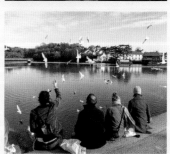

**Page 131**
Dinghies and flowers, Pier Head, 2012. Canon 5D Mark III, 24–105mm.

**Page 132**
Summer drinks at the Trident, 2021. Panasonic S5, Leica 35mm.

**Page 133**
Circus elephants, Market Square, 2007. Leica M8, 28mm.

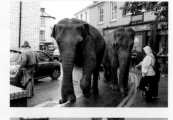

**Page 134**
Corpus Christi Sunday, 2007. Nikon D200, 17–55mm.

**Page 135**
Desmond O'Grady mural by Omin, The Spaniard, 2021. Leica M5, 50mm, Kodak Pro Image 100 film.

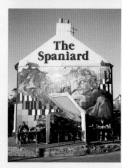

**Page 136**
Coaster unloading at night, 2021. Panasonic S5, 14–24mm.

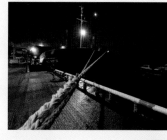

**Page 137**
St Patrick's Day parade, 2012. Canon Powershot G12.

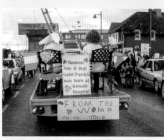

**Page 138–139**
Jumping in at high tide, Sandycove, 2012. Canon 5D Mark III, 24–105mm.

**Page 140**
Mackerel fishing at the bridge, c. 1997. Nikon F90, 70–200mm.

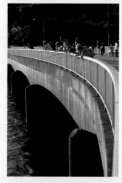

**Page 141**
Outdoor dining, Main Street, 2021. Panasonic S5, 20–60mm.

**Page 142**
Kinsale Railway mural by Omin, Kinsale Holiday Village, 2023. Leica SL2-S, 28–70mm.

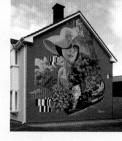

**Page 143**
Gable flowers, Friar's Gate, 2022, Leica M10-P, 50mm.

**Page 144**
Cleaning up, St Patrick's Day parade, 2012. Canon Powershot G12.

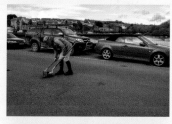

**Page 145**
Buoys on a gate, World's End, 2010. Olympus E-P2, 14–42mm.

**Page 146**
St Patrick's Day maritime parade, 2013. Nikon D4, 24–85mm.

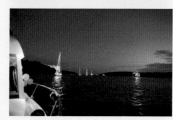

**Page 147**
Anne Bonny mural
by Splattervan,
Stoney Steps, 2021.
Panasonic S5,
20–60mm.

**Page 148**
Fireworks, St Patrick's
Day maritime parade,
2018. Olympus OMD
E-M1 Mark II, 12–40mm,
composite.

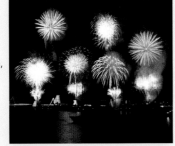

**Page 149**
Pantomime, Rampart
Players, 2016.
Nikon Df, 70–200mm.

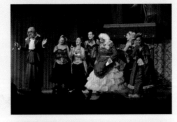

**Page 151**
Sunset surf,
Garretstown beach,
2009. Canon
Powershot G11.

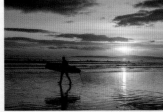

**Page 152**
Flooding, Market
Quay, 2009.
Nikon D3X, 16–35mm.

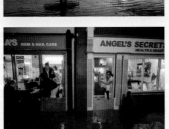

**Page 153**
Flooding, Market
Quay, 2009.
Nikon D3X, 16–35mm.

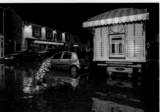

**Page 154–155**
Christmas Day swim,
2004. Nikon D70,
18–55mm.

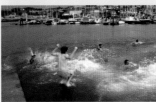

**Page 156**
Interior, Old Head
lighthouse, 2015.
Nikon D810, 14–24mm.

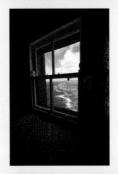

**Page 157**
Sunset, GAA pitch,
2010. Olympus E-P2,
14–42mm.

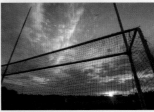

**Page 160**
Old Head of Kinsale
lighthouse and
Courtmacsherry Bay,
2022. DJI Mavic 3
drone aerial.

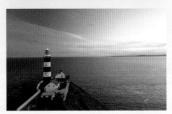

**Page 162**
*Lusitania* grave,
St Multose churchyard,
1989. Nikon FE, 50mm,
Kodachrome 64 film.

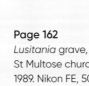

**Page 163**
Lusitania memorial,
Old Head, *c.* 1997.
Nikon F90, 28–80mm.

**Page 165**
Margaret MacKenzie
gravestone,
St Multose Church,
2021. Panasonic S5,
20–60mm.

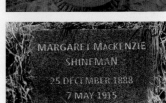

**Page 166**
*Lusitania*, outbound,
passing Old Head of
Kinsale, *c.* 1912.

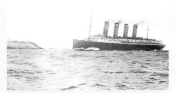

**Page 167**
*Lusitania* sinking,
painting by Stuart
Williamson (with
kind permission of
the artist).

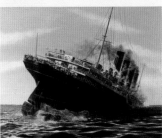

**Page 168**
*Lusitania* shipwreck,
painting by Stuart
Williamson (with kind
permission of the
artist).

**Page 169**
Holeopen Bay West,
Old Head of Kinsale,
2023. DJI Mavic 3,
wide-angle lens,
drone aerial.

**Page 170–171**
Twilight, Scilly, 2014.
Nikon Df, 24–85mm.

**Page 174**
Breaking Atlantic
wave, 2020.
Olympus OMD E-M5
Mark III, 100–400mm.

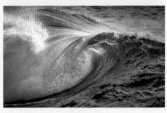

**Page 178**
Wreck of the *City of
Chicago*, Old Head
of Kinsale, 1892.

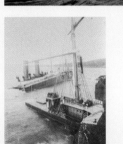

**Page 179**
Underwater wreckage
of the *City of Chicago*,
Old Head of Kinsale,
2014. Olympus OMD
E-M1, Nauticam
housing, 8mm.

**Page 181**
Diver entry, outer
harbour, 2013.
Nikon D4, 16–35mm.

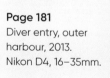
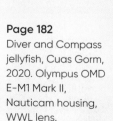

**Page 182**
Diver and Compass
jellyfish, Cuas Gorm,
2020. Olympus OMD
E-M1 Mark II,
Nauticam housing,
WWL lens.

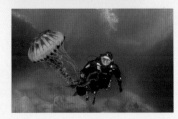

**Page 183**
*Alcyonium digitatum*
('Dead man's
fingers') soft corals,
Ringagurteen,
Old Head, 2014.
Olympus OMD E-M1,
Nauticam housing,
8mm.

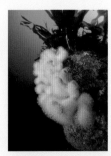

**Page 184**
Diving, Bream Rock,
Old Head, 2014.
Olympus OMD E-M1,
Nauticam housing,
8mm.

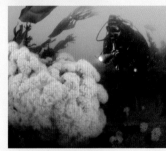

**Page 185**
Lost golf balls,
Old Head, 2014.
Olympus OMD E-M1,
Nauticam housing,
8mm.

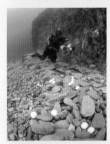

**Page 186 (top)**
Prawn close-up,
Bullen's Bay, Old
Head, 2014.
Olympus OMD E-M1,
Nauticam housing,
45mm.

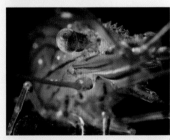

**Page 186 (bottom)**
Juvenile John Dory
feeding, Cuasín na
Daoine Báite, Old
Head, 2014.
Olympus OMD E-M1,
Nauticam housing,
45mm.

**Page 187**
Above and below,
Old Head, 2020.
Olympus OMD E-M1
Mark II, Nauticam
housing, 8mm.

**Page 188–189**
Beach groynes,
Garrettstown, 2009.
Nikon D3X, 24mm
tilt-shift.

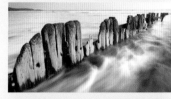

**Page 192**
Photographing at
dawn, Castlepark,
2015. Panasonic GX8,
7–14mm.

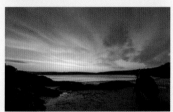

**Page 195**
Twilight, Bandon
River, 2003.
Hasselblad Xpan,
45mm, Fujichrome
Velvia 50 film.

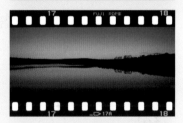

**Page 196**
Three harbours,
Kinsale, 2022.
DJI Mavic 3,
wide-angle lens,
drone aerial.

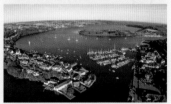

**Page 210**
Top of the tide,
Sandycove, 2022.
Olympus OMD E-M1
Mark II, 8–18mm lens,
Nauticam underwater
housing.

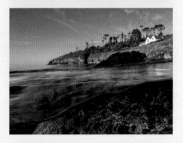

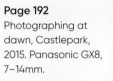
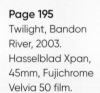
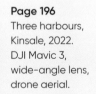

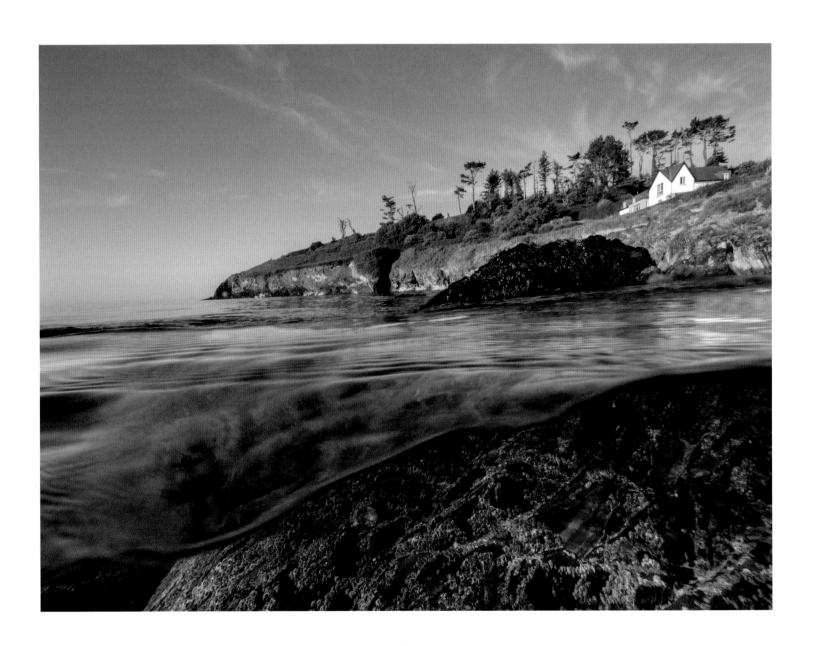